David Busch's Quick Snap Guide to Using Digital SLR Lenses

David D. Busch

THOMSON

COURSE TECHNOLOGY

Professional ■ Technical ■ Reference

Important: Thomson Course Technology PTR cannot provide software support. Please contact the appropriate software manufacturer's technical support line or Web site for assistance.

Thomson Course Technology PTR and the author have attempted throughout this book to distinguish proprietary trademarks from descriptive terms by following the capitalization style used by the manufacturer.

Information contained in this book has been obtained by Thomson Course Technology PTR from sources believed to be reliable. However, because of the possibility of human or mechanical error by our sources, Thomson Course Technology PTR, or others, the Publisher does not guarantee the accuracy, adequacy, or completeness of any information and is not responsible for any errors or omissions or the results obtained from use of such information. Readers should be particularly aware of the fact that the Internet is an ever-changing entity. Some facts may have changed since this book went to press.

Educational facilities, companies, and organizations interested in multiple copies or licensing of this book should contact the Publisher for quantity discount information. Training manuals, CD-ROMs, and portions of this book are also available individually or can be tailored for specific needs.

ISBN-10: 1-59863-455-0

ISBN-13: 978-1-59863-455-6

Library of Congress Catalog Card Number: 2007931839

Printed in the United States of America

08 09 10 11 12 BU 10 9 8 7 6 5 4 3 2 1

Publisher and General Manager, Thomson Course Technology PTR:
Stacy L. Hiquet

Associate Director of Marketing:
Sarah O'Donnell

Manager of Editorial Services:
Heather Talbot

Marketing Manager:
Jordan Casey

Executive Editor:
Kevin Harreld

Project Editor:
Jenny Davidson

Technical Reviewer:
Michael D. Sullivan

PTR Editorial Services Coordinator:
Erin Johnson

Interior Layout Tech:
Bill Hartman

Cover Designer:
Mike Tanamachi

Indexer:
Kelly D. Henthorne

Proofreader:
Sandi Wilson

THOMSON

COURSE TECHNOLOGY

Professional ■ Technical ■ Reference

Thomson Course Technology PTR, a division of Thomson Learning Inc.
25 Thomson Place ■ Boston, MA 02210 ■ http://www.courseptr.com

For Cathy

Acknowledgments

Once again thanks to the folks at Course Technology, who have pioneered publishing digital imaging books in full color at a price anyone can afford. Special thanks to executive editor Kevin Harreld, who always gives me the freedom to let my imagination run free with a topic, as well as my veteran production team including project editor Jenny Davidson, and technical editor Mike Sullivan. Also thanks to Mike Tanamachi, cover designer; Bill Hartman, layout; and my agent, Carole McClendon, who has the amazing ability to keep both publishers and authors happy.

About the Author

David D. Busch has written 10 best-selling guidebooks for specific digital SLR models, and six other popular books devoted to dSLRs, including *Quick Snap Guide to Digital SLR Photography*, *Mastering Digital SLR Photography, Second Edition*, and *Digital SLR Pro Secrets*. As a roving photojournalist for more than 20 years, David D. Busch illustrated his books, magazine articles, and newspaper reports with award-winning images. He's operated his own commercial studio, suffocated in formal dress while shooting weddings-for-hire, and shot sports for a daily newspaper and Upstate New York college. His photos have been published in magazines as diverse as *Scientific American* and *Petersen's PhotoGraphic*, and his articles have appeared in *Popular Photography & Imaging*, *The Rangefinder*, *The Professional Photographer*, and hundreds of other publications. He has reviewed digital cameras for CNet and *Computer Shopper*.

When **About.com** named its top five books on Beginning Digital Photography, occupying the #1 and #2 slots were Busch's *Digital Photography All-In-One Desk Reference for Dummies* and *Mastering Digital Photography*. During the past year, he's had as many as five of his books listed in the Top 20 of Amazon.com's Digital Photography Best Seller list—simultaneously! Busch's 100-plus other books published since 1983 include best-sellers like *David Busch's Digital Infrared Pro Secrets*.

Busch earned top category honors in the Computer Press Awards the first two years they were given (for *Sorry About The Explosion* and *Secrets of MacWrite, MacPaint and MacDraw*), and later served as Master of Ceremonies for the awards.

Contents

Preface

You've unpacked your first digital SLR, used it to create a few hundred photographic masterpieces, and now you are yearning to expand your capabilities by adding an interchangeable lens or two to your camera kit. But what lens should you buy? Do you want a wide angle, a telephoto, or, perhaps, a macro lens? You don't want to spend hours or days studying a comprehensive book on digital SLR photography. All you want at this moment is a quick guide that explains the purpose and function of each type of lens, how to master the mysteries of depth-of-field, and what cryptic terms like *bokeh* and *diffraction* mean. Why isn't there a book that summarizes whole collections of these concepts in a page or two with lots of illustrations showing what your results will look like when you use this lens setting or that?

Now there is such a book. If you want a quick introduction to working with lenses, filters, close-up accessories, and other optical matters, this book is for you. Once you realize that the term *single lens reflex* doesn't mean that your camera must use only a single lens, you need this *Quick Snap* guide.

I'm not going to tell you everything there is to know about using your digital SLR camera and its lenses; I'm going to tell you just what you need to get started using your lenses to take great photos.

Introduction

This is the third book in my *Quick Snap* guidebook series, each of which takes a single puzzling area of digital photography and explains each concept in a few pages that condense everything you need to know to the essential bullet points, some explanatory text that outlines just what you absolutely need to know, and a few salient illustrations. If you're eager to learn about interchangeable lenses, this book is the shortcut you need to optical proficiency.

Like all my *Quick Snap* guides, this one is aimed at photographers who may be new to SLRs or new to digital SLRs, and are overwhelmed by their options while underwhelmed by the explanations they receive in their user's manuals. These manuals are great if you already know what you don't know, and you can find an answer somewhere in a booklet arranged by menu listings and written by a camera vendor employee who last threw together a manual for a VCR.

The book is arranged in a browseable layout, so you can thumb through and find the exact information you need quickly. The basics are presented within two-page and four-page spreads, so all the explanations and the illustrations that illuminate them are there for easy viewing. This book should solve many of your problems with a minimum amount of fuss and frustration.

Then, when you're ready to learn more, I hope you pick up one of my five in-depth guides to digital SLR photography. Three of them are offered by Thomson/Course Technology, each approaching the topic from a different perspective.

They include:

The Quick Snap Guide to dSLR Photography

If you're new to digital SLRs, this book belongs in your camera bag as a reference, so you can always have the basic knowledge you need with you, even if it doesn't yet reside in your head. It serves as a refresher that summarizes the basic features of digital SLR cameras, and what settings to use and when, such as continuous autofocus/single autofocus, aperture/shutter priority, EV settings, and so forth. The guide also includes recipes for shooting the most common kinds of pictures, with step-by-step instructions for capturing effective sports photos, portraits, landscapes, and other types of images.

Mastering Digital SLR Photography, Second Edition

This book is an introduction to digital SLR photography, with nuts-and-bolts explanations of the technology, more in-depth coverage of settings, and whole chapters on the most common types of photography. Use this book to learn how to operate your dSLR and get the most from its capabilities.

Digital SLR Pro Secrets

This is my more advanced guide to dSLR photography with greater depth and detail about the topics you're most interested in. If you've already mastered the basics in *Mastering Digital SLR Photography*, this book will take you to the next level.

Should you need instruction on how to get the most from specific camera models, look for my Course Technology books for the Canon EOS Digital Rebel XT, Canon EOS Digital Rebel XTi, Canon EOS 30D, Canon EOS 40D, and Nikon D300.

Who Am I?

You may have seen my photography articles in *Popular Photography & Imaging* magazine. I've also written about 2,000 articles for (late, lamented) *Petersen's PhotoGraphic*, plus *The Rangefinder, Professional Photographer*, and dozens of other photographic publications. First, and foremost, I'm a photojournalist and made my living in the field until I began devoting most of my time to writing books. Although I love writing, I'm happiest when I'm out taking pictures, which is why I took two weeks off late in 2007 on a solo visit to Spain—not as a tourist, because I've been to the Iberian peninsula no less than a dozen times in the past—but solely to take photographs of the people, landscapes, and monuments that I've grown to love.

Like all my digital photography books, this one was written by someone with an incurable photography bug. I've worked as a sports photographer for an Ohio newspaper and for an upstate

New York college. I've operated my own commercial studio and photo lab, cranking out product shots on demand and then printing a few hundred glossy 8 × 10s on a tight deadline for a press kit. I've served as photo-posing instructor for a modeling agency. People have actually paid me to shoot their weddings and immortalize them with portraits. I even prepared press kits and articles on photography as a PR consultant for a large Rochester, N.Y., company. My trials and travails with imaging and computer technology have made their way into print in book form an alarming number of times, including a few dozen on scanners and photography.

Like you, I love photography for its own merits, and I view technology as just another tool to help me get the images I see in my mind's eye. But, also like you, I had to master this technology before I could apply it to my work. This book is the result of what I've learned, and I hope it will help you master your digital SLR, too.

Contents

Chapter 1: A World of Lenses

Learn how lenses work, what normal, telephoto, and wide-angle lenses do, the differences between prime and zoom lenses, and the precise effects of changing f/stops.

Chapter 2: Lens Controls and Features

Lenses may include a half-dozen or more controls, including focus rings, depth-of-field scales, zoom controls, autofocus/manual switches, and image stabilization/vibration reduction adjustments. This chapter shows you what each of these do, and how particular settings can improve your photography.

Chapter 3: Filters and Lens Attachments

There are lots of cool effects and corrections you can make with filters mounted on your lens that you simply can't achieve in an image editor like Photoshop. This chapter explains some of the

things you can do with neutral density filters, gradient filters, and special effects accessories—with some tips on how you can make your own, inexpensively.

Chapter 4: Improving the Image Quality of Your Lens

The lens you use, and how you use it, can have a dramatic effect on the image quality of your photographs. In this chapter you'll learn how to select your lens's best aperture for a particular type of photo, how to test your lens for sharpness, and measure just how much sharpness you're losing to camera shake. You'll be amazed at how much you can improve the image quality of the lenses you already own.

Chapter 5: Using Telephoto Lenses

Learn the difference between long lenses and true telephotos, how to compress distances, use selective focus, and avoid common telephoto distortion problems.

Chapter 6: Using Wide-Angle Lenses

Wide-angle lenses have their own strengths—and pitfalls, as you'll learn in this chapter. Discover how to counter perspective distortion, and how to make the size distortion that wide-angle lenses produce work for you. Learn how to emphasize the foreground, and use the amazing depth-of-field available with wide lenses to create compelling images.

Chapter 7: Using Macro Lenses

Here, you'll find out that the most important factor in close-up photography is not how close you can focus, but the final magnification that a given lens can produce. You may not have to invest in special macro lenses: the optics you already own can do a great job up close with some inexpensive accessories described in this chapter. You'll learn about extension tubes, bellows, and the magical properties of reversing rings.

Glossary

Want a quick definition of an unfamiliar word? You'll find it here.

1 A World of Lenses

The lens you mount on your digital single lens reflex (dSLR) camera can make a dramatic difference in the quality and impact of your photographs. Indeed, one of the chief advantages of the dSLR over point-and-shoot digital cameras is the ability to remove one lens and replace it with another. But newcomers to dSLR photography often think in terms of simply exchanging one lens for another one with a wider or narrower field of view: they're thinking only in terms of wide-angle and telephoto lenses (or zoom positions). However, there's so much more that add-on lenses can do for you.

Yes, you can mount a wider lens on your camera when your back is against a wall and you need a lens with a wider perspective. Wide angles are great for interior photos, pictures outdoors in crowded surroundings, and for those times when you want to take advantage of the wide-angle lens's perspective "distortion." Telephoto lenses bring things closer or reduce the range of sharpness (so you can choose which portions of your picture are in focus, and which are not). These long lenses can seemingly compress the relative distances, too, making objects that seem widely separated appear to be right next to each other.

There are also *macro* lenses that let you focus as close as an inch or two from the front of the lens, and lenses that are "faster"—they admit much more light to the sensor, so you can take pictures in lower light levels or at shutter speeds that freeze action. Some lenses offer extra sharpness for critical applications where images will be examined closely or enlarged. Some have special features, such as vibration reduction (also called image stabilization), which partially counteracts a photographer's unavoidable shakiness. There are even lenses that provide intentionally distorted fish-eye perspectives that can be used as a special effect.

In later chapters of this book, I show you the importance of the rich selection of features available with the many different categories of lenses. I tell you how to choose the best lenses with these features, and how to use them. This chapter is your introduction to the most basic lens terminology, on the theory that, while you don't need to know how the internal combustion engine works to drive a car, it's really useful to understand the difference between the gas tank and an automatic transmission. Once you understand what a *prime* lens is, or that *lens speed* isn't how quickly your lens can focus, the rest is easy.

How a Lens Works

At its very simplest, a lens element is a (mostly) transparent element made of glass, plastic, or some other material, with one or two curved surfaces that bend (*refract*) the direction of light as it passes through. A curve that bulges outward (*convex*) causes the light to converge towards a single point of *focus*. A curve that bulges inward (*concave*) causes the light to diverge, instead. One of the surfaces of the lens element can be flat (*planar*) and not curved. Figure 1.1 shows a

simple lens element with two convex surfaces, while in Figure 1.2, you can see an equally simple lens element with two concave surfaces. Lens elements can be built with any combination of convex, concave, and planar surfaces (see Figure 1.3) depending on the desired properties of the lens to magnify, reduce, or correct for defects called *aberrations*.

Most lens elements have spherical curvature; that is, the curve of

the element is the same as the surface of a sphere of appropriate size. Some lens elements have more complex, non-spherical surfaces that can provide more sophisticated optical corrections, and are called *aspherical*. Individual lens elements can be created by grinding and polishing a piece of lens material to the desired shape, or by molding.

Photographic lenses usually consist of three or more lens elements arranged in one or more *groups*

that provide the desired optical effects, such as a telephoto or wide-angle viewpoint. Figure 1.4 shows a lens design that has been used for more than 100 years, called a *Cooke triplet*, that is notable because it was the first photographic lens to provide sharpness right out to the edge of the image. More complex designs followed, such as the four-element *Tessar* patented by the Zeiss optical company, shown in Figure 1.5.

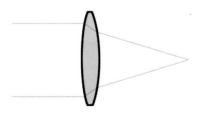

Figure 1.1 A convex lens surface causes light to converge to a focus point.

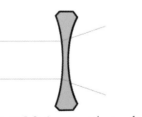

Figure 1.2 A concave lens surface causes light to diverge.

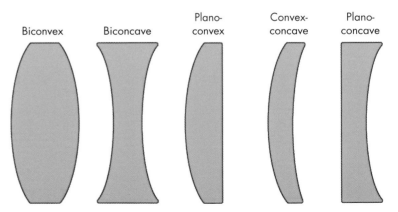

Figure 1.3 Lenses can have any combination of convex, concave, and flat surfaces.

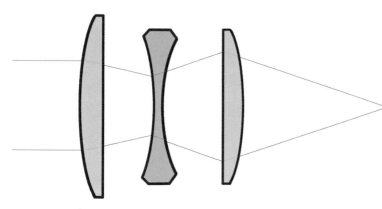

Figure 1.4 A three-element lens.

Lenses are designated by their *focal length*, which is the distance from the optical center of the lens to its point of *convergence* or *focus* at the sensor (or, in a film camera, at the film plane). The more strongly a lens converges light, the shorter its focal length, and the wider its angle of view; a lens that converges light over a greater distance provides a magnification effect, and is most often called a *telephoto* lens. (Technically, a telephoto lens is actually one particular type of long-focal-length lens.) You can read more about focal lengths later in this chapter.

Some lenses, including *zoom* lenses, have moving elements that can be shifted to change the focal length of the lens, thus altering its field of view and magnification. (See Figure 1.6.) I explain wide-angle, telephoto, and zoom lenses in other sections in this and later chapters of the book.

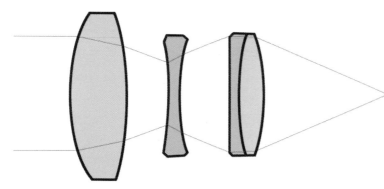

Figure 1.5 The four-element Zeiss Tessar lens design has been used in a variety of lenses for more than 100 years.

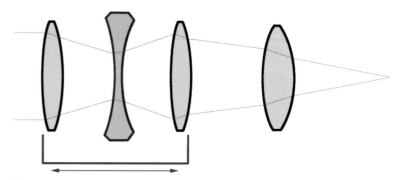

Figure 1.6 In a zoom lens, some components (the three elements at left in this simplified design) can be shifted relative to the other elements of the lens, to change the focal length and magnification.

3

How a Lens Is Made

All photographic lenses are mounted inside a tube that holds the elements, and provides for movement of the elements both for changing the focal length (in zoom lenses) or in changing the point of the subject that is in sharpest focus. Lenses also include a mechanism for changing the size of the opening that admits light (the *aperture*). (See Figure 1.7.)

Zooming is accomplished by turning the zoom ring that wraps around the lens barrel (see Figure 1.8). While digital SLRs all can focus for you automatically, if you prefer, their lenses still retain the ability to focus manually using a focus ring located around the lens barrel. Manual focusing is useful for some types of work, particularly close-up photography; when you want to fine-tune the camera's autofocus setting; and anytime you can focus more quickly and accurately manually (subjects with low contrast, and some kinds of action photography come to mind).

Unfortunately, there is no standardized configuration for the zoom and focus rings. That is, with some lenses, the zoom ring is the outermost ring on the lens barrel. With other lenses (even

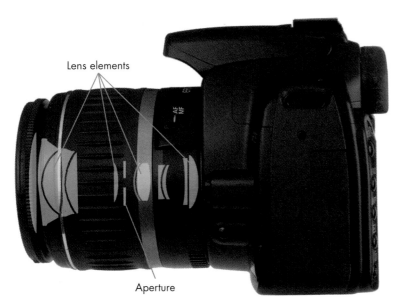

Lens elements

Aperture

Figure 1.7 Lens elements are contained in a tube that allows them to move for focusing and zooming.

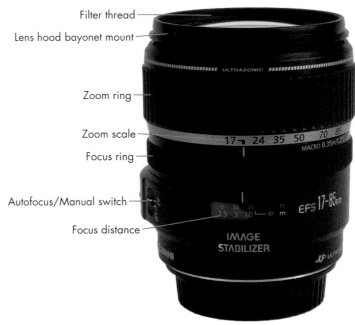

Filter thread

Lens hood bayonet mount

Zoom ring

Zoom scale

Focus ring

Autofocus/Manual switch

Focus distance

Figure 1.8 Lenses share many controls in common.

from the same manufacturer), you might find the zoom ring as the ring closest to the lens mount. The focus ring is usually narrower than the zoom ring, but not always. Some lenses focus and/or zoom by rotating the appropriate ring clockwise; others operate by rotating counterclockwise. Many older lenses zoom by pushing and pulling on the zoom ring or a combination zoom/focus ring that is pulled in and out to zoom, and rotated to focus. Your best bet is to take some time learning the idiosyncrasies of each new lens as you buy it.

Another feature found on some lenses is a separate *aperture ring*, which allows you to set the size of the lens opening manually. Because digital SLRs are capable of making this adjustment using a control in the camera—even with lenses that have an aperture ring—you'll find that you won't use the aperture ring very often. You might need to adjust the lens opening manually when using an older lens that lacks autoexposure features, or when the lens is mounted on an accessory such as an extension

tube that doesn't offer automatic exposure coupling. (More on that in Chapter 8.) Because most lenses today don't have an aperture ring at all, you may never be able to use this capability.

Most lenses have a common set of controls, shown in Figure 1.8. They include:

◆ **Filter thread.** Lenses have a thread on the front for attaching filters and other add-ons. Some also use this thread for attaching a lens hood (you screw on the filter first, and then attach the hood to the screw thread on the front of the filter).

◆ **Lens hood bayonet.** This is used to mount the lens hood for lenses that don't use screw-mount hoods (the majority).

◆ **Zoom ring.** Turn this ring to change the zoom setting.

◆ **Zoom scale.** These markings on the lens show the current focal length selected.

◆ **Focus ring.** This is the ring you turn to manually focus the lens.

◆ **Distance scale.** This is a readout that rotates in unison with the lens's focus mechanism to show the distance at which the lens has been focused. It's a useful indicator for double-checking autofocus, and for roughly setting manual focus or depth-of-field.

◆ **Autofocus/Manual switch.** Allows you to change from automatic focus to manual focus.

◆ **Image stabilization switch (not shown).** Lenses with IS include a separate switch for turning the stabilization feature on or off.

The back end of lenses (the part that attaches to your camera body) include a set of electrical contacts (see Figure 1.9) that convey information such as focus and exposure back and forth between the camera and lens, and makes it possible for the camera to control focusing and the size of the lens opening. There's also a metal

or rugged plastic bayonet mount that mates with a matching mount on your camera body to allow you to attach and detach the lens quickly. Some vendors include other features on the rear of the lens, including a connector to allow a motor in the camera body to focus lenses that lack their own autofocus motor, or a pin that enables the camera body to open and close the aperture. These extra mechanical components are on their way out, because the trend is toward carrying out these functions electronically.

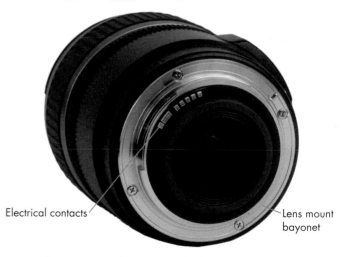

Electrical contacts

Lens mount bayonet

Figure 1.9 A bayonet mount for attaching the lens to the camera body, and electrical contacts may be the only features found on the rear of your lens.

What Is Focal Length?

The explanation that a lens's focal length is the distance from the optical center of the lens to its point of focus doesn't tell the whole story, of course. What *is* important is that the focal length determines the relative field of view produced by a lens—how wide or narrow its perspective is. A lens with a wide perspective will provide an expansive view like the one shown in Figure 1.10. One with an intermediate perspective (which photographers call *normal*) offers a view like that in Figure 1.11. A narrow, telephoto view might bring details of a subject in very close, as shown in Figure 1.12.

Focal lengths are measured in millimeters. Some lenses have a field of view that is fixed at a particular focal length, such as 18mm, 50mm, 105mm, or 200mm. These are called *prime* lenses or, sometimes, *fixed focal length* lenses. Other lenses have the ability to shift lens elements around to produce a continuous range of focal lengths. These are called *zoom* lenses. A typical zoom lens might be able to change magnifications from an 18mm wide view to a 200mm telephoto perspective, thus incorporating the fields of view of the 18mm, 50mm, 105mm, and 200mm prime lenses listed previously, plus all the focal lengths between them.

Whether a given focal length is considered wide, normal, or telephoto depends on the size of the sensor (or film) used to capture the image. For that reason, a lens that might be considered wide when used with one digital camera, might be categorized as a normal lens when used with a digital camera that has a smaller sensor. You can read more about the effects of this *crop factor* later in this chapter.

Because most consumer digital SLRs have sensors that are similar in size, the most common focal lengths can be grouped into

Figure 1.10 A wide-angle focal length takes in a broad field of view, emphasizing the foreground.

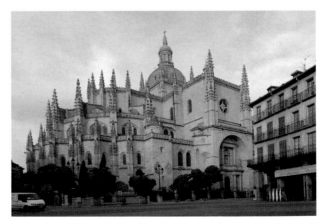

Figure 1.11 A normal focal length offers an intermediate field of view that provides a standard perspective for most subjects.

general categories, with, of course, some overlap between adjacent groups. The following list shows the approximate focal lengths of lenses used with cameras that have a 1.5x or 1.6x "crop factor," with a little overlap in focal lengths between some categories (because that overlap exists in real life). But remember that if you are comparing these focal lengths with lenses used with film cameras or some professional digital cameras with no crop factor, and other models with a different crop factor, the guidelines won't apply.

Figure 1.12 A telephoto focal length brings distant subjects closer.

◆ **Ultra-Wide Angle: 10-15mm.** These lenses provide the broadest view, taking in large swathes in landscape photos, or virtually all of an interior space. Objects closer to the camera may appear larger (a kind of distortion described in more detail in Chapter 6), and the foreground is emphasized, as you can see in Figure 1.10.

◆ **Wide Angle: 16-28mm.** Use these lenses for most landscape, architecture, and interior photography, or any subjects where you have a wide field of view.

◆ **Normal: 28-40mm.** This focal length range is defined separately because, before zoom lenses became predominant, most cameras were purchased with a "normal" lens (a full-frame focal length of 50mm), with an unremarkable field of view that was neither fish nor fowl/wide nor telephoto. While the normal range gained a reputation as "boring," prime lenses of this focal length have large maximum apertures (often f/2 to f/1.4), which makes them ideal for low-light photography. Normal focal lengths are also good for 3/4 and full-length portraits, or shots of small groups.

◆ **Short Telephoto: 40-60mm.** Lenses in this focal length range have been traditionally called "portrait" lenses, because they provide a flattering perspective for head-and-shoulders (and closer) portrait images. Focal lengths shorter than this range can exaggerate the size of features like noses that are closer to the camera, at the expense of features like ears, which are farther away and appear to be too small. Focal lengths of about 100mm or longer tend to compress facial features together in a flattening effect.

◆ **Medium Telephoto: 60-135mm.** Lenses in this range (as well as those at the long end of the short telephoto range) are popular for close-up and macro photography, because they let you maintain a little distance between your subject and the camera. That distance makes lighting the subject easier, and can be less threatening to small living subjects, such as insects. Medium telephoto lenses are also useful for sports at close range, and some portraits, at the shorter (61-90mm) end of the range.

◆ **Long Telephoto: 135-300mm.** These focal lengths are useful for pulling in any subject that's too far from the camera to fill the frame. You'll find them helpful for shooting concerts, sports events, and skittish wildlife. As you'll learn in Chapter 6, longer telephoto lenses require solid technique to minimize the effects of camera shake (image stabilization, a tripod, and/or faster shutter speeds are required) and to manage the reduced range of sharpness these lenses offer.

◆ **Super Telephoto: 300mm and above.** Really long focal lengths are most useful to wildlife photographers, who must photograph creatures from hundreds of feet away (or smaller critters from dozens of feet away). Outdoor sports photographers who want to put themselves into the middle of the huddle, at the edges of the scrum, or capture an exciting play from the other side of the stadium or field also benefit from really long focal lengths. It's true that 300mm just barely qualifies for this category: the really long focal lengths range from 400 to 600mm. Anything above 600mm is likely to be an exotic set of optics with an exotic price, as well.

What Are f/stops?

The f/stop goes by many names, including aperture, lens opening, f-number, relative aperture, and aperture stop. While each of these names don't always mean precisely the same thing, they all refer to the relative diameter of the opening, or *entrance pupil* that admits light to the lens. The larger the opening, the more light the lens can potentially transmit to the sensor; a smaller f/stop limits the amount of light that can "flow through" the lens. The size of the opening is variable, and controlled by a clever adjustable mechanism called an *iris diaphragm* (because it operates like the iris of the human eye) that uses a set of overlapping thin leaves (see Figure 1.13) that move to adjust the size of the gap in the center of the lens.

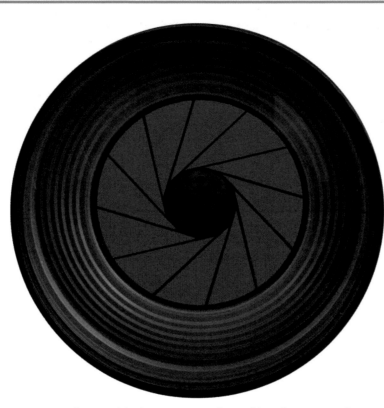

Figure 1.13 The size of the lens opening is changed by adjusing a set of overlapping metal leaves.

In olden times, aperture stops were actual metal plates with fixed-size holes that could be inserted into a slot in the side of the lens. To change the aperture size, you needed to remove the current stop and replace it with one having an opening of the desired size. The iris diaphragm, particularly as used in modern cameras (which can be resized on the fly automatically by the camera's exposure system) is a much more convenient component to use. Indeed, most digital SLR lenses used on consumer cameras lack a control, called an *aperture ring*, that can be used to set the f/stop manually. Most of the time, even in manual exposure mode, you'll use a dial on your camera body to specify the aperture. Some lenses, often "professional" lenses or those originally designed for older film cameras, do have an aperture

ring on the lens barrel that can be unlocked and used to select the f/stop. (See Figure 1.14.) The ability to set the f/stop on the lens itself comes in handy when the lens is not mounted directly on the camera, such as when it is used with a close-up accessory such as a *bellows*, non-automatic *extension tube*, or *reversing ring* (described in Chapter 8).

F/stops are called *relative apertures* because an opening of a given size provides more or less light for the sensor, depending on how far it is located from the sensor. That distance is calculated using the lens's focal length, which you'll recall, is the distance from the optical center of the lens to the sensor (or focal plane). An opening with a diameter of, say,

12.5mm (about half an inch) located inside a lens with a 50mm focal length yields an f/stop of f/4 (50mm divided by 12.5mm). Yet, an opening of the exact same size on a 100mm lens (or a zoom lens at its 100mm setting) would provide an f/stop of f/8 (100/12.5). Figure 1.15 shows a simplified example (in the illustration, both apertures are exactly the same diameter; the top version looks larger thanks to an optical illusion).

You can see from the way f/stops are calculated that they can be considered fractions. And, as fractions, values with a smaller lower number (denominator) are actually larger than those with smaller denominators, just as 1/8 is smaller than 1/4, which is smaller than 1/2. So, in the example above, f/4 (produced when the aperture is 50mm from the sensor) is larger than f/8 (generated when the sensor is 100mm from the lens opening).

But wait! There's more. F/stops are calculated using the square root of 2 (1.414), so that f/4 doesn't admit twice as much light

as f/8; it transmits *four times* as much light. If you want to calculate the sequence of f/stops, each half the size of the previous aperture, the correct sequence includes some odd numbers:

f/1.0, f/1.4, f/2, f/2.8, f/4, f/5.6, f/8, f/11, f/16, f/22, f/32

Figure 1.16 shows how the iris diaphragm changes as the f/stop is adjusted. There are also so-called "half-stops" and "third-stops" between the whole number f/stops, with values like f/3.5, f/4.5, or f/6.3. These are often used to represent the maximum aperture of lenses when that maximum falls between one of the "regular" f/stops, or displayed in your digital camera's read-out when you or the camera select an f/stop that falls between one of the traditional whole number aperture settings. For example, if your digital camera is set to jump in one-third-stop steps, the individual fractional f/numbers between f/4 and f/16 would be (with whole f/numbers in bold):

f/4, f/4.5, f/5.0, **f/5.6**, f/6.3, f/7, **f/8**, f/9, f/10, **f/11**, f/12.5, f/14, **f/16**

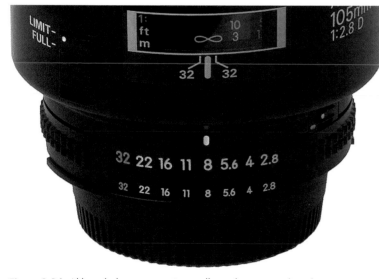

Figure 1.14 Although the aperture is usually set by a control on the camera, some lenses have their own aperture ring to allow manual adjustment.

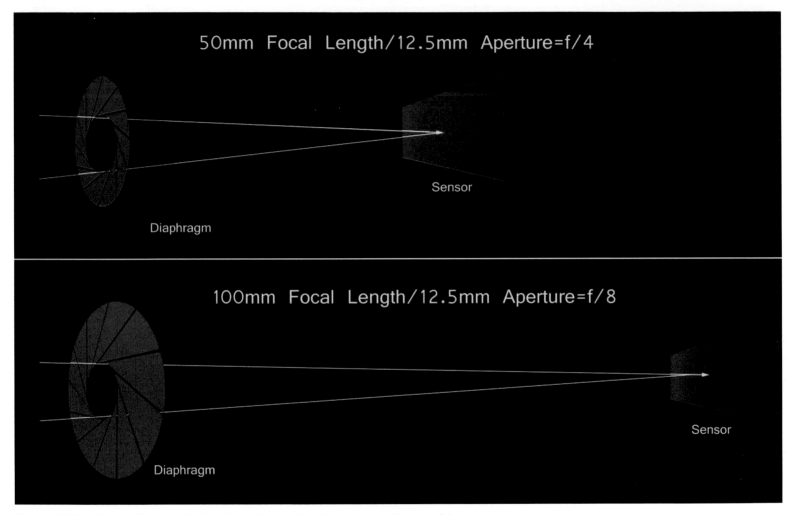

Figure 1.15 The effective f/stop is calculated by dividing the focal length by the diameter of the aperture.

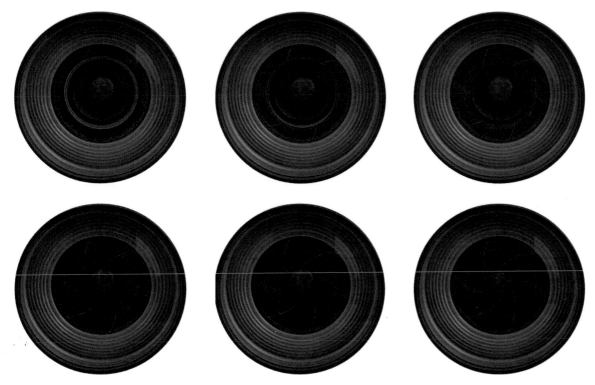

Figure 1.16 The relative size of the lens opening at (top row) f/2.8, f/4, f/5.6, and (bottom row) f/8, f/11, and f/16.

Although your digital SLR may choose an f/stop for you much of the time, there are situations when you will want to select the lens opening yourself to control the range of sharpness (depth-of-field) or to provide the best image quality. To work with f/stops, you'll need to keep the following concepts in mind:

◆ The larger numbers represent smaller lens openings and less exposure; smaller numbers represent larger lens openings and more light admitted to the sensor.

◆ Each standard whole f/number allows twice as much light, or half as much, depending on whether you are *opening up* (changing to a larger f/stop) or *stopping down* (switching to a smaller f/stop).

◆ While f/stops are based on powers of 2, each power of 2 allows *four times* as much light as the last: between f/2 and f/4 is an intermediate whole stop, f/2.8, which admits half as much light as f/2, and twice as much as f/4.

11

How the Aperture Affects Your Photos

The lens aperture or f/stop of your lens can affect your photograph in four different ways. The relative size of the f/stop helps determine your exposure; the aperture affects the range of sharpness (or *depth-of-field*); some lens openings provide better or poorer overall sharpness than others; and the shape of the aperture (and other factors) can determine how smooth looking the out-of-focus areas of your image appear. (This is called *bokeh*.) This section provides a quick introduction to each of these factors; you'll find more information in later chapters of this book.

Exposure

The lens aperture, of course, is used along with the shutter speed, your camera's sensitivity setting (ISO), and the intensity of the light present to determine the exposure needed to take a picture. The f/stop controls how much light is able to pass through the lens; the shutter speed governs the length of time that light is allowed to fall on the sensor; the ISO setting controls how responsive the sensor is to that light; and the intensity of the illumination determines how the other three must be adjusted to allow for the brightness (or lack thereof) of the light. Each of the four are reciprocal and equal: using an aperture that is half as large, a shutter speed that is twice as fast, and ISO setting that is one-half as sensitive, or cutting the amount of illumination in half, produces the same effect. So, your choice of f/stop will be determined by the requirements of a correct exposure, and influenced by one of the other three factors listed next.

Overall Sharpness

So, why not use the smallest possible f/stop at all times? Even if there is enough light to allow both a reasonably fast shutter speed (to freeze action or counter camera shake), it's not always a good idea to use the smallest f/stop available. While smaller f/stops do increase the overall depth-of-field, at the same time they can reduce the amount of overall sharpness because of a phenomenon called *diffraction*. In other words, even though more of your subject will be in focus, the overall sharpness of the sharpest parts of the image may be less.

Most lenses produce their sharpest image at an aperture that's two or three f/stops smaller than the maximum aperture, because the smaller f/stop tends to minimize certain types of distortion that all lenses produce when wide open. So, a lens that has an f/2.8 maximum aperture may provide a decent image at that f/stop, but will provide even better results at f/5.6 or f/8. A zoom lens with an f/4.5-5.6 maximum aperture will look its best when used at around f/11. You can certainly use most lenses at their widest f/stop, but if you need the sharpest image they can produce, you'll want to stop down two to three f/stops. You'll get the best trade-off in terms of depth-of-field and overall sharpness.

While smaller f/stops do increase DOF, image sharpness begins to suffer because of diffraction. The photons striking the edges of the diaphragm are disrupted from their paths, and begin to interfere with those passing through the center of the lens. This phenomenon takes place at all apertures, but is most pronounced at smaller f/stops, when the edges of the iris are proportionately larger compared to the entire lens opening.

The best analogy I can think of is a pond with two floating docks sticking out into the water, as shown in Figure 1.17. Throw a big rock in the pond, and the ripples pass between the docks relatively smoothly if the structures are relatively far apart (top). Move them closer together (bottom), and some ripples rebound off each dock to interfere with the incoming wavelets. In a lens, smaller apertures produce the same effect.

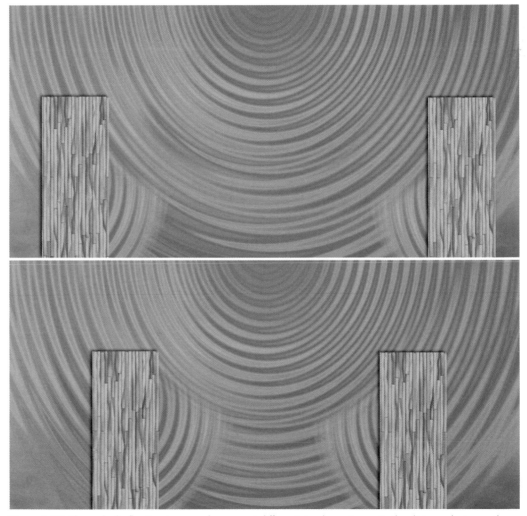

Figure 1.17 These docks floating in a pond represent different-sized apertures. As the distance between the edges grows smaller (as when a lens is stopped down to a small aperture), the waves begin to interfere with each other.

Depth-of-Field

The depth-of-field (or DOF) of a lens is the range in which subjects near and far appear to be acceptably sharp. Shallow DOF means that only the part of your image that you've focused on will be sharp; everything located in front of it or behind it will be out-of-focus and blurry. More depth-of-field allows a broader range of subjects to be in focus. Of course, "in focus" is a relative term. At top in Figure 1.18, DOF is meagre, and only the dandelion in the center of the image is in sharp focus. In the image at bottom, taken from the same position, but with a smaller f/stop that affords more depth-of-field, some of the buds and blossoms in the foreground are in sharper focus, and all the dandelions in the background are slightly better focused, even though they are still blurry. You'll learn more about how to manage depth-of-field in Chapter 4.

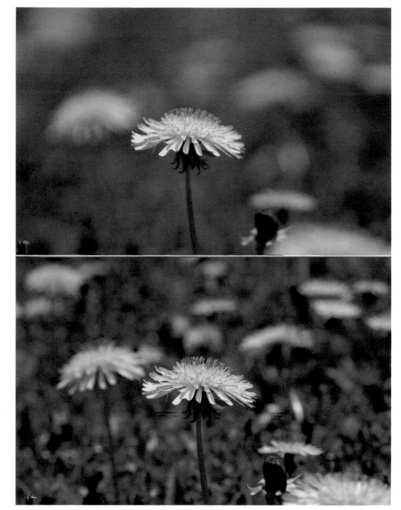

Figure 1.18 With a large f/stop, only the subject focused on is sharp (top); a smaller lens opening brings more of the subject into focus (bottom).

But in the most general sense, the range of focus at a given distance and focal length is determined by the size of the aperture. A larger f/stop, such as f/2.8 or f/4, provides less depth-of-field. As you reduce the size of the lens opening to, say, f/11 or f/16, you end up with more depth-of-field.

Bokeh

Bokeh is a term used to describe the rendition of points of light in out-of-focus areas of an image. When bokeh is good, these points blend smoothly together to provide a relatively unobtrusive background. When bokeh is bad, the background may be filled with distracting disks or other shapes. The type of bokeh a lens produces is determined by factors that can include the f/stop used and the design of the lens, including the shape of the diaphragm itself.

You can see in Figure 1.19 (left) a diaphragm that consists of only six blades, producing a distinct hexagon shape. At right, the diaphragm is constructed of 11 different blades, which creates a smoother lens opening that is closer in shape to a circle. Under some conditions, the shape of the diaphragm can be obvious in the bokeh produced by the lens. Figure 1.20 shows an image (left) captured with a lens having a six-sided aperture. If you look closely, you can see the shape of the lens opening in the out-of-focus areas of the background. At right is a similar image shot with a lens having a more circular diaphragm. Although the out-of-focus areas are noticeable as fuzzy discs, the bokeh at right is considered less obtrusive than the "chunky" shapes at left. I'll provide a more complete discussion of this characteristic in Chapter 5.

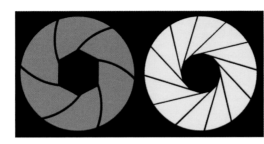

Figure 1.19 The diaphragm at left has six leaves, producing a hexagon shape; the 11 leaves at right produce a more circular iris.

Figure 1.20 The hexagonal shape of the diaphragm can be seen in the out-of-focus shapes in the background (left), while at right the blurry discs are less obtrusive because they are more circular.

Zoom or Fixed Focal Length?

Zoom lenses provide images with magnifications, or *focal lengths*, that can be changed. Such lenses may start at the wide-angle range (say, 17-18mm) and extend through the short telephoto range (in the case of the 18-55mm or 18-70mm lenses available from Nikon, Canon, Sony, and other vendors) or continue on into the domain of the true long lens (for example, 18-200mm and 18-250mm zooms offered by several companies). Zoom lenses can also start in the normal or tele-photo focal lengths and go from there, with typical lenses having 28-300mm, 55-200mm, 70-300mm, and other ranges.

Although zoom lenses are the most common optics used for digital photography, there are also lenses with fixed focal lengths, called *prime* lenses, that don't zoom at all. Before optical science progressed as far as it has

today, prime lenses were the staple tool of pre-digital (film) photographers, because only fixed focal length lenses offered sufficient image quality and large maximum apertures needed for everyday photography. Both types of lenses are available. Which do you need? Here are some considerations to think about:

◆ **Focal length flexibility.** A zoom lens is many lenses in one, so you can choose from the exact focal length you need for a particular image, without the need to step forward or back. This capability is especially handy when the layout of the scene (say, a yawning gorge in front of you, or a towering wall behind you) makes it *impossible* to step forward or back. If you own a 70-200mm lens and need a 143.5mm focal length to frame your image precisely, you can do that easily. Fixed focal length lenses, on the other hand, are just that: fixed. You may own 105mm,

150mm, and 200mm prime lenses, and none of them may do exactly what you want. You'll need to shoot with the lens that is the closest to what you need and either step forward or back, or crop to get the framing you want (wasting

pixels or energy in the process). If you want the most flexibility, you want a zoom lens, like the one that produced the images shown in Figures 1.21 and 1.22.

Figure 1.22 Zoomed in to 250mm, it was possible to shoot a close-up of the tower from the same position.

Figure 1.21 An 18-250mm zoom at the 24mm position produced this overall view.

◆ **Convenience.** Focal flexibility means you'll be changing lenses less often. Swapping optics is never convenient, and it requires a modicum of care to prevent dust from infiltrating your camera and settling on the sensor. You may find that two zoom lenses, like the pair shown in Figure 1.23, cover all the focal lengths from 18mm to 500mm. Back in the film era before zooms became more capable, I would often have two cameras draped around my neck, one with a 35mm f/2 lens, and the

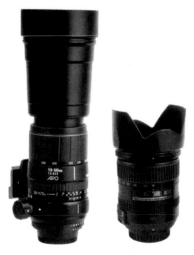

Figure 1.23 The 170-500mm lens (left) and the 18-200mm lens (right) cover all focal lengths from moderate wide angle to extreme telephoto.

other with a 105mm f/2.5 lens. Often, a third camera body with a 20mm f/3.5 wide angle or, perhaps, a longer lens, would reside in my camera body. Prime lenses may have other advantages (discussed next), but they're not the most convenient optics available. Of course, there's a lot to be said for the creative spark that the discipline of using a fixed focal length lens brings to your vision, but most of us will choose convenience over an enforced lesson. If convenience is important to you, choose a zoom lens.

◆ **Size.** Zoom lenses tend to be larger than most fixed focal length lenses that fall into the same general category. That's especially true at the wider end of the focal length range. I've seen 70-300mm lenses that compare favorably in compactness with some 300mm prime lenses—but, compared to, say, an 85mm fixed focal length lens, they are positively huge. If you're traveling light, a prime lens or two can be much more compact and lighter in weight than the typical zoom lens covering the same range. The only category in which zooms and primes compete in terms of size are in "kit" lens territory. The typical 18-55mm or 18-70mm kit lens is quite small, and certainly not much larger than prime lenses in the

same range. But most of the time, if you want a light-weight, compact lens, consider a fixed focal length lens.

◆ **Maximum aperture.** Fixed focal length lenses usually have a distinct advantage in terms of the widest lens opening available. Your 18-55mm or 18-70mm kit lens may have an f/3.5 to f/4.5 maximum aperture at the *wide angle* end of its range. One vendor offers a kit lens that has an f/5.6 maximum aperture when cranked out to 55mm; the same manufacturer sells a 60mm f/2.8 lens that not only admits four times as much light when it's wide open, it shoots macro photos, too. Zoom lenses with maximum apertures of f/2.8 or better typically cost $1,000 or more; prime lenses with f/1.4, f/1.8, f/2, or f/2.8 maximum apertures typically are priced much *less* than $1,000 until you start venturing into fixed focal length ranges above 200mm. For the widest maximum aperture for the least cash outlay, look to prime lenses.

◆ **Image quality.** Prime lenses are generally easier to design (until you start adding special features like image stabilization), compared to zoom lenses, with their constantly shifting elements. So, even

inexpensive prime lenses (such as the sub-$100 50mm f/1.8 optics offered for many models) provide better image quality than the typical zoom in the same focal length range. Unless you're willing to spend extra dough for the very best zoom lenses, prime lenses offer the most bang for your buck.

◆ **Minimum focus distance.** Prime lenses generally focus closer than zoom lenses, as it's easier to extend the fewer (and less complex) lens element groupings of the fixed focal length lens to provide macro focusing. Simple accessories, like extension tubes or close-up attachments, operate most easily with prime lenses (see Chapter 8 for more information). On the other hand, typical zoom lenses may not focus any closer than a few feet, while some may force you to stand six to 10 feet from your subject. Most close-up lenses, typically available in focal lengths like 55mm, 60mm, 85mm, 105mm, 150mm, and 200mm, are prime lenses. Some macro zooms exist, but even these often don't focus as closely as their prime lens counterparts. If close focusing is on your "must have" list, think about a prime lens.

Lens Crop Factors

While 35mm film cameras use a frame that measures 24mm x 36mm (about 1.0 x 1.5 inches), the sensor in most digital SLRs is smaller than that, producing a *crop factor* when the field of view of the average dSLR is compared with that of a 35mm film SLR or a professional-level digital SLR that uses a "full frame" sensor. Because larger sensors are much more costly to produce and require bulkier camera designs, most digital SLRs have a sensor that's smaller than full frame, as you can see in Figure 1.24. Depending on the size of the sensor, the image may include only 50 to 77 percent of the lens's traditional field of view. However, the *effect* of this cropping is to "multiply" the apparent focal length of the lens: a telephoto or zoom lens at 100mm when used with a camera having a 1.3X, 1.5X, 1.6X, or 2X crop factor (all available from Canon, Nikon,

Olympus, and others) has the equivalent field of view of a 130mm, 150mm, 160mm, or 200mm lens. That's where the erroneous term *lens multiplier* comes from.

Of course, no multiplication is being done. The depth-of-field and aperture of the lens remain exactly the same, regardless of the crop factor, just as they do when you trim a picture in your image editor. The crop factor does have several real world effects that you need to keep in mind when using your lenses.

◆ **Telephoto lenses offer a tighter image.** That 100mm lens really does offer a cropped view similar to a 150mm telephoto (with a 1.5X crop factor at work), and your 300mm lens is now magically a 450mm super-telephoto. This can be a great benefit to sports and wildlife photographers who can't afford the true longer lenses and would have had to crop anyway. The camera does it for you.

◆ **Wide angle lenses are less wide.** An 18mm ultra-wide lens becomes a moderate 27mm wide angle when a 1.5X crop factor is applied. To achieve a true ultra-wide angle look, you'll need a more expensive 10mm to 12mm lens.

◆ **Depth-of-field is "increased."** Your 450mm super tele (or zoom position) has the same apparent DOF as the 300mm lens it really is; your 18mm ultra-wide angle (after 1.5X crop factor is applied) has the near-infinite depth-of-field of the 12mm lens you're actually using. Most of the time, this added depth-of-field won't be a problem, unless you need less DOF for a selective focus effect.

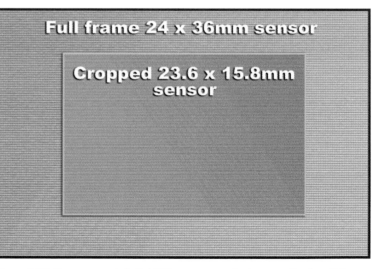

Figure 1.24 Because most digital SLRs use sensors that are smaller than 24 x 36mm, the image is effectively cropped to a smaller size.

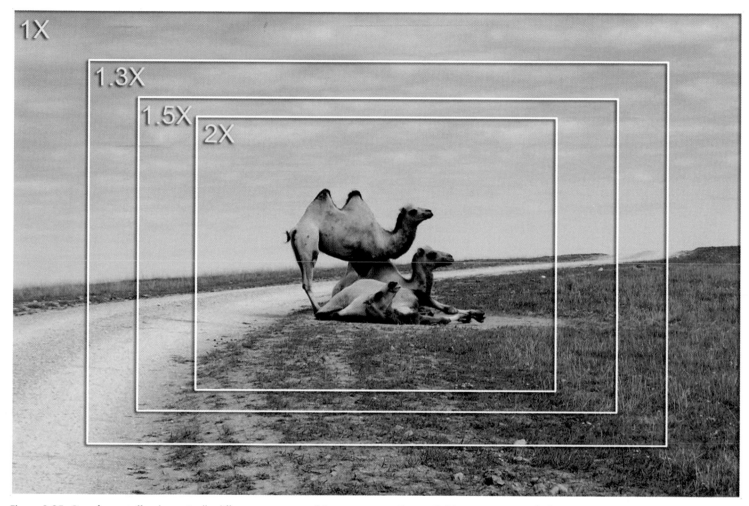

Figure 1.25 Crop factors offer dramatically different viewpoints of the same scene. The 1X (full-frame) view is typical of what you'd get with a wide-angle lens on a Canon EOS 5D or Canon EOS 1Ds Mark II. The 1.3X crop is similar to what you would see with a Canon EOS 1D Mark III, while the 1.5X crop is typical of many different digital SLRs, including the Nikon D2X, D200, D70s, D50, and D40/D40x, as well as cameras from Pentax, Fuji, and Sony (formerly Konica Minolta). Olympus and Panasonic offer digital SLRs with a 2X crop factor, as does Nikon with its optional High Speed Crop mode in the D2X. Sigma and Canon also offer digital SLRs with 1.7X and 1.6X crop factors (respectively), which are very similar to the 1.5X factor shown.

2 Lens Controls and Features

You may find that the only control on your lens that you use regularly is the zoom ring that you twist (or sometimes pull in and out) to change the magnification of your image. You can happily shoot all day with the camera clasped in your right hand and the lens nestled in your left hand with fingers wrapped around the zoom ring, ready to make some adjustment in framing. Of course, if you're working with a fixed focal length (prime) lens, you won't even need to do that.

Other lenses fairly bristle with switches, dials, knobs, rings, and controls used to specify, fine-tune, or lock-in adjustments. You might be able to switch your lens from autofocus to manual, or into a special mode that combines both automatic focus with manual override using the focusing ring. There may be a focus-limit control that will restrict your autofocus system's "seeking" action to a specific distance range.

Some controls are mundane. An aperture ring might be included on your lens to let you set the f/stop manually. Various scales on the lens can provide a visual indicator of the range of sharpness at a given focus point; others might show an adjustment that needs to be made if you're shooting an infrared photo. More exotic controls can activate various image stabilization/vibration reduction options if the lens has them.

This chapter will demystify the various controls and adjustments that you might find on your lens. No single lens will have them all, but as your lens collection grows, you will probably encounter most of these features eventually.

Autofocus

Whether a subject appears as an out-of-focus blur, or seems to be sharply focused is determined by the placement of the focusing elements inside your lens. One or more groups of lens elements move farther away from the sensor to bring distant subjects into focus, or are moved closer to the sensor to focus on objects that are nearer to the camera.

However, exactly where those elements need to be positioned is calculated by the electronic autofocus components contained in your camera itself. In autofocus mode, sensors in the camera evaluate the contrast/sharpness of the viewfinder image, based on focus zones chosen by you or the camera. As the correct focus point is calculated, elements in the lens are adjusted appropriately so your subject is seen with maximum contrast. Changing the focus is accomplished either by sending signals through electrical connections in the base of the lens to tiny autofocus motors built

into the lens itself, or by operating a small motor in the camera body that mechanically moves a pin at the back of the lens. (You'll find more on autofocus in Chapter 5.)

Most dSLR manufacturers today offer only lenses that use electronic focus coupling to operate motors inside the lens. Canon even named the new lens mount it introduced in 1987 after this feature: the "EF" in Canon's EF and EF-S lens product lines stands for "electronic focus." Nikon retained the in-camera focus pin mechanism on its camera bodies for use with its autofocus (AF-series) lenses, even after it introduced its AF-I and AF-S lenses with a built-in motor. Lenses that lack an internal motor can be produced less expensively, and Nikon also wanted to preserve compatibility with the huge number of older autofocus lenses that have been sold in the last 25 years. So, all Nikon digital SLR cameras, except for its newest

entry-level cameras, can autofocus with any AF, AF-I, or AF-S lens. (The Nikon D40 and D40x were the first the company introduced without the camera-body motor.)

Sometimes you'll want to focus manually. (See the next section for a list of reasons why you might want to do that.) Switching from autofocus mode to manual focus mode can be accomplished in one of three ways, depending on the camera model you own:

◆ **AF-M or AF-MF switch on the lens.** Many lenses have a control that can be adjusted (usually a switch, but sometimes a rotating ring) to specify autofocus or manual focus modes, as you can see in Figure 2.1. If you want to focus the lens yourself, which is common for some types of work, such as close-up photography, you can turn off the autofocus function by adjusting this switch.

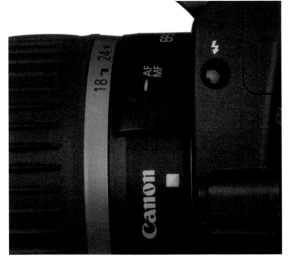

Figure 2.1 Most lenses have a switch that allows toggling from autofocus to manual mode.

◆ **A-M/M switch on the lens.** Some lenses may use an autofocus mode that cannot be overridden by the photographer: when autofocus is activated, it makes all the focus adjustments. Other lenses provide an *autofocus/manual* option (see Figure 2.2); the camera autofocuses, but the lens allows you to fine-tune that autoexposure setting manually. You'll find autofocus/manual convenient for situations in which autofocus generally works well, but you want to retain the ability to refocus slightly. For example, you might be photographing two people, and want one of them to be in sharp focus, while the other is allowed to blur slightly. Manual override lets you fine-tune focus on the exact subject you want. Note: your lens *must* have a specific manual override feature to allow this fine-tuning of the autofocus. Lenses that do not have such a feature must be switched to manual mode to safely adjust focus manually without damaging the lens motor.

◆ **AF-M switch on the camera body.** Your camera may have a switch on the camera body (see Figure 2.3) that allows changing from autofocus to manual mode. With some cameras, this switch either adjusts between manual and automatic focus only. Other models use the switch to change from manual and several autofocus options, such as AF-S (single autofocus), AF-C (continuous autofocus), and AF-A (automatic autofocus, which switches between single and continuous AF as appropriate).

◆ **Auto/Manual options in the camera menus.** Cameras that don't have an autofocus/manual switch on the camera body often have a setting for that option in the menu system.

CAUTION

If your camera has autofocus/manual switches on *both* the lens and the camera body, they must "agree." That is, if *either* is set to manual mode, then autofocus is disabled.

And to emphasize my previous warning, unless manual over-ride is available, you should be careful *not* to try to manually focus a lens that is set for autofocus mode. The motor/gear mechanisms in some lenses can be damaged if you try to force them.

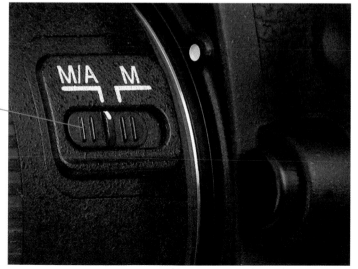

Lens Manual/ Autofocus switch

Figure 2.2 Many lenses include an autofocus mode that can be manually overridden.

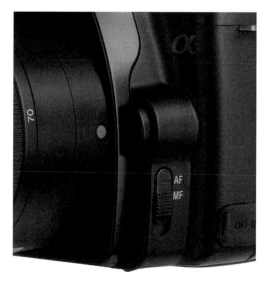

Figure 2.3 You may also be able to set the autofocus mode on the camera body.

Manual Focus

You can manually focus your lens if you are using an autofocus lens that has been set for manual operation (using a switch on the lens, camera, or specified in a menu), or if you're using a non-autofocus (manual focus) lens. Some shooting modes, such as the Live View mode on the Canon EOS 40D (which flips up the mirror so a real-time preview of the sensor image can be seen on the LCD) may call for manual focus. You may also be able to focus a lens manually if the lens is mounted on a bellows extension, extension tube, reversing ring, or other attachment that cuts off the normal autofocus connection between your camera and the lens. (You'll find more about these accessories in Chapter 7.)

Manual focus is usually achieved by twisting a focus ring on the lens barrel. The time-honored technique for focusing by eye is to rotate the focus ring back and forth in opposite directions, using smaller and smaller arcs until your eye judges that the image is sharply focused. This is necessary because our brains have a poor memory for sharpness and needs to compare the current image with the last one to determine if it is as sharp as possible. (Any eyeglass wearer will be familiar with the "Is it sharper now, or was it sharper before?" routine in the optometrist's chair.)

Unfortunately, there is no real standardization for the position or even direction of rotation of the focus ring. Indeed, some lenses integrate the focus function into the zoom ring through a push/pull action (see the Zoom Controls section that follows this one for more information). The ergonomic variations in focus rings can be confusing. For example:

- **Position.** With a zoom lens, the focus ring may be the ring closest to the camera body, or it may be located farthest from the camera body. Or the zoom ring may occupy one of those positions. I own several lenses on which the focus ring is a band located at the front edge of the lens, just aft of the lens hood. With fixed focal length (prime) lens, the focus ring will be the most prominent control on the lens, but there may be additional control rings for functions like manual/autofocus control or aperture setting. These other rings are located closer to the camera mount. Figure 2.4 provides some examples.

- **Width.** The focus ring may be the widest ring on the lens barrel, or it may be narrower than the zoom ring. Indeed, relative width (and position) can vary within a single vendor's lens product line.

- **Texture.** Focus rings are designed to be easy to grip, so you can change focus without your fingers slipping off. They may be ribbed, knurled, or given a rubberized covering. If you're lucky, the "feel" of the focus ring will differ from that of the zoom ring, but with some lenses, the texture of both may be so similar that you may need to rotate the control to see what it does.

- **Direction of rotation.** You might need to rotate the focus ring clockwise to focus closer, or counterclockwise. Most vendors stick to one or the other for all (or most) of their product line, but if your lens kit consists of optics from several different manufacturers, you'll probably experience some frustration when an odd-ball lens or two focuses in the opposite direction of what you expect.

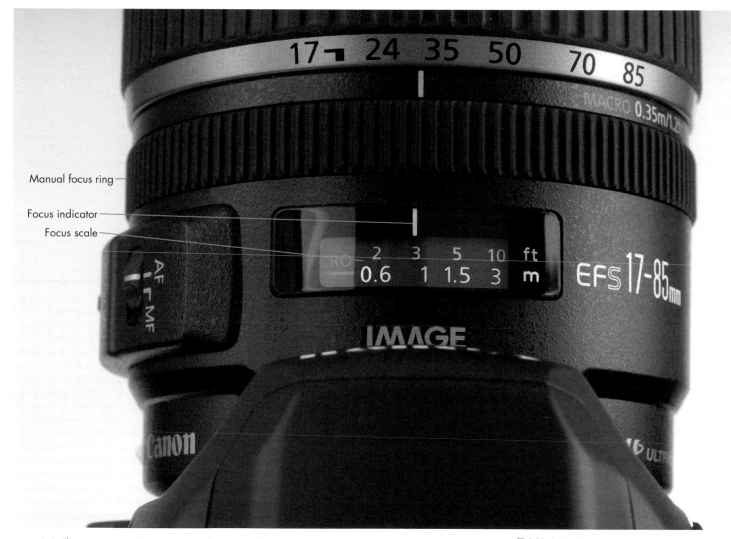

Manual focus ring

Focus indicator

Focus scale

Figure 2.4 The position, width, texture, and rotation of manual focus rings and associated features like focusing scales can vary widely.

Zoom Controls

The zoom control is the adjustment on your lens that is used to change the magnification of the image, allowing you to zoom out to the wide-angle position, zoom in to the telephoto range, or settle on any focal length in-between. The zoom control is what gives your lens its multifocal flexibility.

As with the focus ring, there is no standardization in terms of position, width, texture, or direction of rotation, or even if rotation is used to effect the zoom change, as some lenses use a push-pull motion to zoom in or out. (See the Manual Focus section before this one for more information on common focus/zoom ring variations.)

The typical zoom ring will have a continuous zoom scale (see Figure 2.5) that shows all the available focal lengths from the minimum to the maximum and an indicator that points to the currently selected focal length. You can select any zoom position in the range. Here are some things you need to know about zoom controls:

◆ **Operation.** Most zoom controls rotate clockwise or counterclockwise (the direction can vary even within a vendor's product line). Some use a push-pull motion to zoom in and out, with rotation serving to provide manual focus for the lens. That allows a single control to adjust both zoom and focus, so you don't have to shift your fingers between rings to change functions.

◆ **Zoom creep.** There's almost nothing more annoying than a droopy zoom lens. The designer of your lens provided silky-smooth zoom action so you could zoom seamlessly from one focal length to the next over the entire range. Unfortunately, with some lenses, the tension restricting the movement of the zoom isn't quite strong enough. Point the lens upwards or downwards, or just let the lens dangle naturally between shots and it may zoom all by itself. That's zoom creep. If your zoom seems to have a mind of its own, sometimes the vendor can tighten it up a little for you. Some lenses known for this syndrome exhibit less undesired movement in later versions; you might want to check out any lens you buy to see if it's a creeper or one of the newer models.

◆ **Focus shift.** Because of the way they are designed, some zoom lenses just naturally change focus slightly as you zoom. The original zoom lenses changed focus dramatically as the focal length changed; today, they are called *varifocal* lenses to differentiate them from true zooms. If your camera's autofocus mechanism is active, you may never notice a small change in focus, because the lens will be instantly refocused at each new zoom setting. However, if you are manually focusing, say, a close-up photo with the camera locked down on a tripod, should you re-adjust the zoom setting you may need to re-focus.

Push Me~ Pull You

Unfortunately, push-pull zooming has several drawbacks, which is why newer zoom lenses don't use it. First, it is not as precise as zooming with a rotating ring. It's easy to shoot past the exact zoom point you want, and even a slight inward bump on the lens can change your zoom position. While it's convenient to use one ring for both focus and zooming, the flip side of that coin is that it's likely that you'll accidentally change the focus point while zooming, or modify the zoom setting as you focus. For most situations, two controls are better than one.

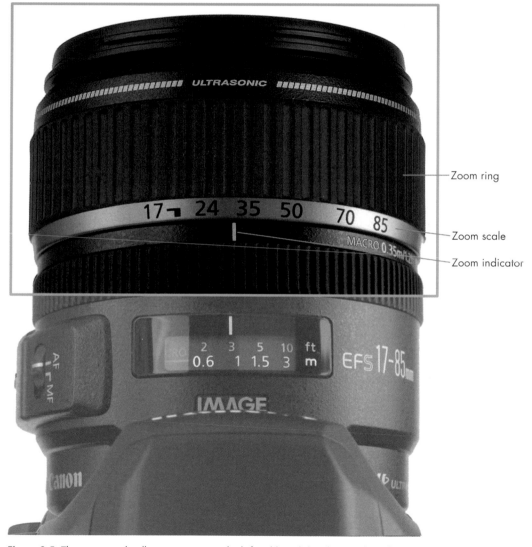

Zoom ring

Zoom scale

Zoom indicator

Figure 2.5 The zoom scale allows you to see which focal length has been selected.

Image Stabilization Controls

Image stabilization is a feature built into some lenses to counteract blur that can result when the photographer and camera shake during exposure. Sensors detect horizontal or vertical motion, and tiny electromagnets built into the lens realign select lens elements so that the light passing through the lens is redirected to the path it would have originally taken were the camera and lens not moving. The effect is to eliminate camera shake as if you were using a shutter speed up to four times faster than the actual speed in use. For example, you can shoot at 1/15 second and get results similar to what you might expect at 1/250 second. (However, a moving *subject* will be just as blurry as it normally would be at 1/15 second.)

IS can also be built into the camera body itself by moving the sensor in response to camera motion, and such dSLR models are offered by Sony, Pentax, Samsung, Panasonic, and Olympus. While image stabilization is the term favored by Canon, the technology is also called *optical image stabilization* and (by Nikon) *vibration reduction*. Sony calls its in-camera stabilization technology *anti-shake*. You'll learn more about IS and see some examples in Chapter 4.

If you own a lens that includes image stabilization, you'll want to keep in mind as many as five controls (but you'll never find all five on any single lens) when using the feature:

◆ **Autofocus/Manual focus.** If your lens has an AF/M switch, you'll usually want to leave the autofocus feature activated to take best advantage of the IS features. When IS is switched on, you'll actually be able to see it make its stabilization adjustments at the same time your autofocus snaps in.

◆ **IS/VR On/Off.** Image stabilization is not recommended in certain shooting situations, such as when the camera is mounted on a tripod or monopod. The sensors may actually "seek" a little, introducing "compensating" element movement where none is needed, producing results that are less sharp. Some IS systems interpret lack of camera motion to mean that the camera is mounted on a tripod and disable themselves automatically. Your IS on/off control (see Figures 2.6 and 2.7) allows you to shut off the stabilization/vibration reduction feature when you don't need it.

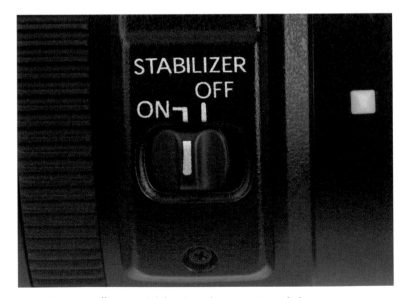

Figure 2.6 Turn off image stabilization when it is not needed.

◆ **VR activation.** You might own an older Nikon lens that offers two VR activation modes. In one mode, stabilization is active as long as the shutter release button is pressed halfway down. In the other mode, stabilization operates only during the actual exposure. The latter option saves power, but doesn't provide the visual feedback through the viewfinder that the function is active.

◆ **IS/VR Normal/Panning.** Some IS systems have a switch you can use when you plan to take photos while panning the camera from side to side. The horizontal sensors are disabled, but you still benefit from image stabilization in the vertical direction.

◆ **VR Normal/Active.** Nikon includes a Normal/Active switch on many of its VR lenses (see Figure 2.7). The "Active" mode counters extreme vibration, such as what might be experienced when shooting from a moving car. This extra-aggressive stabilization produces poor results in normal shooting situations, and should be disabled by setting this switch to the Normal position.

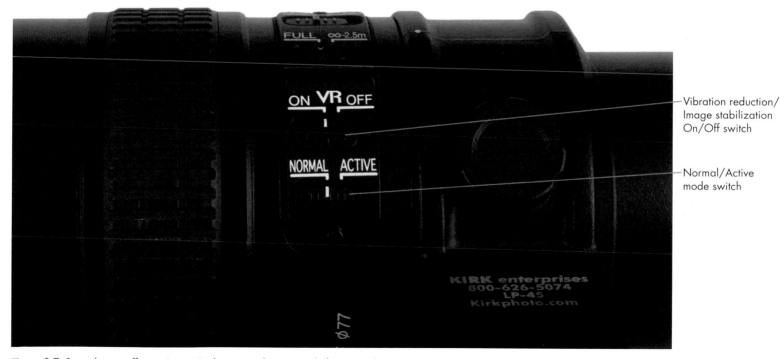

Figure 2.7 Some lenses offer an "active" vibration reduction mode for use under extreme camera motion conditions.

Tripod Collars

Many lenses with focal lengths of 150mm or more are furnished with collars that wrap around the lens barrel and include a shoe with a socket for a tripod or monopod. These are generally the larger, faster, longer telephoto and telephoto zoom lenses, which can benefit from mounting directly on a tripod or monopod to provide a better-balanced camera/lens setup and to take some of the weight off the camera's lens mount.

Lenses that are smaller and lighter in weight don't require a tripod collar, or may offer them only as an option. For example, both Nikon and Canon sell compact 70-300mm zoom lenses with VR/IS that are often used hand-held, and, should extra support be needed, function well when the camera is secured to a tripod or monopod. Some hefty

lenses with large maximum apertures, but focal lengths as short 150mm may have a tripod collar. By the time you reach 400mm and longer focal lengths, virtually all lenses include this handy accessory.

Although these collars are usually used to attach a tripod or monopod to your lens, they can also be used to mount other devices, such as chestpods or rifle-stock shoulder pods, which are exactly what they sound like: steadying devices that rest against your chest or shoulder to provide support for the camera and lens. A pistol grip can also be attached to the lens's tripod socket, which may make it easier to hold a heavy lens (but also complicates using manual focus; a pistol grip often works best with an autofocus lens).

Here's what you need to know about tripod collars:

◆ **Rotatability.** Tripod collars rotate, which is a tremendous advantage. You can loosen the collar's knob and rotate the lens/camera slightly to even up your horizontals without the need to make an adjustment with your tripod. The rotating collar also allows switching from horizontal to vertical orientation very quickly. This flexibility alone may convince you to add an optional collar to a longer lens that currently doesn't have one.

◆ **Removability.** Most collars can be loosened and removed so you can use the lens without one if you like. (See Figure 2.8.) Because the collars and their tripod mount add extra weight, if you plan on using a lens handheld, you might want to take the collar off to lighten your load. However, I find the mounting foot of the collar makes a handy grip for supporting the lens when I am using autofocus and don't need to grip the focusing ring.

◆ **Replaceability.** The collars furnished by the manufacturer for many higher-end lenses can be replaced with third-party collars that have features customized for particular tastes. Really Right Stuff (www.reallyrightstuff.com) and Kirk Enterprises (www.kirkphoto.com), for example, offer several models for specific lenses that have larger adjustment knobs and quick-release shoes so the lens can be mounted on the tripod or removed in seconds.

◆ **Modularity.** Many collars come in several pieces: the collar itself, the adjustment knobs used to lock the collar in a given position, and the mounting foot that attaches to the support. Some photographers don't like the knobs furnished with their tripod collars, and replace them with knobs sold separately by Really Right Stuff, Kirk, and other suppliers. Others replace the original foot with one designed for popular quick release mounts, such as the popular Arca-Swiss style mount. (See Figure 2.9.) Modularity also means that if one of these components breaks, you can replace the failed piece without needing to buy a whole new collar assembly.

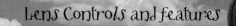

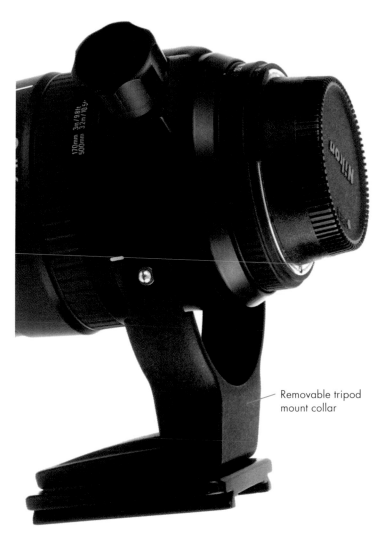

Figure 2.8 Tripod collars are detachable so you can remove them to lighten your load.

Removable tripod mount collar

Arca-Swiss-compatible quick release tripod mounting plate

Figure 2.9 Custom components, such as this special foot with an Arca-Swiss quick release mount, are available for popular tripod collars.

Filter Threads

You'll find threads located at the outer edge of most lenses, designed to accept filters or other accessories that can be attached to the front of the lens. These include filters (which color or otherwise change the light before it enters the lens); lens hoods; rings that allow you to flip the lens and mount it in reverse on the camera body, bellows, or extension tube; fish-eye converters; slide copying attachments; holders that accept square filters and other gadgets; and close-up lenses. You can find more information on these add-ons in Chapters 3 and 7.

As you've surmised, filters are furnished in various diameters, measured in millimeters. The most typical filter sizes are:

37mm, 43mm, 46mm, 49mm, **52mm, 55mm, 58mm, 62mm, 67mm, 72mm, 77mm**, 82mm, 86mm, 95mm

Only the seven sizes shown in boldface are commonly used with digital SLR camera lenses. Filters in 37mm-49mm sizes fit lenses offered for older film SLRs, rangefinder cameras, and digital point-and-shoot models. Filters larger than 77mm are designed for huge lenses that most of us can't afford to buy filters for, let alone purchase the lens itself.

Life can be potentially complicated for photographers who like to use lots of filters and attachments, because the front diameters differ so much among various lenses, depending on the speed and complexity of the lens design. Ordinary zoom lenses and prime lenses with unexceptional maximum apertures may have filter threads of 52mm to 67mm. Optics with large maximum apertures usually require 72-77mm filters, or larger, and older long zooms and prime lenses can easily require even larger filters. (Newer designs use rear-mounted, drop-in filters in more affordable sizes like 52mm, fortunately.)

If your lenses take a variety of different filter sizes, you might need to use an adapter, like the one shown in Figure 2.10 to allow using smaller/larger filters on lenses with larger/smaller filter threads. You may not be able to use a lens hood with a step-up/step-down ring combination, and will need to make sure your ring/filter/hood (if used) combination doesn't produce dark corners in your photo. This *vignetting* is more likely with wide-angle lenses, but can occur at any focal length if the assembly you fasten to the front of your lens intrudes into the image area.

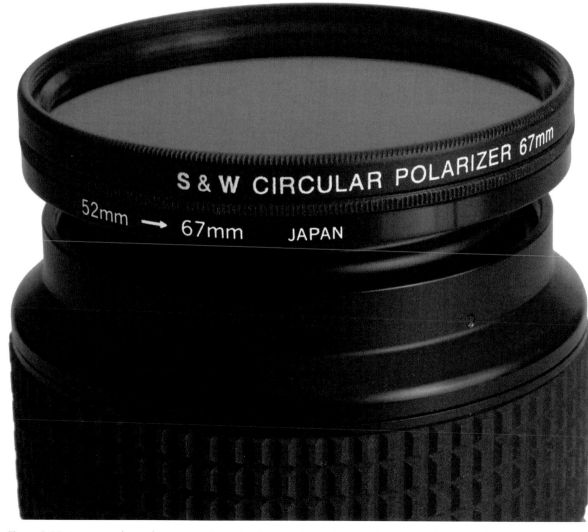

S & W CIRCULAR POLARIZER 67mm

52mm → 67mm JAPAN

Figure 2.10 Step-up and step-down rings allow using filters and other lens attachments with lenses that have different filter thread diameters.

FILTER THREAD ALTERNATIVES

When using conventional threaded filters isn't practical or desirable, enterprising lens designers have developed alternatives. Nikon's mondo-expensive ($5,000-plus) 200-400mm f/4 VR zoom lens would require 112mm filters, which cost about $175 each, unless you want something fancy like a polarizer for a mere $340. Of course, the camera is furnished with a removable 112mm clear front element (it's not a filter, as it doesn't filter anything) that is used primarily for protection in harsh environments. (Or, rather, in any environment you please if you're nervous about damaging a $5,000-plus lens.) The actual filters used with this lens are inexpensive 52mm drop-ins. You'll find similar systems on many lenses.

Another alternative to filter threads are filters that are built right into the lens. I own several older extreme wide-angle lenses that have tiny filter wheels that allow dialing in a specific filter when it's needed. (See Figure 2.11.) Finally, if your lens has filter threads, you don't need to use them. Add-on filter holders from Cokin and other vendors are available that fasten onto the front of a lens using tightening screws. You can then drop filters in a variety of configurations into the holder. Such systems allow using the same filters with lenses having different lens diameters; the universal adapter means that "one size fits all."

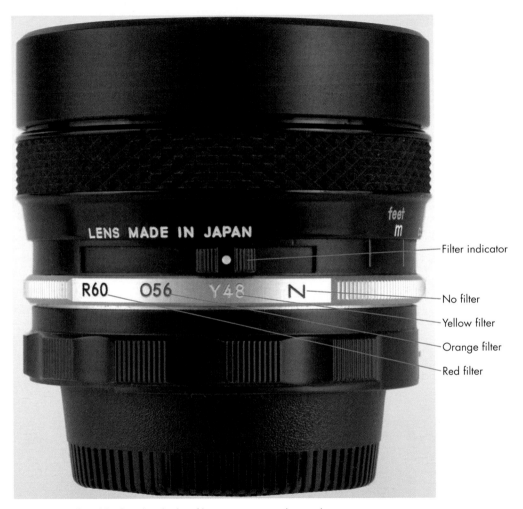

Figure 2.11 This older lens has built-in filters; some newer lenses do, too.

Lenses without Filter Threads

Some lenses do not have filter threads at all, and use other methods for working with filters. These lenses include the following types:

◆ **Super wide lenses.** Some lenses have such extreme wide-angle perspectives that any filter fastened in front would appear within the field-of-view of the lens, causing darkening, or *vignetting* in the corners. Such lenses typically don't have removable lens hoods, either; instead, they boast a built-in vestigial hood with its corners removed to stay out of the way of the light path.

◆ **Lenses with extremely curved front surfaces.** Fish-eye lenses and some other ultra-wide lenses have curved front surfaces that would interfere with the mounting of a filter, as shown in Figure 2.12. Such lenses typically don't have lens filter threads, and may include a built-in, non-removable lens hood like the one shown.

◆ **Lenses with very large front diameters.** Some very fast and very long lenses have such large front elements that front-mounted filters for them would be exorbitantly expensive. Filters for these optics take the form of smaller, drop-in elements that are inserted in a slot at the rear of the lens (see Filter Thread Alternatives).

◆ **Lenses that use bayonet or some other filter mounting system.** Some lenses, particularly older lenses that were introduced before standard filter thread sizes became so popular, use a bayonet system for mounting filters, rather than a filter thread.

◆ **Mirror lenses.** A few decades ago, mirror, or *catadioptric* lenses were popular, because the folded light path allowed building compact, light-weight telephoto lenses in 250mm, 500mm, and 1000mm focal lengths. Of course, these lenses also had mediocre image quality, a fixed f/stop (usually f/5.6, f/8, or f/11), and horrible, doughnut-shaped bokeh. Their front elements were so large that conventional threaded filters were not practical, and some kind of built-in or drop-in filter system was used instead. The most common use for filters with these lenses was for adding a *neutral density* filter under bright lighting conditions, to reduce the light-gathering ability of the lens from its fixed f/stop value to something more useful.

Figure 2.12 Lenses with a sharply curved front element and wide field of view may not allow attaching front-mounted filters or lens hoods.

Other Controls

There are a few other controls and indicators that may or may not appear on your particular lens. Some are used for specialized functions; others remain as vestiges from the olden days when more photographers needed and used them. The other controls that you might encounter include:

◆ **Focus limiters.** This is a switch that controls the distance range that will be used by your camera's autofocus system in seeking the correct point of focus, potentially speeding up the process. For example, if you're shooting close-up photos, you might not want to waste time having the autofocus mechanism seek through the entire focus range from infinity down to the closest focus point. Nor would you want to lose precious fractions of a second looking for a focus point inches away when shooting sports or wildlife at a distance. A focus limiter (see Figure 2.13) tells the camera to look for correct focus only in the most distant range, or in

the closest distances exclusively. If you do want maximum flexibility when grabbing subjects at a variety of distances, turn the focus limiter off, and let your lens seek to its heart's content.

◆ **Depth-of-field scales.** Prime lenses often have one or more depth-of-field markers on the lens barrel opposite the distance scale, showing the approximate range of sharpness at a given f/stop for that focal length. (See Figure 2.14.) These indicators were standard on all lenses in the past: today, many lenses don't even have aperture rings on the lens, so including a DOF scale has become somewhat problematic. At the marked aperture on the DOF scale, everything within the brackets will be acceptably sharp. Back in the pre-autofocus era, it was common for lenses, even zoom lenses, to include DOF scales for every available f/stop. Today, zoom lenses may also have a DOF scale, but will show a limited number of f/stops, using a curved marker (because depth-of-field changes as the focal length increases or decreases).

◆ **Infrared focus indicators.** Infrared illumination doesn't focus at the exact same point as visible light, so some lenses have an IR indicator on the lens barrel that

can be lined up with the position indicated as the focus point using visible light. You can see an IR indicator above the f/16 marking on the lens shown in Figure 2.14.

Figure 2.13 The focus limit switch can speed the autofocus process by locking out either the nearest or farthest range of distances.

◆ **Autofocus activate buttons.**
Some vendors include an autofocus activation button or two on their longer telephoto lenses for the convenience of photographers who are supporting the long lens with the left hand, while the right trigger finger is poised over the shutter release. (See Figure 2.15.) The AF activate button can be used to start autofocus and lock in a focus point independently of the shutter release. For example, when tracking fast action, you might want to focus on your subject as it moves, and then press the shutter release to lock exposure and take a picture a second or two later.

◆ **Electronic connections.** The metal tabs or bumps on the rear mount of the lens allow communication between the lens and camera for functions including autofocus, autoexposure, and image stabilization (if performed in the lens rather than camera body). (See Figure 2.16.)

HOW DEPTH-OF-FIELD INDICATORS WORK

Lenses that include aperture rings that have depth-of-field indicators place them in pairs (often color-coded) on either side of the f/stop indicator on the lens. You can see in Figure 2.14 that a pair of pink DOF lines matches the similarly-colored f/8 marking on the lens. The lens also has more closely-spaced green markers (for the f/3.5 maximum aperture) and more widely separated yellow and blue markers for f/11 and f/16. To read depth-of-field, just see what distances on the focusing scale on the next ring out match the appropriate DOF markers. In this example, the pink lines line up roughly with the 2.5M (8-foot) point on the left and 0.5 meter (1.66-foot) point on the right.

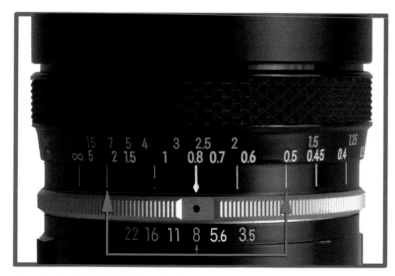

Figure 2.14 A depth-of-field scale shows the approximate range of sharpness at a given f/stop.

Figure 2.15 Long lenses sometimes have an autofocus activation button.

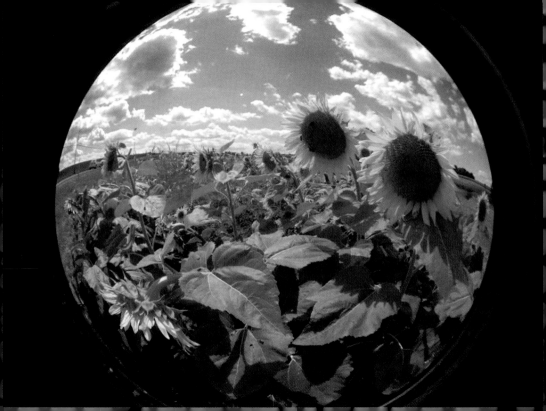

3 Filters and Lens Attachments

*f*ilters and other lens attachments change the way your lens views the world. Filters are add-on disks or squares of glass, gelatin, or some other transparent/translucent material that you fasten to the front of your lens (or, sometimes, drop into a special slot at the rear of the lens barrel). They modify the light in some way, changing its color, reducing the amount of light that reaches the sensor (frequently both at the same time), or, in the case of *polarizing* filters, wholly or partially eliminating glare. Other kinds of lens attachments do different things in changing the characteristics of light before it passes through the lens. Some change the magnification of the lens, producing a more pronounced telephoto or wide-angle effect. So-called *fisheye lenses* are the most commonly used accessories in this category. Lens attachments can also allow you to focus more closely, or, distort your image in some way.

The versatility of filters and lens attachments is often overlooked in our modern digital world, because many of the effects that they produce can be mimicked in Adobe Photoshop or another image editor. Indeed, there are only two (some would say three) filters that any serious photographer absolutely *must* have: a polarizing filter to reduce reflections that can reduce contrast and produce flare and a neutral density filter that decreases all light equally to allow you to use slower shutter speeds and/or larger f/stops for creative effects. For more serious photographers, I would add a third "must-have"—a *graduated neutral density* filter that can darken the sky (which would otherwise appear to be too bright and washed out) to more closely match the foreground of landscapes and similar brightness-mismatched compositions. There are vociferous fans of yet another "must-have"—a protective filter to shield the front surface of your lens from dirt and damage. I have mixed feelings about this. This chapter explains the essential filters, as well as some optional lens accessories that can enhance your photos. Lens attachments used for close-up or *macro* photography will be described in Chapter 7.

Attaching Filters and Accessories to Your Lens

Most lenses have threads that can be found inside the outer front rim. (See "Filter Threads" in Chapter 2.) These threads can be used to attach filters, close-up lenses, add-on optical attachments such as fisheye adapters and lens hoods. Some extra-wide-angle lenses, optics with curved front surfaces, as well as those with extremely large front diameters or other characteristics that make ordinary filters and lens attachments problematic, may not have these threads. In such cases, as I noted in Chapter 2, filters may be built-in or inserted into a slot at the rear of the lens.

Screw-in, front-mounted filters and attachments have some disadvantages to watch out for:

◆ **One size does not fit all.** Attachments designed with a specific diameter won't fit lenses with other diameters without use of a step-up or step-down ring. For example, to mount a 67mm filter on a lens with a 62mm filter thread, you'd need to use a 62mm-to-67mm adapter ring.

◆ **Vignetting.** A filter or other add-on may intrude into the picture area, particularly when used with wide-angle lenses, at smaller apertures (which have greater depth-of-field), and when shooting close-ups (which brings the plane of focus closer to the front of the lens). The result is darkened corners, as you can see in Figure 3.1.

◆ **Lens/filter conflicts.** Some lens barrels *rotate* during focusing (while others use *internal focusing* and may not change length or rotate). That can cause problems when using a filter that needs to be used in a specific orientation, such as a polarizer (which is rotated until the desired degree of reflection-removal is achieved), gradient filters (which have a particular density and/or color in one portion, and a different density/color in another), and certain special effects attachments (such as "kaleidoscope" lenses that change rendition as they are rotated).

◆ **Lens/lens hood conflicts.** If you're using a lens hood that fastens to the filter thread rather than to a bayonet on the lens barrel, certain unpleasantries can occur. One of them is vignetting (described earlier), which is almost inevitable with wide-angle lenses when you attach the filter first and then screw in the lens hood (which is now moved farther away from the front element of the lens, and potentially visible in the picture area). A lens hood may interfere with your ability to adjust a filter, such as a polarizer or star filter, which must be rotated to the orientation you want. Another drawback of this configuration is that each time you decide to switch filters, you must remove the lens hood first. It's also easy to screw a lens hood into a filter thread too tightly, making it difficult to remove. Some attachments have no matching filter thread on their front rim (polarizers frequently don't) so you have no way of attaching a lens hood in the first place.

Figure 3.1 A filter that is too thick causes vignetting that appears at the corners of this image.

AVOIDING VIGNETTING

The chances of getting vignetting can be reduced by avoiding the most common causes and minimizing their effects. For example, some vendors sell specially designed thin filters that have less tendency to intrude in the picture area. Avoid *stacking* several filters together. Perhaps you want to reduce the amount of light reaching the sensor and combine both an ND4 and ND2 neutral density filter; if the resulting stack causes vignetting, consider buying a single ND6 or ND8 filter that will do the job. Close-up lenses can also be stacked; a single, more powerful close-up attachment might be a better choice if you find vignetting to be a problem.

Finally, the effect can be compounded by the use of step-up and (particularly) step-down rings (to use a smaller filter with a lens having a larger diameter). Both step-up and step-down rings may not be a good idea when using wide-angle lenses. I've standardized on several lenses for my basic photography kit that all have 77mm front diameters: a 17-35mm f/2.8; 28-70mm f/2.8; and 70-200mm f/2.8. The 77mm filters are expensive, of course, but I need only a single set for all three lenses, and no step-up or step-down rings are required.

Other Attachment Options

In addition to traditional screw-in filters, and those dropped into slots on the back of the lens, you can select from several one-size-fits-all and one-size-fits-most options. In the one-for-all/all-for-one category are filter holders that attach to the front of your lens (and the same holder can be adapted to fit *many* lenses) and then accept slide-in filters that fit into one or more slots in the holder. Many filters, including expensive infrared filters, are available as 2 × 2-inch or 3 × 3-inch gelatin squares (or some other size), sometimes mounted between pieces of thin glass to protect the gelatin. Just buy the filter you want to use and drop it into a filter holder designed for that purpose on the front of your lens. I describe use of this kind of filter in the next section.

Another kind of multipurpose filter mounting system (what I call *one-size-fits-most*) is lesser used today, but is still viable, and can be very, very inexpensive. The Series system, a kind of filter holder dating back from before filters in standard screw-in sizes were available can come in very handy. Before standard thread sizes became universal, lenses didn't necessarily have common systems for mounting filters up front. Some lenses had threads, others used bayonet mounts. Some required push-on mounts that attached to the lens using friction to hold accessories.

The solution was the Series system, which used threadless standard filter *sizes* and holders that accepted those filters. The inexpensive filter holder, tailored to each type of lens, had the threads. You'd simply drop the

filter you wanted to use into a Series adapter suitable for your particular lens. You can still buy Series adapters and filters today, and they're easily found in the used/junk bins of most camera stores because they have been largely supplanted by standard filter sizes. When purchased from a junk bin, such adapters and filters can be very, very inexpensive.

The Series system works like this: the filter mount comes in two pieces, shown in Figure 3.2. One piece attaches to your lens, using either a screw-in thread that matches your lens's filter thread size, or by a bayonet or push-on mount suitable for your particular lens. Several different size ranges are available, called Series VI, VII, VIII, or IX (or, today, 6, 7, 8, or 9) with each Series size suitable for a range of lens diameters. There can be a little overlap; for example, a Series VII ring might fit lenses in the 46mm-67mm range, with Series VIII fitting lenses with 62mm to 77mm diameters. A standard-size retaining ring screws into the inner ring, with enough space between the two for a Series-sized filter.

The Series system is remarkably flexible. You'd buy an inner ring, say a Series VII size, for each of your lens sizes, a set of Series VII filters, and one outer Series VII retaining ring and use the combination with multiple lenses. Other accessories, such as lens adapters, can also be screwed into Series adapters.

Figure 3.2 A Series adapter consists of two parts, and the unthreaded filter fits between them.

Using Cokin and Similar Filter Systems

Slotted filter holders that attach to the front of a lens and accept square filters are nothing new, dating back to the 1950s and earlier. But their dramatic increase in popularity in more recent times can be traced directly to the introduction of the Cokin Creative Filter System in 1978. Developed by French photographer Jean Coquin, the popularity of the Cokin system (as well as derivative filter holders based on the Cokin design) can be traced to several factors. The most important are *standardization*, which allows Cokin holders and filters to be used with the vast majority of digital SLR lenses (plus point-and-shoot models and camcorders); and the *vast number* of different types of filters available. There are hundreds of different filter models offered for special effects, color correction, neutral density, diffusion, and other applications.

The factors to consider in going with the Cokin system or similar accessories are varied. Among the pros:

- **Simplicity.** Drop-in filters are even easier to use than the screw-in kind. Slide them into the holder frame (see Figure 3.3) and you're ready to go. Several filters can be used in combination, and quickly changed when you want to use a different filter.

- **Cost.** If you already own a filter holder (priced at about $20 for an adapter-ring/filter holder set), your subsequent filter purchases can be very inexpensive. Many individual square filters can be purchased for less than $20 each, with more specialized slide-in circular filters (including polarizers) priced at $25-$50 or more. When you consider that a 77mm screw-in polarizer can easily cost more than $100, these filters are bargains.

- **Interchangeability.** You can buy adapter rings for filter mounting systems for many different thread sizes, so you might be able to use the same filters on many different lenses in your collection.

- **Do it yourself.** You can easily make your own filters, including star filters and other special effects add-ons, from square pieces of optical-quality polycarbonate. Indeed, if the techniques you want to explore include soft-focus or diffusion, the optical quality of the material may not even matter that much.

There are also some cons to consider:

- **Vignetting.** The filter holder extends at least 0.75 inches in front of the lens. The entire contraption can show up within the frame when using wide-angle lenses. You can often minimize this by using a filter holder that's larger and holds larger (and more costly) filters.

Figure 3.3 Drop a square filter into the holder frame and you're ready to go.

- **Problems with lens hoods.** The filter holder makes it impossible to attach the lens hood furnished with your lens. While the holder itself provides some shielding from extraneous light, you can still get glare on the lens. Cokin sells a lens hood attachment for its filter holders that provides a partial solution: their coverage may not exactly correspond to the lens's field of view, but it may be fairly close.

- **Rotation complication.** The front of some lenses rotates when focusing, which means the entire filter holder may rotate. The retaining ring used with the Cokin system can rotate independently of the filter holder itself, so you can maintain the desired orientation even if your lens rotates.

- **Extra stuff hanging on your lens.** One reason I prefer the standard filter size option over filter holders is that the latter are a little klutzy and require fastening a bunch of extra stuff to the front of your lens. Of course, some kinds of work, such as scenic and infrared photography, are often slow-moving contemplative pursuits involving non-mobile subjects such as landscapes, so all this paraphernalia may not be a concern for you.

Cooking with Cokin

As you investigate the Cokin system, you'll see that its flexibility accounts for much of its popularity. The first step in setting up is to purchase a filter holder suitable for your camera and lens and a retaining ring to attach the filter holder (see Figure 3.4). The company also offers "magnetic" filter holders (primarily for amateur cameras without a filter thread, but which can accept Cokin's stick-on metallic strip) and shoe mount filter holders that attach to the camera's tripod socket and extend out in front of the camera and lens.

For thread-attached holders, there are several different sizes, scaled to fit square filters of the proper width (although round filters mounted in plastic frames can also be used). You'll probably want to avoid the A (Amateur) series, which use 67 × 67mm filters, suitable for lenses with filter diameters up to 62mm, because so many interchangeable lenses have larger diameters than that.

Instead, look for the larger P (Professional) series holder, which uses 84 × 84mm filters, and is suitable for lenses with front diameters of up to 82mm. For lenses that are even larger, Cokin offers the Z-Pro series (100 × 100mm filters) and X-Pro series (130 × 130mm filters—more than five inches square), used primarily for medium format film and digital cameras (or larger). You'll also want to purchase an adapter ring for your lens or lenses with the correct diameter for your lens's filter thread. You can attach this ring to your lens and slide the filter holder right on.

There are more than 200 different Cokin filters, but other manufacturers also produce filters and holders in the A and P series

"standard" sizes. You can place two different square filters in the pair of slots on the holder. They're held in place by friction, so you can move them up and down to partially or fully cover the lens when you want to vary your effect. A third, circular filter can be dropped into a special slot that's closest to the camera lens. These include star filters, polarizers, and other filters, and they can be rotated within the slot to produce a particular effect (say, to vary the amount of polarization).

You can learn about the different types of filters available for the Cokin system (www.cokin.com), as well as in standard screw-in filter configurations, later in this chapter.

Figure 3.4 Purchase a single filter holder and a retaining ring for each lens diameter the holder will be used with.

Polarizing Filters

Polarizing filters can provide richer and more vibrant colors while reducing some of the reflective glare that affects many photos taken in bright daylight. Polarizing filters operate in much the same way as polarized sunglasses. Figure 3.5 is a simplified illustration that may help you understand how polarizing filters work.

At top, sunlight arriving at a 90-degree angle (right side of the image) to both the classic auto and camera reflects off the shiny paint of the car, just above the bumper (as well as from the chrome bumper itself), then scatters in many different directions, including a path that takes the illumination toward the camera lens. As you probably know, light moves in waves, and in this case the waves vibrate at many different angles; some side to side, some up and down; others at

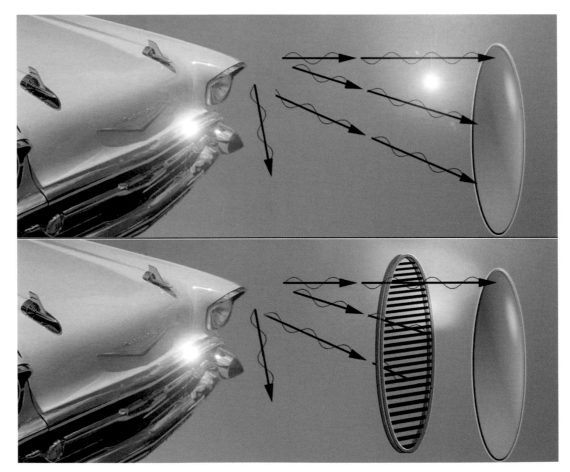

Figure 3.5 Light bouncing from shiny surfaces scatters in all directions (top), but a polarizer allows only those vibrating in a single direction to pass through (bottom).

diagonal angles. It's difficult to illustrate this, but I think you know what I'm saying. Some of this hodgepodge of light strikes the lens of your camera, producing glare and reduced contrast.

A polarizer contains what you can think of as a tiny set of parallel louvers that filter out all the light waves except for those vibrating in a direction parallel to the louvers. Again, this is difficult to demonstrate in two dimensions, but you can see the net result in the bottom figure. All the light waves from the paint reflections are blocked except for those vibrating from side to side (imagine them moving from side to side in the illustration) so they can pass through the horizontal louvers. The polarizer blocks much of the scattered light, so the reflections off the glossy paint are partially nullified; there is much less (or no effect at all) with metal surfaces, as I'll explain shortly.

The polarizer itself consists of two rings; one is attached to the lens, while the outer ring rotates the polarizing glass. This lets you change the angle of the louvers and selectively filter out different light waves. You can rotate the ring until the effect you want is visible. The amount of glare reduction depends heavily on the angle from which you take the photograph and the amounts of scattered light in the reflections (which is determined by the composition of the subject). Polarizers work best when the sun is low in the sky and at a 90-degree angle from the camera and subject (that is, off to your left or right shoulder). Blue sky and water, which can contain high amounts of scattered light, can be made darker and more vibrant as glare is reduced. You can also reduce or eliminate reflections from windows and other nonmetallic surfaces.

WHAT WORKS?

Light becomes polarized (and therefore susceptible to the effects of a polarizing filter) when it is scattered by passing through a translucent medium. So, light from a clear blue sky becomes polarized when it passes through the dust-laden atmosphere. Light striking, passing through, and reflecting off water also becomes polarized. The same is true of many other types of objects, including foliage, and the paint on the car body in the figure is also partially transparent (otherwise, the automobile would require only a single coat of paint). Shiny metallic objects, like the chrome on the automobile, aren't transparent, and thus don't inherently provide any polarization of the light. *However*, if the light reflecting from the metal has already been partially polarized (that is, it is reflected skylight), you can see some glare-reduction from the polarizing filter. The effect is much less than with most non-metallic shiny objects, however.

Danger, Will Robinson!

There are two other polarizer factoids you should be aware of. First, there are two *kinds* of polarizing filters: the so-called *linear polarizer* and the more desirable (for SLR camera users) *circular polarizer*. Neither refers to the shape of the filter; all polarizers are furnished in a circular frame for easy rotation.

Both types transmit linearly polarized light that is aligned in only one orientation. However, circular polarizers have an additional layer that converts the light that remains into circularly polarized light (never mind what *that* is; it's

not important unless you're fascinated with helixes/helices). What *is* important is that the metering and autofocus sensors in digital SLRs are mightily confused by linearly polarized light, but they work just fine with circular polarizers (also referred to as CPL filters). Make sure the polarizer you purchase is a circular polarizing filter.

The second thing to watch out for is the use of polarizers with wide-angle lenses. Such filters produce uneven results across the field of view when using lenses wider than the equivalent of about 28mm (which would be a 17-18mm lens on a camera with a 1.5X to 1.6X crop factor). As I mentioned earlier, polarizers

work best when the camera is pointed 90 degrees away from the light source, and provides the least effect when the camera is directed 180 degrees from the light source, as when the light source is behind you. The field of view of normal and telephoto lenses is narrow enough that the difference in angle between the light source and your subject is roughly the same across the image field.

But an extra-wide-angle lens may have a field of view of about 90 degrees. It's possible for subjects at one side of the frame to be oriented exactly perpendicular to the light source, while subject matter at the opposite side of the frame will actually face the light

source (at a 0-degree angle). Everything in between will have an intermediate angle. In this extreme case, you'll get maximum polarization at one side of your image, and a greatly reduced polarization effect at the opposite edge, as you can see in Figure 3.6. Use caution when using a polarizer with a very wide lens. This phenomenon may not even be a consideration for you: many polarizers will intrude into the picture area of wide-angle lenses, causing vignetting, so photographers tend to avoid using them entirely with the very widest lenses.

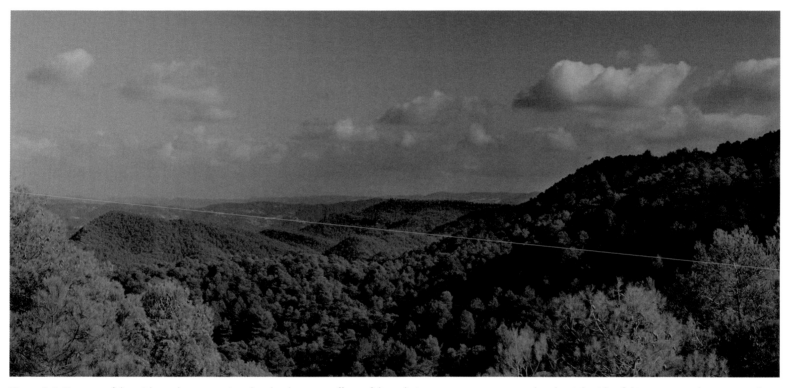

Figure 3.6 Because of the wide-angle perspective, the cloud-contrast effects of the polarizer are most pronounced at the right side of this image, and progressively less at the left side.

Color Correction and Adjustment Filters

Light comes in many "colors," from the bluish bias of daylight at high noon, to the warm tones of incandescent lights and candles. Films—unlike digital cameras— are "balanced" for only a single illumination color, usually either daylight or tungsten. If you take a picture with a film that is also the final product—such as a color slide or transparency—and use a light source with the wrong color balance, you're stuck with what you end up with, usually a picture that is too blue or too orange. With color negative films, the final product is a print, and although negative films are also balanced for a particular color of light, it's possible to compensate for the type of illumination used when making the final print. That's why you can take snapshots indoors or out with color negative films and not have to worry about color balance.

It's a different kettle of fish with digital cameras. Technically, a digital sensor responds to all colors of visible and near-visible light, including some wavelengths we don't want, such as near-ultraviolet and near-infrared. So, red, green, and blue colored filters nestled over each individual pixel in the sensor allow it to respond to the different colors in light by preventing all (or most) of the other colors of light from falling on a particular photosite. Adjusting this response to provide properly neutral colors, including grays and whites, is called *white balance*.

The white balance setting found in all digital cameras replaces the need to use filters on the lens itself. Where a film photographer would need to use a Kodak Wratten 85B filter to balance a

tungsten film for daylight, digital photographers can simply set white balance for tungsten, flash, bright daylight, overcast daylight, fluorescent lighting, and other types of illumination.

In addition, image editors like Photoshop (with its 20 Photo Filter adjustments and color balance commands) can reproduce most color-correction and adjustment effects. There is much less need for using color correction filters on the lens itself. You can still do that if you wish to create certain color balances or adjustments "in camera." That's often the case with tradition-minded photographers who want to shoot black-and-white pictures by setting their camera to monochrome mode and firing away (rather than creating black-and-white images from color versions in an image

editor). In that mode, it's often useful to add at the time of exposure the special tonal effects that yellow, red, and green filters have offered filter-using black-and-white photographers for decades. While some digital SLRs offer built-in filter processing of this type (several Canon models come to mind), other models require the use of actual yellow, red, and green filters (like the ones shown in Figure 3.7) on the lens.

These particular filters, when used in monochrome mode, change the tonal values of the black-and-white image in ways that aren't easy to achieve in an image editor. Figure 3.8 shows an example of the kind of looks you can get.

Figure 3.7 Yellow, green, and red filters have been a basic tool of black-and-white photography for decades.

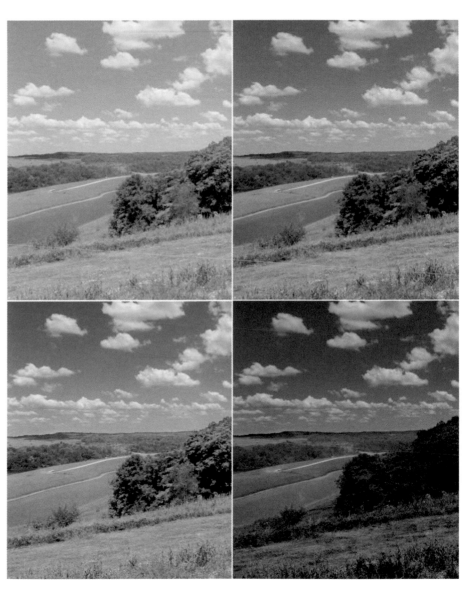

Figure 3.8 No filter (upper left); yellow filter (upper right); green filter (lower left); and red filter (lower right).

Neutral Density Filters

Neutral density filters are one of those high-concept tools with a function that's easy to grasp: they add nothing to the image except density (by preventing some of the light from reaching the sensor), and they are neutral (so the colors remain the same). A straight gray ND (neutral density) filter increases the amount of exposure required, so that you'll need to use a larger aperture, slower shutter speed, or higher ISO setting to achieve correct exposure with the filter in place. You can even use all three in appropriate proportions, if you like. The net effect is the same as if there were less light illuminating the subject, so extra exposure is required.

The exact amount of neutral density supplied can be found in the filter's name, which usually includes either the *filter factor* or *optical density* of the particular filter. For example, you might see neutral density filters labeled ND2, ND4, and ND8, which would signify that these filters

would require one stop (2X), two stops (4X), and three stops (8X) of additional exposure, respectively. If you think about the relationship between f/stops—a one stop difference requires twice as much exposure, a two stop difference calls for four times as much exposure, the nomenclature makes sense.

ND filters are also sometimes referred to by their optical density, with ND2, ND4, and ND8 filters given values of 0.3, 0.6, and 0.9, respectively. Today, the NDx labeling is much more common, and the one-stop, two-stop, and three-stop filters are the most popular. You might see stronger or weaker neutral density filters available, but the basic ND2, ND4, and ND8 set will handle most situations, because they can be stacked and used together to provide higher light-stopping values. (Stacking filters does increase the chances of noticeable image degradation and/or vignetting, but you might not find the effects objectionable.)

Given the eternal quest for faster and more sensitive sensors, what good are neutral density filters? You'll find them useful anytime you want to use a slower shutter speed or a larger f/stop in a situation in which your camera's lowest ISO setting won't allow the use of one or the other. A slow shutter speed (for creative blurring purposes) *and* wide f/stop (also for creative selective focus applications) may be almost impossible to achieve. Proper use of ND filters can give you both options. As I mentioned, you can *split* the effects among all the exposure factors: an ND8 filter's three-stop light-blocking power will let you use a shutter speed that is half as fast, an f/stop that is twice as large, and an ISO setting that is twice as sensitive, all in the same photograph if that's what you want.

◆ **Slower shutter speeds.** Many digital SLRs have ISO 200 as their lowest ISO setting; more have a minimum of ISO 100, and only a very few go as low as ISO 50. The

average lens has f/22 as its smallest f/stop. So, outdoors in bright daylight you may find it impossible to use a shutter speed longer than 1/50 or even 1/100 second. If your mountain stream is not in bright sunlight, it's still unlikely you'll be able to use a shutter speed any longer than about 1/30 to 1/15th second. That's a shame when you have a beautiful waterfall or crashing ocean waves in your viewfinder and want to add a little creative motion blur. An ND8 filter can give you the 1/2 second to several-second exposures with your tripod-mounted camera that you'll need for truly ethereal water effects, as shown in Figure 3.9.

◆ **Larger f/stops.** Frequently there is too much light to use the large f/stop you want to apply to reduce depth-of-field. The wide-open f/stop you prefer for selective focus applications might demand shutter speeds of 1/4000 second or higher. With a 2X or 4X ND filter, f/2.8 or f/2 are available to you.

◆ **Countering overwhelming electronic flash.** I have several older manual studio flash units that are simply too powerful for *both* my available range of f/stops and ISO settings, even when switched

from full power to half power. (Newer units generally offer 1/4, 1/8, 1/16, and 1/32 power options and may be continuously variable over that or an even larger range.) An ND filter allows me to shoot flash pictures with these strobes at my camera's lowest ISO setting and apertures larger than f/22.

- ◆ **Vanishing act.** Create your own ghost town despite a fully populated image by using a longer shutter speed. With an ND8 filter and shutter speeds of 15 to 30 seconds, moving vehicular and pedestrian traffic doesn't remain in one place long enough to register in your image, as you can see in Figure 3.10. With enough neutral density, you can even make people and things vanish in full daylight.

- ◆ **Sky and foreground balance.** A special kind of neutral density—the split ND or graduated ND filter is a special tool for landscape photographers. In the average scene, the sky is significantly brighter than the foreground and well beyond the ability of most digital camera sensors to capture detail in both. An ND filter that is dark at the top and clear at the bottom can even out the exposure, restoring the puffy white clouds and clear blue sky to your images. There are other types of split and graduated filters available, as you'll learn from the next section.

Figure 3.9 This one-second exposure turned the crashing waves into a creamy soup.

Figure 3.10 With a long enough exposure, moving objects, such as the pedestrians not shown in this photo, disappear or show only as blurry ghosts.

53

Split Density and Graduated Filters

When your glass is half empty *and* half full, it may be the optical glass in a photographic filter. Some filters have different personalities in their top and bottom halves, so you may encounter one that has neutral density, a color, or some other filtration in one half, and just clear glass (or a completely different type of filtration) in the other. These dual filters are called *split filters, split density filters,* or, if the transition between the upper and lower halves is gradual, *graduated filters.* Of these, the graduated neutral density filter and graduated color effect filter are the most popular. But a wide range of other types exist, including split close-up lenses that can be used to bring the foreground of a scene into sharp focus while retaining focus at infinity for more distant parts of the image.

Split density and graduated filters are available in both traditional round screw-in filter types as well as in square versions that can be slipped into a Cokin or similar filter holder. The most useful variety is the graduated neutral density filter, which I mentioned at the beginning of the chapter as the number three "must have" filter that belongs in any serious photographer's kit.

A graduated ND filter, or its kin, the non-graduated split density filter (seen at top left and right in Figure 3.11), has gray coloration in its "top" half and clear glass in its "bottom" region. In practice, though, the filter can be rotated in use so that the neutral density is placed in the bottom or left/right orientations. The filter holds back light in the neutral density region, while allowing all the light to pass through the clear

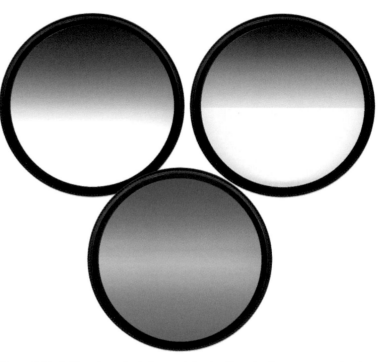

Figure 3.11 Split and graduated neutral density filters (top) can even out bright and normally illuminated areas in your photos, while their colored equivalents (bottom) add special effects.

portion. The most common usage
is to darken the sky in landscape
photos shot in horizontal format
(which would otherwise be over-
exposed) and allow the fore-
ground area of the scene to be
exposed normally. Because the fil-
ter can be rotated, you can use it
for this purpose when shooting
vertical landscape photos, or,
simply to darken the left, right, or
bottom of an image when taking
pictures in any orientation. Figure
3.12 shows a cornfield scene
with an overexposed sky (top),
with the lower version showing
the same field with a graduated
neutral density filter used to
darken the upper half.

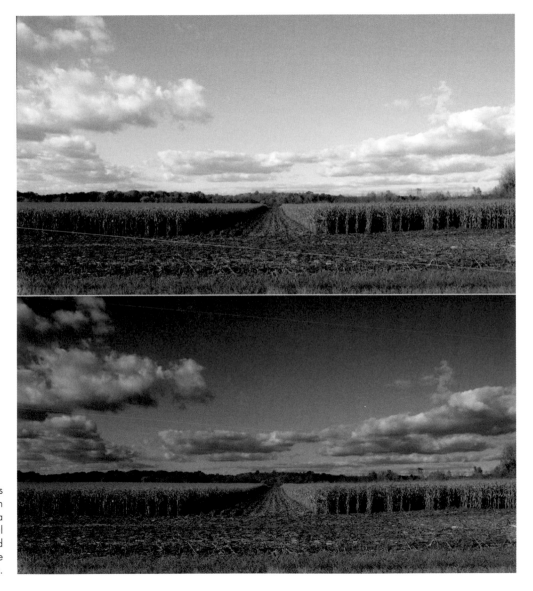

Figure 3.12 The sky is
too bright to capture in
the version at top; a
graduated neutral
density filter was used
(bottom) to even out the
exposure.

Here's a quick summary of the things you need to know to use a graduated or split-density filter:

◆ **Choose your strength.** Some vendors offer graduated/split ND filters in various strengths, so you can choose the amount of darkening you want to apply. This capability can be helpful, especially when shooting landscapes, because some skies are simply brighter than others. Use an ND2 or ND4 (or 0.3 or 0.6) filter for most applications.

◆ **Don't tilt.** The transition in the filter should match the transition between foreground and background, so you'll want to avoid tilting the camera—unless you also rotate the filter slightly to match.

◆ **Watch the location of your horizons.** The ND effect is more sharply defined with a split ND filter than with a graduated version, but you need to watch your horizons in both cases if you want to avoid darkening some of the foreground. That may mean that you have to place the "boundary" in the middle of the photograph to properly separate the sky and foreground. Crop the picture later in your image editor (as I did for Figure 3.12) to arrive at a better composition.

◆ **Watch the shape of your horizons.** A horizon that's not broken by trees, mountains, buildings, or other non-sky shapes will allow darkening the upper half of the image more smoothly. That makes seascapes a perfect application for this kind of neutral density filter. However, you can use these filters with many other types of scenes as long as the darkening effect isn't too obvious. That makes a graduated ND filter a more versatile choice, because the neutral density effect diminishes at the middle of the image.

Graduated and split filters are available in various color combinations, in addition to neutral density. One such filter is shown at the bottom of Figure 3.11. They may have a transition from one color, such as amber, brown, red, cyan, or blue, to clear, or from one color to another contrasting hue. For example, filters that have a ruddy sunset glow on one half and a blue tone on the other can simulate sunrise or sunset effects, or simply add an interesting color scheme, as in Figure 3.13. You'll find dozens of graduated filters available to provide the looks you want. Because the density in these filters can cancel out overly bright portions of the image and bring those areas within the dynamic range of your sensor, the effects you get with graduated/split filters can be superior to the same treatments applied in an image editor.

Figure 3.13 Golden-to-blue graduated filters are popular for adding sunset/sunrise effects to photographs.

Infrared Filters

One of the most exciting emerging applications for digital SLR cameras is infrared photography, which provides a new and eerie perspective on many familiar subjects. The majority of dSLRs are fully capable of taking photographs using only infrared illumination when equipped with a *cut-off* filter that blocks visible light and allows only IR light to continue on to the sensor. An IR filter will let you produce images with dramatic dark skies, vivid puffy white clouds, and ghostly foliage on trees. IR can be used on subjects other than landscapes, too, to image humans with strange, pale complexions,

and architecture quite unlike anything you may have seen before. However, because your camera itself includes a filter designed to *pass* visible light and *block* most (but not all) infrared illumination, you'll have to shoot using very slow shutter speeds, because so little light is left for the exposure once the majority of both visible and infrared light have been removed.

In addition, the IR filter (see Figure 3.14) seems virtually black to the human eye, so you'll be unable to preview your shot. An SLR viewfinder turns black when an IR filter is mounted.

Figure 3.14 The Hoya R72 is a popular and affordable infrared filter.

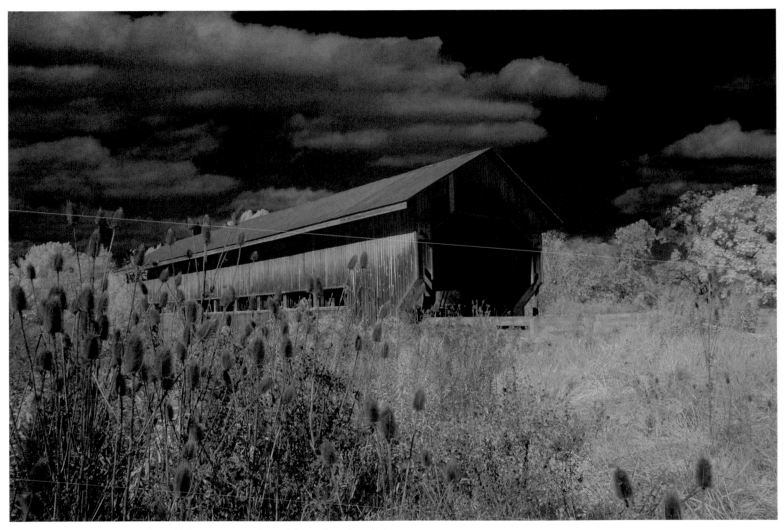

Figure 3.15 Landscapes with lots of foliage are a traditional theme for infrared photos.

The filter you want should block as much as possible of the illumination in the visible light range, below 700 nanometers, while transmitting near-infrared light in the 700 to 1200 nanometer range. An IR filter is considered to be effective if it removes at least 50 percent of the illumination at a particular wavelength. Table 3.1 shows a table of common filters (using the Wratten numbering system developed by Eastman Kodak Company). You'll find other nomenclatures applied by different filter manufacturers. For instance, a Wratten #89B filter is the same as an R72 filter sold by Hoya, or the Cokin A/P007. The Hoya R72 is the easiest IR filter to find, and, although relatively expensive (in the $75 to $110 range), one of the most affordable.

To use an IR filter, you'll almost always want to mount the camera on a tripod. First, set your white balance manually (without filter attached), using the method required by your particular camera's menu system—but point the lens at a subject that reflects a lot of IR, such as grass or foliage. Then, set up the camera, frame your image, focus, and set exposure manually (start with ISO 200 and about 1/4 second at f/8 or f/11). Finally, attach the infrared filter and take your photo. You might want to use a remote release or the self-timer to avoid residual camera shake that can result from pressing the shutter release button.

Review your image on the camera's LCD. If you've set the white balance correctly, the image will appear in a black-and-white or sandstone-and-gray color scheme (see Figure 3.15). Otherwise, the image may be tinted slightly red. You can remove color casts later in your image editor (see my book David Busch's Digital Infrared Pro Secrets for detailed instructions on post-processing IR photos). The most important thing to look for during the shooting session is proper exposure. If the image appears too dark or light, change the exposure appropriately. It might be a good idea to bracket your shots (making several exposures of more and less than your first guesstimate) in any case. With a little practice, you'll be getting images like the one shown in Figure 3.16.

Table 3.1 Light Blocked by Red/Infrared Filters

Filter Number	50% blockage
Wratten #25	600nm
Wratten #29	620nm
Wratten #70	680nm
Wratten #89B	720nm
Wratten #88A	750nm
Wratten #87	800nm
Wratten #87C	850nm
Wratten #87B	940nm
Wratten #87A	1050nm

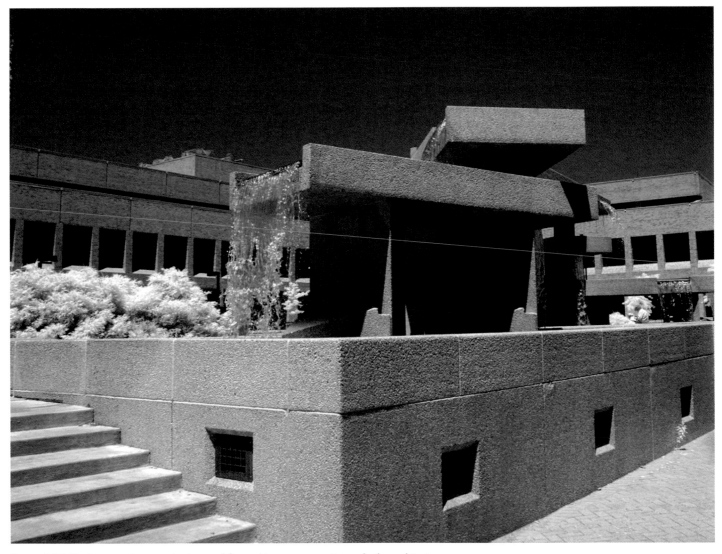

Figure 3.16 IR photography can also be used for architecture, portraits, and other subjects.

Special Effects Filters

You can make your own special effects filters, like those shown in Figure 3.17. With a little work, you can sometimes duplicate the effects of filters that would be quite costly to buy, or create brand-new filters that have never been seen before outside your imagination. It's easy to manufacture new filters out of ordinary, otherwise-useless filters like skylight or UV filters. You can use a Cokin-style filter holder and make square filters, or purchase a Series x adapter ring, described earlier in this chapter, and create a round filter to fit inside.

You'll recall that series adapter rings come in various sizes to suit the front filter diameter of your lens, with the x replaced by the number of the ring suitable for your lens, such as Series V, Series VI, Series VII, or Series VIII. You'll use both parts of the set; one part has a thread that screws into the front of your lens, while the second piece screws into the retaining ring, with your custom-made filter sandwiched between the two.

Here are some ideas for some do-it-yourself special effects filters:

◆ **Glamour filter.** Take an old UV filter (it doesn't even matter if it is scratched) and carefully smear the outer edges with petroleum jelly. Such a filter is a great tool for romantic portraits of females who want to be seen with flawless skin. The smaller the center spot, the larger the area of diffusion.

◆ **More glamour.** A piece of stocking material or other material with texture can be used to provide even more diffusion over the entire image—or cut a hole in the middle to allow the central portion of the image to remain sharp. Many years ago, Hollywood cinematographers photographed aging stars through a chicken feather to provide the needed softening effect. (One wag pointed out that a certain actress was so wrinkled that it would be advisable to use an entire chicken, instead.)

◆ **Starry night.** A piece of window screen material can produce a star-point effect. The advantage of going the do-it-yourself route is that your screen "filter" can be fitted even to lenses that don't normally accept filters. Just use a large enough piece. Figure 3.18 was taken with a fisheye lens that can't be fitted with a conventional filter. A large piece of screen held in front of the lens worked just fine.

Figure 3.17 You can make your own special effects filters using pieces of colored plastic, window screen, or petroleum-jelly-smeared UV filters.

◆ **Split filters.** Get yourself a sample book of Lee or Roscoe lighting filter swatches and use pieces to construct a split neutral density filter (use gray swatches) or split color filters. While lighting filters may not have the optical quality you need for super-sharp photos, you may find them good enough for experimentation.

◆ **Go wild.** Anything that you can fit in front of your lens, from a kaleidoscope with the colored-speckle end removed, to diffraction gratings can be used to produce a special effects filter. You can try out various possibilities just by holding them in front of the camera lens, then convert the ones that work best into permanent makeshift filters.

Figure 3.18 A square of window screen produced this star effect with a fisheye lens.

Protective Filters—Or Not?

Very few topics relating to lenses are as controversial as the question, "Do I need to use a filter to protect my lens?" I have a definitive answer for you: yes and no. Some folks put a UV, skylight, or clear glass filter on every lens as soon as they buy it, and never take it off except to clean it. Others never use such filters, or (like me) use them only when taking pictures in harsh environments, fraught with rain, splashing waves, or dust storms. Which camp you belong to depends on whether you believe conventional wisdom (which I find to be more conventional than wise) or you depend on your own experiences.

As with most controversies, there are pros and cons for each side. You'll find many photographers who have never used a protective filter and who have suffered no mishaps in 30 to 40 years that a lens hood wouldn't counter. A significant percentage of those who are most adamant about using a protective filter have tales of woe about smacking or dropping a lens or two that was "saved" by the filter. I don't know if the non-filter users are more careful and/or lucky, or whether the filter proponents are clumsy, careless, or unfortunate. The real bottom line: If you're convinced you need a filter to protect your lens, you *really* need one. Otherwise, you're sure to have an accident and regret it for the rest of your life.

Here are the relevant pros and cons.

First, the no-filter-required arguments:

- **No filtering required.** It's known that general-purpose UV and skylight filters have no effect in the digital world. However, strongly yellow UV filters, such as a Haze2A or UV17, can reduce chromatic aberration. If you're not using a lens plagued with this defect, you really don't need to be filtering anything. A piece of clear glass (an "optical flat") would provide the same effect—good or bad.

- **Varying performance.** Lower quality filters can cause problems with autofocus and can degrade the image. That means if you use a protective filter at all, you should use one of high quality. A $20 filter might do more harm than good. A very good filter, on the other hand, can cost $70 to $100 or more in larger filter sizes (and don't forget you'll need one of these for each and every lens).

- **Cost.** If you are using a $1,500 lens, a $70 filter might make sense to you. But a $70 filter for a $180 lens makes little sense. But, oddly enough, that cheap lens might have little quality to spare and would, ironically, benefit more from a pricey filter than the expensive lens that is so sharp you won't notice a little degradation. If you have nothing but inexpensive lenses, consider self-insuring: not buying three $70 filters will save you $210, enough to replace a $200 lens that is damaged. (If you expect all three to suffer an accident, you're probably clumsier than the average photographer.)

- **Softer images.** Adding another element can degrade image quality due to aberrations and flare. Why reduce the quality of every image you take to guard against an accident that may never happen?

◆ **Damage from a broken filter.**
A badly broken filter can scratch the optical glass element behind it. For every lens "saved" by a protective filter, you may find one that's really been whacked, sufficiently that the filter is cracked, crushed, and the pieces driven into the glass behind it. In some cases, the damage might have been less had the protective filter not been in place.

Figure 3.19 A lens hood, not a protective filter, should be your first line of defense against lens damage. Then, decide for yourself if a filter will provide additional safety.

◆ **Lens hoods provide better protection.** I don't use protective filters, and have never had an accident where one would have helped. However, I've gently bumped the front of my lens up against objects, and my lens hood prevented any damage every time. The insidious thing about filters is that when one is being used, the camera owner may actually be less likely to use a lens hood, which should always be your first line of defense.

And on the other side of the fence:

◆ **Protection from small sharp and blunt objects and falls.** If the lens is dropped, the filter may well suffer scratches or breakage instead of the front lens element. Small pointy things can sneak past a lens hood and strike the front of your lens. A lens hood is great at blocking a door that opens unexpectedly, but will not help if the first thing that hits your lens is a doorknob.

◆ **Reduced cleaning.** One can clean the filter frequently without having to worry about damaging the lens coatings; a filter scratched by cleaning is much less expensive to replace than a lens. I must admit, though, that this rationale applies most to those who don't know how to clean their lenses properly.

◆ **Makes a good lens cap.** A protective filter can do its job and still not interfere with image quality. Keep a screw-on filter mounted on your lens at all times—without a lens cap protecting the filter. Then, if an impromptu opportunity for a picture appears without warning, you can flip your camera on (if necessary), sight through your viewfinder, and take a picture. There is no time lost fumbling for the lens cap. If you have more time, *take the filter off*. It makes a great transparent lens cap. I've worked in this mode from time to time. The filter/lens cap gets damaged more quickly without the protection of a "real" lens cap, but I use inexpensive filters for this purpose. I usually don't care if one of my "grab" shots with filter in place is not as sharp as it could have been. It's a grab shot, an opportunity that would have been lost entirely.

Fisheye Attachments

Fisheye lenses were originally developed as a way to provide a hemispherical view in unreasonably tight places, generally for technical reasons, such as examining the insides of a boiler, or for photographing things like the sky's canopy for astronomical research. Because of their specialized nature, they tended to cost a fortune, but that didn't stop photographers of the 1960s who were looking for a way to come up with novel images. My own first fisheye lens was a second-generation Nikon optic, an improved 7.5mm lens that replaced the original 8mm Nikon fisheye, and which required locking up the single lens reflex's mirror and using a separate viewfinder. I later got Nikon's 16mm "full frame" fisheye lens, which did not produce a circular image like the original.

Today, fisheye lenses are available as attachments for many digital cameras, like the one shown in Figure 3.20, as well as prime lenses. In November 2007, Sigma introduced two new fisheye lenses (a 4.5mm circular image lens and a fast 10mm f/2.8 lens that fills a cropped frame). Tokina's 10-17mm fisheye zoom lens is also available. They're still not something you'd want to use everyday. The add-on attachments are inexpensive (often less than $100) and easy to use. Just screw into the filter thread of a recommended focal-length lens (wide angles seem to work best) and shoot to get photos like the one shown in Figure 3.21. Don't expect top-notch sharpness, and be prepared for severe barrel distortion, as the distortion itself is what provides the fisheye view.

Figure 3.20 Screw-in fisheye attachments let you convert a lens you currently own into a fisheye.

I've lumped fisheye prime lenses into this section, too, even though they are not filters. These lenses (see Figure 3.22) are mounted on your camera like any lens, and they offer better quality along with more even illumination across the fisheye frame than the attachments. Fisheyes can provide a full, circular image, or fill the frame with a distorted (but not circular) image. You'll want to choose your subject matter carefully. Horizons will bend, and objects nearer to the camera will be closer than they appear—as well as larger and more than a little warped.

I usually have a fisheye attachment or a fisheye prime in my kit so I can shoot a novelty photo or two during every session. I like them, but many folks dislike fisheyes intensely, so you'll want to avoid overloading your portfolio with these weird images.

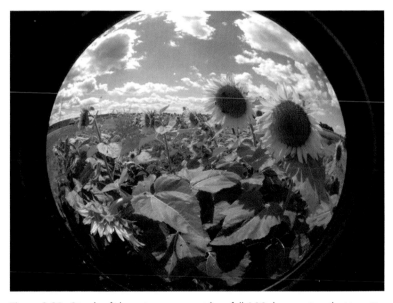

Figure 3.21 Circular fisheye images provide a full 180-degree view that is quite distorted.

Figure 3.22 Fisheye prime lenses can be mounted directly on your camera.

Lens Replacements

Full lens replacement "gadgets" are another type of non-filter attachment you can use to create special effects. Possibilities include body caps pierced with a pinhole to transform your expensive dSLR into a pinhole camera, various optics mounted on bellows or extension tubes to create an ad-hoc lens, and commercial products like the famed Lensbaby.

The latter is a decidedly *low-quality* piece of glass mounted on a system that allows you to bend, twist, and distort the lens's alignment to produce transmogrified images unlike anything else you've ever seen. Like the legendary cheap-o Diana and Holga cameras, the pictures are prized expressly because of their plastic image quality. Jack and Meg White of the White Stripes are, in fact, selling personalized Diana and Holga cameras on their website for wacky *lomography* (named after the Lomo,

another low-quality/high concept camera). The various Lensbaby models are for more serious photographers, if you can say that about anyone who yearns to take pictures that look like they were shot through a glob of corn syrup.

The latest Lensbaby 3G, shown in Figure 3.23, has the same shifting, tilting lens configuration as previous models but is designed for easier and more precise distorting movements. Hold the camera with your finger gripping the

knobs as you bend the camera to move the central "sweet spot" (sharp area) to any portion of your image. With two (count 'em) multicoated optical glass lens elements, you'll get a blurry image, but the amount of distortion is under your control. F/stops from f/2 to f/22 are available to increase/decrease depth-of-field and allow you to adjust exposure. The 50mm lens focuses down to 12 inches and is strictly manual focus/manual exposure in operation. At $270, it's not a cheap accessory, but there is really no other easy way to achieve the kind of looks you can get with a Lensbaby. (See Figure 3.24.)

Figure 3.23 The Lensbaby 3G makes it easy to get creatively distorted images.

Figure 3.24 Everything is uniquely blurry outside the Lensbaby's "sweet spot," but you can move that spot around within your frame at will.

4 Improving the Image Quality of Your Lens

The lens you use, and how you use it, is one of the four most important factors that impact the quality of your images. So, understanding how your lens can improve—or degrade—your images can be a key to raising the bar on overall image excellence. This chapter will help you understand the aspects that you can control, and ways to minimize the effects of those that you can't manipulate readily.

The most important element in image quality is, of course, content—including the composition. A photograph that is technically perfect, but which lacks a coherent theme, an interesting subject, an artful arrangement, is nothing more than a documentary record of a moment in time. If you truly want to improve the quality of your images, the creative aspect is the one you should work on the most. Some memorable, award-winning images have been produced that are slightly out-of-focus, blurred by camera or subject motion, and improperly exposed. The late Eddie Adams' Pulitzer Prize-winning photo "Execution of a Viet Cong Guerrilla 1968" is an example of a technically imperfect image that changed public opinion worldwide.

Of course, effective imagery doesn't exclude sloppy technique. The three primary image quality factors in addition to content are sharpness (including lens quality, focus, and lack of subject/camera motion), exposure (appropriate tonal relationships and range), and, in color photography, the use of the hues in the picture. This chapter deals primarily with those aspects that derive from the use of lenses—sharpness and focus. I'm including a couple quickie lens tests adapted from Chapter 1 of my book *Digital SLR Pro Secrets*, which goes into more detail on raising the bar on image quality.

What Is Image Sharpness?

The sharpness of your images is like art: difficult to describe in concrete terms, but you know what you like to see in a photograph. The inevitable fuzziness associated with sharpness has developed because sharpness is, in practice, a relative term. You'll rarely want *all* of a photograph to appear sharp. After all, creative application of depth-of-field is an invaluable tool when used to emphasize the main subject of a photograph while allowing foreground and/or background to be cloaked in blur, as you can see in Figure 4.1. When we say that a photograph should be sharp and clear, what we really mean is that the center of interest of the image *looks* sharp, compared to the other portions of the photo.

The *apparent* sharpness of an image depends on the amount of enlargement of the image and the viewing distance. An image that *looks* sharp when printed as an 8 × 10 and viewed from three feet away might appear to be very *unsharp* when enlarged to 16 × 20 and examined from the same distance. Move back a dozen feet, and the image probably looks sharp again.

What appears to be sharp to our eyes and what is considered blurry is determined by the point at which the individual points of light in an image change visually from points to out-of-focus discs called *circles of confusion*. Detail seen as distinct points is perceived as sharp. Detail in discernable fuzzy discs is seen as unsharp. The degree of enlargement, how close we are to the image, the amount of contrast between the points/fuzzy discs, and how fussy an individual is all contribute to the phenomenon of sharpness. Although there are formulas that allow you to calculate the circle of confusion (CoC) at a particular viewing distance, the only measurement that counts is whether the image looks sharp to you.

Figure 4.1 Because the background is out of focus, you can't tell that the tan shape is an old tarp rather than a Native American teepee.

Sharpness is usually measured using components called resolution and acutance, and a sharp image must have both qualities, carefully balanced. A given photograph can be high in resolution, but low in acutance, or have high acutance but low resolution. Ideally, you'll combine both in a single image, so there's no harm in learning how these elements affect your picture taking.

Resolution vs. Acutance

It's easy to misuse the term *resolution* when we really mean sharpness or *acutance*. Resolution is the amount of detail that a digital SLR can capture and is fixed by the number of pixels in the sensor. There is no way to add image information after the picture has been taken, although the *apparent* resolution can be changed in an image editor. If your camera has a sensor measuring 3872 × 2592 pixels, then your dSLR's resolution is 10,044,000 pixels, or, 10 megapixels. Of course, those pixels are divided among the three primary colors, with 5 megapixels worth of green information

(because the eye is most sensitive to green light), and 2.5 megapixels each of red and blue data. The camera then uses a mathematical formula to *interpolate* the missing information to produce a full color image.

The term acutance relates more directly to image sharpness, because sharpness is a way of describing the transitions between edge details in an image. If the transition is abrupt, going from one tone to the next with no intermediate tones, as it is with a distinct circle of confusion disk, the edge is sharp. If the

change is gradual, transitioning from one tone to the next with a gradient from one to the other (as with a fuzzy CoC disk), the edge is blurry.

Like resolution, practical acutance can be affected by the quality of your lens, how the lens is focused, the f/stop selected, and the shutter speed you used. These can all conspire to blur edge details in an image and thus reduce acutance. However, unlike resolution, you can adjust acutance to some extent after the photo is taken. In fact, if you've used unsharp masking or

a similar tool in Photoshop or another image editor, that's exactly what you've done: adjusted the contrast in the transitions between edge details in your photograph, as you can see in Figure 4.2.

However, it's still in your interest to achieve the best sharpness in your original photograph, rather than through fiddling with an image editor. Artificially boosting acutance after a photo is taken improves sharpness, but sacrifices some resolution as detail when the transitional areas is removed.

Figure 4.2 The increase in contrast of the edge details makes the image at right look sharper than the original at left.

Lens Sharpness

The sharpness of your lens is one of three factors that determine the sharpness of your image. (Motion blur and focus/depth-of-field are the other two.) If you want sharp photos, you'll have to start with a lens that is capable of producing them. There is no substitute for a lens that can resolve fine details.

Lenses with the sharpness you need don't have to be expensive. Many dSLR vendors offer a 50mm f/2 or f/1.8 lens for about $100 that will almost certainly be among the sharpest lenses you ever own. You may have to give up some desirable features to get a low-cost tack-sharp lens, however. Such a lens may have a limited zoom range (or might not zoom at all), or have a relatively small maximum aperture (say, f/4.5 to f/6.3) that forces you to stop down (use an even smaller f/stop) to obtain the best sharpness. Some of the best bargain super-sharp lenses are older manual focus lenses available for certain models.

Nor does a high price tag guarantee sharpness, although most vendors try to justify hefty prices by ensuring that their high-end lenses are as sharp as possible. Even so, an expensive lens can sometimes be outperformed by a less expensive set of optics. A costly 85mm f/1.2 lens may not be especially sharp wide open, and may actually be less sharp than, say, a modestly priced 85mm f/1.8 lens at an intermediate f/stop of f/4 or f/5.6. An expensive lens with an extreme zoom range (say, 18-250mm) will often offer less sharpness than an inexpensive 18-70mm lens in the focal lengths where they overlap.

So, in choosing the sharpest lens for your work, you'll want to consider the following factors carefully:

◆ **$ vs. $$$$$.** As I mentioned, you don't need to spend a lot to get a sharp lens. A basic 50mm f/1.8 lens can have sharpness galore. Lenses are priced based on their complexity to design and cost

to manufacture, how many the vendor expects to sell, and marketing factors such as the competition for the lens and what the market will bear. You might pay more and get a sharper lens, but then, again, you might not.

◆ **Zoom vs. Prime.** Some zoom lenses rival fixed focal length lenses for sharpness at some settings. In general, however, a prime lens may provide better sharpness. Zooms require additional elements that must shift in complex ways to provide the convenience of different magnifications. A prime lens can be built to do one thing: provide a sharp image at its intended focal length. A fixed focal length lens design must also accommodate the desired maximum aperture (that is, an f/1.4 lens is often more complicated to design than a slower lens of the same focal length), and (with extreme wide angles in particular) require special elements to minimize various kinds of distortion. However, if you're maximizing sharpness, a top-quality prime lens will beat most zooms at its focal length. Figure 4.3 was taken with an 85mm f/1.8 prime lens, which allowed a shutter speed of 1/160 second at ISO 800 under stage lighting conditions.

◆ **Special Features.** Special features add to the price of a lens, but not necessarily its sharpness. With a zoom lens, a *constant aperture* (one that does not change as the lens is zoomed) is desirable, but it might not offer an improvement in sharpness. You'll pay more for a 70-200mm zoom with a constant f/2.8 maximum aperture than for one that varies between, say f/4 at 70mm to f/6.3 at 200mm. You *might* get a sharper lens for the extra money, but that's not guaranteed. Vibration reduction/image stabilization is another extra-cost feature that boosts the price of the lens without necessarily giving you sharper optics. While VR/IS will counteract camera motion to produce sharper images at a particular shutter speed, you might be able to get the same or better sharpness at the same focal length and aperture with a non-stabilized lens mounted on a tripod or used with a high shutter speed.

◆ **Design Quality.** Some lenses are simply designed better than others. One might have extra low dispersion (ED) glass that allows it to focus all colors on the same point, reducing a defect called *chromatic aberration*. Another might use

Figure 4.3 A prime lens at f/1.8 allowed shooting at 1/160 second and capturing a sharp image of Too Slim of Riders in the Sky.

more non-spherical (*aspherical*) lens elements to improve sharpness, or improved multicoating on the lens elements to reduce contrast- and sharpness-robbing flare. Lenses with high-quality designs focus quickly and accurately, so fewer of your images will suffer from improper focus. Even coatings on lenses (and filters used with them) can be important, because such extra layers can reduce flare caused by light striking the lens from outside the image area. Of course, with digital SLRs (more so than with film SLRs), multicoating can benefit the surface of lenses, too. The surface of the sensor is so much shinier than that of film that light can bounce back from the sensor, strike the rear of the lens, and, if the lens doesn't have a proper anti-reflective coating, find its way back onto the sensor to add flare.

◆ **Build Quality.** Some lenses are simply better built than others. It's always nice to own a lens that's solid as a rock and won't wear out prematurely, but if your quest is for sharpness, good build quality takes on extra importance. A well-built lens won't bind when zooming or wobble when focusing, even after years of use. A quality lens is well sealed so it won't become infested with dust or become a host for fungus, both of which can impact sharpness if the invasion is serious

enough. A well-built lens has a tough, wear-resistant lens mount that maintains perfect alignment with the sensor.

◆ **Consistency.** Unfortunately, lens quality and sharpness can vary even among different samples of the same lens from the same manufacturer. Inexpensive lenses tend to have more variability. If you haunt the camera forums, you'll find discussions on the eternal quest to find a "good" copy of a particular lens. Unfortunately, the same tales are sometimes told by the extremely fussy (or paranoid) about expensive lenses. My opinion is that if you buy a lens that is from a well-known vendor, the variations are likely to be small. The true best approach was probably taken by *Life* magazine photographer Alfred Eisenstadt: He bought a lens, and if he liked the pictures he took with it, he kept it. Otherwise, he returned or sold it. If you're determined to separate the sub par from the superb, I offer some lens testing tips in the next section.

◆ **Filter factors.** As I mentioned in Chapter 3, the use (or non-use) of filters over the front of the lens can affect sharpness. Poor quality filters can degrade the image, an effect that's compounded when you stack several filters on top of one another. Filters can also add to lens flare. The very best filters have virtually no effect on sharpness.

Testing Your Lenses for Sharpness

I have mixed feelings about lens testing. Test results you see published in magazines and online may or may not have some value for you. Few, if any, of the test photos will be taken under the same kinds of conditions you shoot under. Most importantly, *you can't buy the exact lens they tested.* Some vendors produce lenses that are very consistent and the one you buy might perform like the one tested in the magazine. Other vendors have spotty quality control, and the lens you get might be *nothing* like the one used for the test.

You're better off testing lenses yourself, although even then your results may vary enough to render your evaluation useless. You can perform the traditional "brick wall" test, which involves photographing a brick wall to see if the bricks and their texture are sharp, as well as to evaluate how straight the straight lines appear. Some lenses will cause straight lines to bow inwards towards the center of the frame, or outwards,

in what is known as pincushion and barrel distortion. Others prefer to photograph newspapers, or test charts like the one shown in Figure 4.4.

Personally, I think it's a better idea to operate like Alfred Eisenstadt, and simply take photos and examine your results. Do

you like your photos, especially when blown up? If so, buy the lens and forget about what others say. One of my favorite lenses is a 10-17 fisheye zoom. While it's not a mainstay, I end up taking a few pictures with it during many of my shooting sessions, just for fun, even though the lens is not super-sharp and imbues each

photo with copious amounts of chromatic aberration in the form of purple fringing. But the photos end up published in books like this one in relatively small sizes, and the lens's defects don't really matter, as you can see in Figure 4.5.

If you want to perform your own lens tests, you can cobble one together using the United States Air Force 1951 lens testing chart shown in Figure 4.4, which has the advantage of being in the public domain and available to anyone. You'll find a copy to download at the website that accompanies this book (www.courseptr.com/downloads).

❶ Download **chart.gif** from the website.

❷ Make multiple copies of the chart at about 3 × 3 inches. Use the highest resolution printer you have available, and resize carefully to avoid losing resolution. You might find that printing a larger version and then having it duplicated in a smaller size at a reproduction shop is the best way.

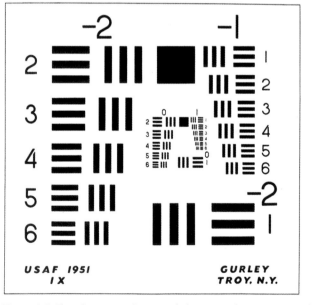

Figure 4.4 This classic test chart can help you evaluate your own lens.

❸ Glue copies of the chart to a 2 × 3-foot foam core board, with charts at the corners, edges, and centers.

❹ Fix the board to a sturdy support, such as a wall, so that it is perpendicular to the floor (using a carpenter's level or plumb bob to make sure it is not askew). Tape a label to the bottom of the board listing the name of the lens, focal length, aperture being tested, and date. Replace this label when you change lenses, focal lengths, or apertures.

❺ Mount your camera on a tripod, and position it at a distance roughly equivalent to one inch per mm of lens focal length that will be tested. For example, if you're testing an 80mm-200mm zoom lens, you'd want to place the tripod 80 inches (about 6.6 feet) from the chart to test the lens' shortest focal length, then move the tripod out to about 16 feet (200 inches) to test it at the telephoto end of the scale.

❻ Adjust and level the tripod so the camera back is parallel to the plane of the test chart.

❼ Illuminate the chart with bright lighting. You can shoot outdoors in sunlight, or use several bright lamps indoors placed at 45-degree angles. Electronic flash will also work.

❽ Set your camera for its highest resolution. Use the RAW format.

❾ Focus *very* carefully on the test chart. Refocus as you change f/stops for different test shots.

❿ Take several test pictures at various lens openings. Make sure that you minimize the effects of camera and subject movement on the image by using a fast shutter speed and either the self-timer or remote release to make sure that you don't jiggle the camera when you trip the shutter. If your camera has pre-shot mirror lockup, use it to eliminate any loss of sharpness from mirror slap.

⓫ Examine your test shots in your image editor. The smaller the sets of lines that can be distinguished, the better your lens. Compare the center results with the edges, and with other lenses, for the best "picture" of how good your lenses are.

Figure 4.5 Sometimes a lens, like the fisheye zoom used for this shot, has properties that make up for a lack of sharpness.

Choosing the Right Aperture for Sharpness

To get the best sharpness in an image, you'll want to use your lens's best aperture for a particular type of photograph. That means for general-purpose photography you'll want to use an aperture that's about two stops smaller than the maximum aperture of the lens. For available light photography, the "best" aperture might be a compromise: either wide open or one stop smaller. If you're shooting sports, the "best" f/stop may be the one that's sharpest that still allows you to use the shutter speed you need to freeze action.

Once you've arrived at the best aperture for sharpness, it's easy to "lock" it in when using most digital SLRs. Just switch to aperture priority mode (represented by A or Av) on your camera's mode dial, and select the aperture you want to use. The camera will then choose an appropriate shutter speed. If you're concerned that the selected f/stop will cause the camera to use a shutter speed that's too slow to block subject or camera motion, one trick you can use is to set your camera's automatic ISO feature so it will increase the sensitivity setting when the shutter speed ventures

into blur-land. Some models, such as recent cameras from Nikon, let you specify the minimum shutter speed that triggers this adjustment, as well as the maximum ISO that will be used (which lets you avoid unexpectedly ending up with photos taken at your favorite f/stop, but at a very noisy ISO 1600 setting). Some Canon models have a feature called Safety Shift, which tells the camera to ignore your selected aperture (or shutter speed) setting if your preference will lead to an improperly exposed photo.

However, there are many shooting situations where maintaining control over the aperture used is a good idea when your main concern is sharpness. Here are some considerations to think about:

◆ **What's the sharpest aperture?** As I mentioned, all lenses have an f/stop at which they produce their sharpest overall image, as you can see in Figure 4.6, usually about two apertures smaller than the maximum aperture of the lens. For a zoom or prime lens with an f/2.8 to f/3.5 maximum aperture, the best results will often be found at f/5.6 to f/6.3.

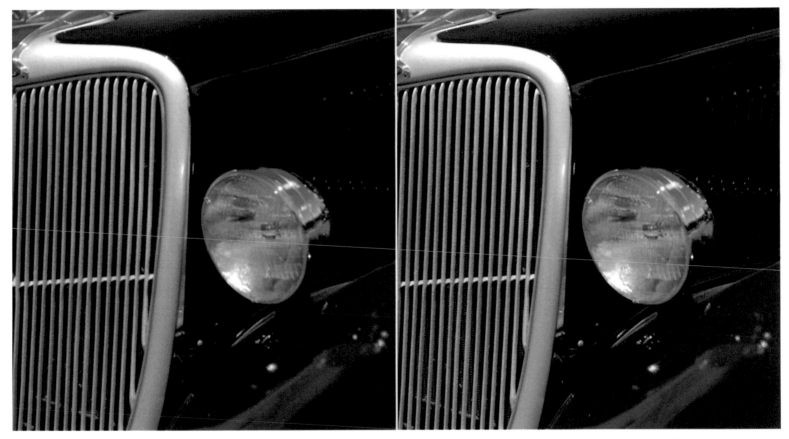

Figure 4.6 The image at the left, exposed with the zoom lens's maximum f/6.3 aperture is less sharp than the version taken a second later at f/11 (right).

◆ **What kind of use was your lens designed for?** Some lenses are designed to produce good sharpness at certain apertures, which may or may not be a larger f/stop, and probably won't be the same as the optimum aperture for a lens designed for a different kind of application. For example, "fast" lenses are often intended to be used wide open under relatively low light conditions. A 55mm f1.2 lens, a 400mm f2.8 optic, or an 80-200mm f2.8 zoom are all likely to provide good results at their maximum apertures. You wouldn't pay $1,500 for a 28mm f/1.4 lens to use it at f/5.6 or f/8 all the time. While such a lens would indeed likely be a little sharper at f/8 than at f/1.4, the improvement might not be all that much. A fast lens is *designed* to be useful at its maximum aperture.

◆ **What depth-of-field do you need?** Don't force yourself to use your lens's "optimum" aperture when you need a specific depth-of-field range for close-up photography or creative purposes. Understand when it's wise to trade a little overall sharpness at the exact plane of focus for a larger degree of apparent sharpness elsewhere in the image through use of smaller apertures. Or, if you *want* to isolate your subject with very shallow depth-of-field, as in Figure 4.7, realize that a wider lens opening while possibly less sharp in an absolute sense, might actually *appear* to produce a sharper image because of the contrast between the object in focus and the out-of-focus foreground and background. At its most fundamental level, sharpness is the contrast between objects, and your use of depth-of-field can increase or decrease this contrast.

◆ **Is diffraction always evil?** I described in Chapter 2 the phenomenon of diffraction (which causes a decrease in sharpness when f/stops smaller than a lens's optimum aperture are used). This is another twist on the depth-of-field tradeoff puzzle. The sharpness lost to diffraction is partially offset by increased depth-of-field. When taking macro photographs, in particular, you might find that your flower photograph at f/32 *looks* sharper than the same image exposed at f/11, even though the smaller portion of the image in the plane of focus is sharpest at the latter aperture.

Figure 4.7 Shallow depth-of-field can actually make a wide lens opening appear to be sharper, because of the contrast between the main subject and out-of-focus background.

Shutter Speed and Lens Sharpness

The shutter speed that you use is another factor that can enhance or limit the sharpness you can get from your lens. In practice, shutter speed has three functions as part of the picture-taking process. It works in unison with the aperture, ISO sensitivity, and the amount of available illumination to produce the proper exposure. The duration of the exposure, as determined by the shutter speed, is what freezes subject movement in your image, say, as a race car crosses the frame. The shutter speed also counters a second type of movement: that of the camera itself. Shaky hands or anything else that causes the camera to wobble, jiggle, or move will certainly reduce sharpness.

The focal length of your lens, its shape, and how you hold it can have a direct effect on image sharpness. I won't address the effects of shutter speed on exposure or subject motion. My only concern in this chapter (and in this book) is how shutter speed relates to the results you get with your lenses.

Taming camera motion blur is actually one of the easiest ways to improve the sharpness of your images, and also the one that's easiest to neglect. Photographers upgrade to higher-resolution cameras to get better photos, buy the best-quality lenses, and focus with utmost precision, only to lose detail to camera motion. Some even brag that they are able to capture images handheld at remarkably low shutter speeds, not realizing that those shots at

1/15th second, while acceptable, aren't as good as they *might* have been. Taking and partially releasing deep breaths, special bracing techniques, and a gentle finger on the shutter release can help, but they can't replace other methods for reducing camera motion, such as a tripod or higher shutter speed. (And, of course, do nothing at all when your subject is moving faster than your shutter speed can freeze.)

Try an informal test yourself. Find a subject outdoors at night with multiple point sources of light, such as streetlights or holiday decorations. Focus manually very carefully, using the pinpoints of light as your focus point, and turn the focus ring until the points are as sharp as possible. Take a few shots using manual exposure until

you find out which f/stop will give you a good exposure. Try to use f/8 to f/11 so your lens will be at a relatively sharp aperture. (Adjust the ISO setting, if necessary, to bring your aperture into this range.) Then, take several pictures at each shutter speed you want to test.

When you're done, examine your shots. As you reduce the shutter speed, you'll probably notice that the pin circles become elongated in the vertical, horizontal, or diagonal directions, depending on the bias of your shakiness. At worst, you may notice little wavering trails of light that show you're not merely shaking a bit, but positively quivering, as you can see at right, bottom, in Figure 4.8.

Figure 4.8 The point source lights (circled in green) appear fairly sharp with an exposure of 1/15 second handheld (top). At 1/4 second (bottom), the points are deformed enough to clearly show camera motion blur.

Countering Camera Motion Blur

A handheld camera will shake at any shutter speed, potentially reducing the apparent sharpness of your lens. How much this unwanted vibration degrades your image depends on its magnitude (some photographers and camera/lens combinations are more susceptible to camera shake than others) and the motion-stopping ability of the shutter speed you've selected. The solutions range from simply changing some of your shooting habits to using higher shutter speeds, or using a dSLR or lens with built-in image stabilization technology. If those aren't enough, you can use a tripod, monopod, or other steadying device.

Shakiness can be exaggerated by several factors. A camera or camera/lens combination that is poorly balanced is prone to additional camera shake. The 500mm lens used for Figure 4.9 demands a shutter speed of at least 1/2000 second because of its heft. Turning the camera from a horizontal to a vertical orientation can produce more shake if the rotated grip is uncomfortable, or if there is no second "vertical" shutter release and the photographer's hand is forced into an awkward position. Camera shake is also magnified by enlarging the image or using longer focal lengths. Vibrations that are almost imperceptible when shooting photos with a 25mm lens will be seemingly magnified 20X at 500mm. Enlarging a small section of a photo in an image editor, or the magnification produced by a non-full frame camera's crop factor can also magnify the effects of camera shake.

Don't be duped by supposed "rules of thumb." You'll be told that you should use a shutter speed that's the reciprocal of the lens's focal length, for example 1/200 second with a 200mm lens, or 1/500 second with a 500mm lens. By that reasoning, you should be able to handhold an 18mm lens at 1/15 or 1/20 second. Maybe you can, or maybe you can't. Do you really want to stake the quality of your image on maybes? There are many variables involved, ranging from an unsteady photographer using poor technique, to poorly balanced camera/lens combinations that exacerbate normal camera wobble, and dSLR crop/magnification factors that make 300mm lenses act, in some ways, like 450mm telephoto monsters. No single rule can be used to determine a "safe" shutter speed for any particular lens. Here are some of the ways you can reduce the effects of camera shake:

◆ **Use higher shutter speeds.** A higher shutter speed—typically twice or four times as fast as the "rule of thumb" speed—can reduce the effects of camera shake. I have a front-heavy 500mm lens that simply can't be hand-held at 1/500 second, but which produces acceptable results in that mode at 1/2000 second. When I'm using a 24mm wide-angle focal length, a shutter speed of 1/125th second is usually sufficient for carefully snapped off grab shots (but I'll *still* use a tripod or monopod at that shutter speed for architectural or landscape photos). Unfortunately, the shutter speeds available to you are dictated by the amount of available light and the aperture you want to use. Those 1/250 or 1/500 second speeds may or may not be available to you. It's easy enough to switch from 1/125 second at f/11 to 1/250 second at f/8, when using a normal or wide-angle lens that still provides adequate depth-of-field at the wider aperture. But if you're already shooting at 1/125th at f/2.8, gaining a faster shutter speed might require boosting ISO a notch or two, which, in the higher sensitivity ranges has image degradation implications of its own.

Figure 4.9 The 500mm lens used for this shot requires a shutter speed of at least 1/2000 second when hand-held.

◆ **Improve your holding technique.** Take a solid stance with feet firmly planted, hold your camera with both hands, cradling the lens with your left hand, if necessary. Tuck your elbows close to your sides. Don't be shy about leaning against a wall or post if it will help steady you. If your exposure time is going to be long enough to cause concern, consider taking a deep breath and gently squeezing the shutter release button. Improved technique can help reduce camera shake. (And now you know why amateurs with point-and-shoot cameras held out from their bodies at arms' length so they can compose on an LCD end up with blurrier results than you do!)

◆ **Perfect your shooting habits.** Do you "punch" the shutter release in your eagerness to take a shot? When you bring the camera to your eye, do you wait until the camera has stopped moving and then gently squeeze off an exposure? I've seen amateurs flip their camera up and shoot in a single motion. That's a perfect recipe for camera shake! Modern cameras that lock focus and exposure when the shutter release is depressed halfway have actually helped improve sharpness, because more of us are now gently releasing the shutter after that initial half-press.

◆ **Watch for mirror bounce.** The mirror in a dSLR directs light to the viewfinder and then, just before exposure (or during Live View display of the active image on the rear LCD with cameras like the Nikon D300 or Canon 40D—see Figure 4.10), flips up (or sideways, with some specialized models), allowing the light to proceed directly to the shutter curtain and

sensor. Then, the mirror moves back to its original position. Unfortunately, the movement of the mirror prior to exposure can cause a tiny bit of vibration that's transmitted to the sensor, producing a minor, but potentially significant kind of camera shake. Mirror bounce affects your image most within only a small window of shutter speeds, about 1/15th to 1 second. With shorter shutter speeds, the effects are not very pronounced, and at longer exposures, the period of vibration is such a small part of the overall exposure that it's more or less canceled out. While you're unlikely to use such slow shutter speeds when hand-holding your camera, it can affect tripod shots. Some digital SLRs have a provision for locking up the mirror prior to exposure, which eliminates the problem. Others have what is called *mirror prerelease*, which causes the mirror to flip up and lock automatically a very short interval before the picture is taken, but allowing enough time to elapse to damp the vibration the mirror's movement caused.

◆ **Use image stabilization or a camera support.** A lens or camera equipped with image stabilization/vibration reduction technology can nullify up to four stops' worth of camera shake. That is, you can theoretically shoot at 1/50 second with the same camera motion (but not subject motion) freezing power of a 1/200 second shutter speed. A monopod, or, better yet, a tripod, used instead of image stabilization, provides even more steadying power: exposures of several seconds to several minutes can be made when the camera is mounted on a solid tripod. Both IS and camera supports are covered in more detail in their own sections within this chapter.

Figure 4.10 The Live View mode of the Canon 40D has a side benefit: with the mirror flipped up and Quiet Shooting mode activated, there is less sharpness-robbing vibration even when the camera is mounted on a tripod.

Image Stabilization/Vibration Reduction

Canon calls it image stabilization (IS), while Nikon prefers the term vibration reduction (VR). Both are incorporating the technology into an increasing number of lenses. In November 2007, Nikon even added VR features to its basic 18-55mm "kit" lens offered with its entry-level cameras. Other vendors, such as Sony, add anti-shake features to the cameras themselves, so you don't need to purchase a special lens to gain blur-reducing capabilities. No matter how it's implemented, IS can counter camera shake caused by too-slow shutter speed in conjunction with other factors that range from something as mundane as the photographer breathing to attempting to shoot from a moving vehicle.

By countering the natural motion of your camera and lens, IS can provide you with the equivalent of a shutter speed that is at least four times faster, effectively giving you two extra stops to work with. That can be important under dim lighting conditions. For example, suppose you're shooting in a situation with a 400mm lens that calls for a shutter speed of 1/500 second at f/2.8 for acceptable sharpness. Unfortunately, you're using a zoom lens with a maximum aperture at that particular focal length of only f/5.6. Assume that you've already increased the ISO rating as much as possible, and that a higher ISO either isn't available or would produce too much noise. Do you have to forego the shot?

Not if you're using a camera or lens with IS. Turn on your IS feature, and shoot away at the equivalent exposure of 1/125th second at f/5.6. If the image stabilizer works as it should, blur caused by camera shake should be no worse than what you would have seen at 1/500 second. Your picture may even be a little sharper if your lens happens to perform better at f/5.6 than at f/2.8 (which isn't uncommon).

There are some things to keep in mind when using image stabilization:

- ◆ **Fixes camera shake only.** Image stabilization mimics the higher shutter speed *only* as it applies to camera shake. It will neutralize a wobbly camera, but won't allow you to capture faster-moving objects at a slower shutter speed.

HOW IMAGE STABILIZATION WORKS

Optical image stabilization built into the lens is the system used by Canon and Nikon. Several piezoelectric angular velocity sensors operate like tiny gyroscopes to detect horizontal and vertical movement, which are the usual sort of camera shake you'll experience—up and down or side to side shaking, rather than rotation around the optical axis. Once motion is detected, the optical system uses prisms or adjustments in several "floating" lens elements to compensate. Lenses that can be adjusted to compensate only for up and down motion can successfully use image stabilization even when you're panning.

Sony, Olympus, Panasonic, and other vendors use a system in which the *sensor* is moved in response to camera motion. The advantage of this method is that you don't have to purchase a special lens that incorporates IS; the anti-shake technology is in the camera and therefore works with virtually any lens you use. Special lenses are not required. However, if the anti-shake feature of your camera breaks, you have to send the entire camera in for repair. Photographers who have tried both types of systems like being able to see the image being stabilized in the viewfinder as you partially depress the shutter release to lock in focus. In-camera IS provides no such feedback, but may be indicated by a viewfinder icon.

◆ **Use of panning techniques and tripods may interfere.** The intentional camera movement of panning may confuse the IS, or provide only partial compensation, so you'll end up with a picture that is not as good as if IS were switched off. Use of image stabilization when the camera is on a tripod leads to wasted use of the feature, or, worse, unneeded compensation that adds to the blur. However, newer image stabilization systems can recognize horizontal motion as panning and interpret extraordinarily low levels of camera movement as tripod use, and disable themselves when appropriate, so you can take photos like the one shown in Figure 4.11 even when panning. Your camera or lens may have a special "active" mode that can be selected when shooting from a moving car or other vibration-heavy environments.

◆ **Performance hit.** Image stabilization can slow down your camera slightly. The IS process takes time, and, unlike autofocus and autoexposure, does not necessarily cease when you partially depress the shutter release. Image stabilization can produce the equivalent of shutter lag, and, oddly enough, may not work as well as you think for sports photography. IS is great for nature photography, long-range portraits, close-ups, and other work with subjects that aren't moving at a high rate of speed, but less suitable for fast action.

◆ **Telephoto or macro lenses not required.** Image stabilization can be used for applications besides long-range telephoto or close-up photography, and it doesn't require macro or tele settings to be of benefit. For example, if you find yourself in an environment where flash photography is not allowed, such as a museum or concert, IS can be a life-saver, letting you shoot with normal or wide-angle settings at shutter speeds as slow as 1/4 second.

Figure 4.11 Newer image stabilization systems can operate even when panning the camera.

Tripods and Monopods

Most of the images in my books were taken using either a tripod or a monopod (the one-legged version of a tripod). That's not to imply that I take all of my photos with a tripod or monopod—only that the ones that are good enough to appear in print seem to have been given an additional technical boost thanks to the steadying influence of a supporting device.

You won't want to use a tripod (like the one shown in Figure 4.12) or monopod all the time, of course. When you're shooting quickly and taking shots from many different angles, or covering a fast-moving sport like basketball at both ends of the court, you won't want to be slowed down by a tripod or monopod. If you're shooting in a studio-type setting with electronic flash, or indoors in other environments with flash, if the strobe is your main source of illumination, you can generally count on it to freeze movement. A high shutter speed isn't necessary (except to

curb ghost images caused by ambient light when the subject moves during the exposure), and a tripod or monopod is superfluous. Tripods are prohibited in some venues, such as museums, professional sports events, and other public settings.

On the other hand, lacking the availability of image stabilization, you should at least consider having a tripod or monopod

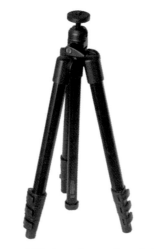

Figure 4.12 A sturdy tripod can help you get all the sharpness available from your lenses.

available in these kinds of situations, some of which are related to convenience rather than image quality alone:

◆ **With telephoto lenses.** Any lens longer than 200mm (actual focal length or equivalent) can usually benefit from a little extra steadying. In the 400mm-500mm range, you'll definitely get better results if you can mount the camera or, better yet, the lens, on a tripod or monopod. The longest lenses are front-heavy, which can result in a seesawing motion as you try to aim, zoom, and control your camera using just two hands. Longer lenses often have their own original equipment or accessory tripod socket collars (see Chapter 2), and bracing them provides the steadying influence you need and enable you to more easily manipulate your camera's controls.

◆ **For wildlife photography.** A tripod lets you trigger the shutter release (with a remote control or wired cable release, if you like) at the proper moment when you're hidden in a blind, or stalking hummingbirds you hope will be attracted to a feeder you've set up. Fast-moving creatures can be hard

to capture on the fly, but with a tripod you can preframe and prefocus your picture and be ready to shoot at the right moment. Some digital cameras can link to a computer for images taken by remote control. Or, you can use the built-in time-lapse feature (if your camera has it) or the timed sequence feature of your camera's capture software to take a series of wildlife exposures. Of course, nature photography often involves long telephoto lenses, too, so you have *two* reasons for using a tripod.

◆ **When composing carefully.** Landscape and architectural photography often involves painstaking preparation and meticulous framing of just the right composition. A tripod lets you set up, compose your image, shoot multiple versions, and fine-tune your picture without needing to reframe after every shot. A tripod can also help when shooting panoramas that will be stitched together from several images.

◆ **For close-up photography.** Macro photography often benefits from a tripod's ability to lock down your camera in a particular orientation. You can frame and focus your image, without worrying that

the camera will move. Some close-up photos require the long shutter speeds because of low light levels or the small f/stops needed, and a tripod can be a valuable steadying tool.

◆ **For longer exposures.** A rock-solid tripod lets you make long exposures without blur caused by camera motion.

◆ **When you're shooting infrared.** Digital SLRs force you to shoot blind when you've mounted an infrared filter on your camera. In addition, IR photography usually calls for long shutter speeds. A tripod will let you frame the photo without the filter, then expose the same composition for the requisite second or two after you've locked down the tripod and mounted the IR filter.

◆ **When you want to get in the photo yourself.** You can always set your camera down on a nearby wall or shelf, activate the self-timer, and then run and get into the picture. But, you'll find that a tripod is more convenient.

Support Options

Although I've been using the term *tripod* for the most part, your actual options for camera support are much broader than just the traditional three-legged camera stand. You can choose from:

◆ **Tripods.** These devices consist of a set of telescoping legs, topped with either a ballhead (which can be loosened and rotated in virtually any direction) or a pan and tilt head (which rotates along the axis of the center column, plus tilts forward and back, and tilts from the horizontal position to a vertical orientation). Some tripods are modular and can be purchased as a set of legs, with or within a center column. The head, such as the ballhead shown in Figure 4.13, is purchased separately, and can easily cost almost as much as the tripod legs. When selecting a tripod, choose the composition material (usually aluminum or lighter but equally strong carbon fiber material); height (to bring the camera up to eye level or beyond, with the flexibility to go very low when needed); and the number of leg

Figure 4.13 A ballhead allows you to position the camera in a variety of orientations quickly.

sections (tripods with four or five leg sections fold up smaller than those with three leg sections). You'll also want to evaluate special features, such as the ease of adjusting the legs (especially at a variety of angles), sure-grip "feet," reversibility of the center column for shooting at low angles, and any special accessories, such as clamps for flash units.

◆ **Monopods.** These are a handy alternative to a tripod when all you need is to steady the camera and don't need a freestanding support. My Manfrotto carbon fiber is my take-everywhere accessory that goes right in my shoulder bag for use whenever I mount a lens longer than 200mm, or in light levels less than full daylight when I am not using flash. I've also found it useful when shooting outdoors in full daylight at low sensitivity settings (such as ISO 100) when using a light-robbing polarizing filter. I have a quick-release adapter on my monopod and a matching plate on every camera, so I can just whip out the monopod, snap on the camera, and shoot with just a few seconds' preparation. Like tripods, monopods are available in both aluminum and lightweight materials such as carbon fiber, and can be purchased in three-, four-, and five-section configurations.

◆ **Tripod Alternatives.** There are lots of alternatives to tripods and

monopods, many of them a lot more portable and convenient. For example, many photographers like to carry around a beanbag or two. Throw the beanbag down on just about any surface, then set your camera's lens on top. The beanbag molds to the shape of the lens, provides solid support, and is pliable enough to allow aiming the camera at various subjects without moving the beanbag. Some photographers swear by gunstocks they can put to their shoulders and steady their cameras and long lenses. Others use chestpods and other gadgets. I carry a C-clamp device, like the one shown in Figure 4.14, which can be fastened to railings and other fixed objects as a versatile replacement for a "real" tripod.

Figure 4.14 This clamp can be fastened to stationary objects, converting them into an ad hoc camera support.

Achieving Correct Focus

If your lens doesn't sharply focus on the main subject of your scene, your final image won't be satisfactorily sharp. Intentional blur is fine when you're using selective focus or creating a particular look as a creative effect, but *something* must be sharp. For example, when shooting portraits, if the eyes of your subject are sharp, it's less important for the background or even the rest of the face to be in exact focus. Selective focus works only when the desired areas of an image are in focus properly. For the digital SLR photographer, correct focus can be one of the trickiest parts of the technical and creative process.

Prior to the introduction of autofocus lenses, badly focused photos were always the fault of the photographer. However, our eyes and focus-screen-based automatic focus systems operate on similar principles. When part of an image is in sharp focus, the contrast of the image at the boundaries between tones is the highest. As we focus manually, our brains try to judge whether the image we are looking at now is more or less contrasty than the image we saw most recently. That's why manual focusing involves jogging the focus ring back and forth until you've zeroed in on the point of correct focus.

Your dSLR's autofocus mechanism also evaluates increases and decreases in contrast, but it is able to lock in much more quickly and, with an image that has sufficient contrast, more precisely. Unfortunately, there are some factors that complicate your lens's automatic focus operation:

♦ **Focus on what?** Your camera doesn't know what object in the frame you want to be in sharpest focus. Is it the closest object? The subject in the center? Something lurking *behind* the closest subject? A person standing over at the side of the picture? Many of the techniques for using autofocus effectively involve telling your camera exactly what it should be focusing on.

♦ **Too much depth-of-field.** A lot of DOF is great when you want an extensive range of objects in your image to be reasonably sharp, but remember that there is always only *one* plane of exact focus. Think of depth-of-field as a bonus range of sharpness that surrounds that plane. When it comes time to focus, you want the *least* amount of depth-of-field possible, so that the contrast between the object being focused on and those in the foreground and background is easily discerned. That's one of the reasons why lenses are generally wide open during the autofocus process: the image is bright and has the least amount of DOF. It's easier to achieve sharp focus at f/1.8 than it is at f/8. It's easier to focus at 70mm than it is at 18mm, too.

♦ **Subjects move.** With subject matter that's moving—particularly with sports photography—the point of sharpest focus may shift rapidly. If someone is coming towards the camera, your autofocus mechanism needs to compensate dynamically. Or, something may move across your frame, blocking your subject for an instant before moving on.

Your camera has to decide whether to lock focus on this new object, or to keep the focus on the original subject until a short interval has passed.

♦ **Confusing subjects.** Some kinds of subject matter can be difficult to focus on because of a lack of sufficient contrast to the camera's autofocus mechanism "lock on." A clear blue sky, blank walls, shiny subjects, windows, or other subjects with a multitude of tiny details that can't be resolved easily by the autofocus system can cause problems.

Because of these challenges, your camera uses multiple types of autofocusing systems, all operating on information from several different autofocus sensors within the frame (current dSLRs vary from three to 51 different autofocus zones within a single viewfinder). (See Figure 4.15.) These focus sensors consist of vertical or horizontal lines of pixels, cross-shapes, and often a mixture of these types within a single camera. Different sensors may be used in bright light than in dim

light. Plus, you may be able to *move* the sensor's viewpoint from place to place in the frame, using your camera's cursor keys. Your camera may work with a single sensor at a time, or zero in on one sensor but take into account the other adjacent zones. How the camera selects which sensor to use (or how you choose the zone manually) has a significant impact on how successfully the image is focused.

Once the camera evaluates the autofocus information, the lens is snapped into focus, using (most commonly) a tiny motor built into the lens itself or (with some older designs) a motor in the camera that drives a screw that presses on a matching lever in the lens. When and how often this happens depends on the autofocus mode you've selected. The most common modes are:

◆ **Single autofocus.** This mode (AF-S), the default for most cameras, focuses once when you press the shutter release button down halfway. Focus remains at that setting until the button is fully depressed, taking the picture, or until you release the shutter button without taking a shot. For non-action photography, this setting is usually your best choice, as it minimizes out-of-focus pictures (at the expense of spontaneity). The drawback here is that you might not be able to take a picture at all while the camera is seeking focus; you're locked out until the autofocus mechanism is happy with the current setting. Single autofocus is sometimes referred to as *focus priority* for that reason. Because of the small delay while the camera zeroes in on correct focus, you might experience slightly more shutter lag.

◆ **Continuous autofocus.** Use this mode, usually called AF-C, for sports and other fast-moving subjects. When the shutter release is partially depressed, the camera sets the focus but continues to monitor the subject, so that if it moves or you move, the lens will be refocused to suit. You'll sometimes see continuous autofocus referred to as *release priority*, because some cameras can be set to take a picture during continuous autofocus even if precise focus hasn't been achieved. Continuous autofocus uses the most battery power, because the autofocus system operates as long as the shutter release button is partially depressed.

◆ **Automatic autofocus.** Use this setting, often called AF-A, when you're shooting a mixture of action photos and less dynamic subjects. When selected, the camera will examine a scene and then switch from single autofocus to continuous autofocus if the subject starts to move.

Other autofocus parameters you might be able to specify include whether the camera uses a single focus area, or groups information from several adjacent focus zones to determine focus. With more advanced cameras, you might be able to select the focus group pattern, and whether the nearest subject should be given priority when choosing a focus zone. Many cameras have a separate focus lock button that can lock in a point of focus independently of the traditional half-press of the shutter release. That button allows you to zero in your focus at a certain point, but allows exposure to be set only when you press the shutter release.

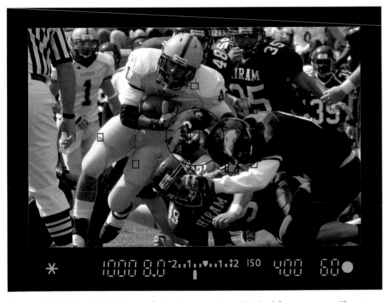

Figure 4.15 Digital SLRs have from three to 51 individual focus zones. The nine focus areas in the Canon EOS 40D's viewfinder are highlighted in red when active.

Back Focus and Front Focus

Back focus and front focus are defects in an autofocus system that cause a lens to focus behind or in front of the actual point of sharp focus. The camera determines the focus point accurately, but somehow the focus instructions become lost in translation, and your result is a photo that is not sharply focused on the subject you intended, as in Figure 4.16. If you have a lens with this problem, you'll want to return it to the vendor for recalibration.

You can easily test for front focus and back focus yourself, using a ruler, or a ruled piece of paper. Here's how to test for back focus and front focus yourself. You'll need a chart. If you Google *back focus test chart* you'll find dozens of suitable charts on the Internet. One of the best is Tim Jackson's, available at www.focustestchart. com/chart.html. The chart can be

Figure 4.16 When you focus on the object in front, but actual focus is on an object behind the intended point, your lens suffers from back focus problems and needs to be recalibrated.

printed on a single 8.5 × 11-inch sheet of paper. Most focus charts include measurements showing the distance between the lines, so you can see just how errant your lens's focus is.

To use the chart, lay it down on a flat surface and shoot obliquely, focusing on the center of the chart using your lens's widest aperture and the autofocus mode you want to test. Mount the camera on a tripod so you can get accurate, repeatable results.

If your camera/lens combination doesn't suffer from front or back focus, the point of sharpest focus will be the center line of the chart, as you can see in Figure 4.17. If you do have a problem, one of the other lines will be sharply focused instead. Should you discover that your lens consistently front or back focuses, it should be sent in for calibration.

Figure 4.17 A chart with distance markings and a test focus subject can be used to determine if your lens focuses correctly (top), front focuses (middle), or back focuses (bottom).

5 Using Telephoto Lenses

Although the concept may seem odd to you if you're new to the world of single lens reflex cameras, some photographers are clearly "telephoto people" while others are "wide-angle shooters." You'd think that every photographer would want to use all of the photographic tools available, equally, because, in the case of lenses, telephotos and wide-angle lenses clearly have different perspectives and purposes.

Even so, some of us prefer subject matter that is better served by one type of lens or the other. You might be a sports or wildlife photographer who dotes on long lenses. Perhaps you favor indoor photography, landscapes, or architectural subjects that often work best with optics having a wider view. It may even be that you "see" things from a telephoto or wide-angle perspective. Don't be ashamed of your bias: it's natural. But keep in mind that approaching your favorite subjects from the opposite viewpoint can be a great way to spark your creativity. Can you shoot sports with a wide-angle lens, or architecture with a telephoto? You certainly can, and you may be surprised at the results.

This chapter looks at the uses for telephoto lenses, how they operate, and what they can do for your photography. If you're an inveterate long-lens shooter, this chapter is for you. But, it may also help those of you who favor wide-angle lenses look at things in a new way. Photographers who go both ways may find some new ideas, too.

What Telephoto Lenses Can Do

Telephoto lenses make things look bigger. Everyone knows that. But don't use your telephoto lens simply to magnify distant objects. Long lenses also provide a particular perspective and "look" that you can use creatively in a variety of ways. Whether you're applying selective focus to concentrate attention on a subject while allowing the background to blur, or squeezing the apparent distance between two subjects that are, in fact, widely separated, the telephoto lens is a versatile tool. Here are some of the ways you can use them. I'll devote a section to each of them later in this chapter:

◆ **Isolate interesting subjects.** A telephoto lens or zoom setting offers less depth-of-field so you can use selective focus to make your subjects stand out distinctly from their backgrounds. This effect is especially useful when the background is cluttered or distracting, as in Figure 5.1.

◆ **Get closer to skittish creatures.** Interesting wildlife such as deer, wild birds, tree frogs, and less friendly creatures such as bears, can become wary when humans approach. (See Figure 5.2.) While you have capturing a great picture in mind, they may be thinking *flight* or *fight*. A telephoto lens, a bit of stealth, and maybe some camouflage can bring these distant critters nearer to you.

◆ **Compress distances.** Lenses with focal lengths compress the apparent distance between objects, so a line of automobiles will appear to be bumper-to-bumper when they are actually each 20 feet apart. Telephoto compression is a great tool for creating a feeling of intimacy between subjects that are actually widely separated.

Figure 5.1 The reduced depth-of-field of telephoto lenses lends itself to selective focus techniques, making it simple to throw a distracting background out of focus.

Figure 5.2 Long lenses let you capture wildlife from a distance.

◆ **Get in the middle of the action.** Telephoto lenses are a valuable tool for getting you into the middle of sports action. You can take your camera to the periphery of a conference between a pitcher and catcher at a crucial moment, or capture a running back bursting through a hole to pick up yardage. Even sports that can be photographed from fairly close, such as basketball or soccer, can benefit from a telephoto perspective.

◆ **Improve your portraits.** Wide-angle lenses can exaggerate human features, making noses (which are much closer to the lens) appear larger, and ears (which are relatively much farther away) look too small. A moderate telephoto lens can help your portrait subjects look their best, by providing a flattering perspective with noses, ears, and other body parts portrayed in their best proportions. An 85mm to 105mm lens (35mm film camera equivalent), which is roughly the same as a 55mm to 70mm zoom setting on cameras with the typical crop factor, seems to provide the best rendition.

Of course, telephoto lenses, like wide angles, have characteristics that must be compensated for. Here's a checklist of the things you must watch out for.

◆ **Use higher shutter speeds.** The magnification provided by telephoto lenses also magnifies any camera shake. In Chapter 4, I mentioned the "rule of thumb" that says you should use, as a *minimum*, the reciprocal of the focal length of the lens or zoom setting. So, a 200mm lens would require a shutter speed of 1/200th second. Very long, clumsy lenses can set up a rocking action of their own and might require a higher shutter speed. If you plan on enlarging your image, use a shutter speed that's even faster, too. A tripod or monopod is often a must for sharp telephoto shots.

◆ **Work with smaller f/stops to maximize depth-of-field.** Selective focus is a cool tool, but sometimes you want to have more of your subject in focus than your telephoto lens allows at your current f/stop. The solution is to use a smaller aperture, which calls for higher ISO settings or, preferably, a tripod to allow the lower shutter speed required.

◆ **Deal with flare.** Telephoto lenses often exhibit flare when illumination from light sources outside the picture area enters the lens and bounces around within that long tube. A lens hood is a must with most long lenses!

◆ **Be prepared for dirty or wet air.** Any time you photograph distant subjects, the light that makes up your image has to pass through a lot more of the atmosphere, which, if it contains dirt, moisture, or smog, reduces the contrast and saturation of your images. There's not a lot you can do when the picture is taken to compensate for dirty air, so be prepared to brighten up your photo in your image editor, or use the atmosphere...to provide atmosphere for your photograph, as in Figure 5.3.

◆ **Handling flash fall-off.** If you're photographing distant subjects with electronic flash, you'll discover that few built-in units are much good beyond 20 feet, and more powerful add-on flash seldom is effective much beyond 30 feet. Plan on increasing your ISO setting using multiple flash units with telephoto lenses, or, in many cases, not using electronic flash at all.

Figure 5.3 A rainy night's mist provided a foggy feeling to this evening skyline.

How a Telephoto Lens Works

The term *telephoto* actually applies to a particular type of lens design, which uses elements that *shorten* the length of the lens. Without that special design, a non-telephoto long lens would be unwieldy: a 400mm prime lens would have to be 14 to 15 inches in length. I own a 28mm to 200mm zoom lens that is 2.8 inches long—not the 8 inch measurement end-to-end that you might expect. Lenses that do not use a telephoto design are properly called *long lenses*, but for convenience, all long lenses are usually called telephotos, even if the term isn't necessarily accurate.

British mathematician Peter Barlow found in the early part of the 19th century that placing a negative (concave) rear lens behind the main (convex) element in a telescope caused the device to focus at a greater distance than its unmodified focal length

would indicate. In a camera, this has the effect of producing, say, a lens with a 400mm focal length that need be only 200mm in length. Photo lenses using a telephoto design can be shorter and more compact. Optical devices called Barlow lenses are used to this day with telescopes to multiply their effective focal length.

Figure 5.4 shows an ultra-simplified diagram of a 60mm lens (which equates to the same field of view on a camera with a 1.5X crop factor as a 90mm

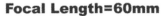
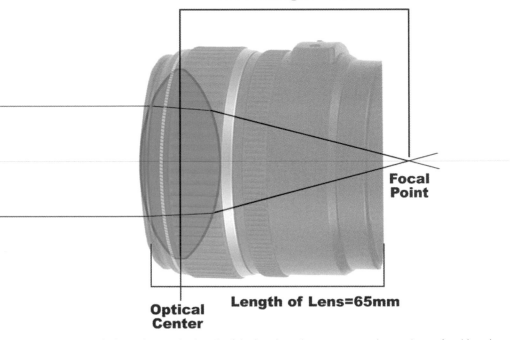

Figure 5.4 In a non-telephoto design, the length of the lens barrel is approximately equal to its focal length.

short telephoto on a full frame [24 x 36mm] film or digital camera). The single green element represents all the lens elements that would be present to focus the light passing through the lens at a point 60mm from the *optical center* of the lens. In this lens, the optical center passes through the center of the front element. Although the focal point is behind the lens mount of the lens (to allow room for the mirror when the lens is on the camera), this particular lens has a barrel that is about 65mm in length. Other "long lenses" with greater focal length would be proportionately larger.

In Figure 5.5 you'll see a simplified diagram of a totally fictitious 60mm lens that uses a *telephoto* design. (I chose the 60mm focal length to keep the example simple; in real life most 60mm lenses are close-up/macro lenses.) To produce a telephoto

lens, designers place a negative (double concave) lens element *behind* the convex positive element, spreading the incoming light farther apart again, causing the photons to converge a little farther from the optical center

than they would otherwise. The negative element has the effect of keeping the same focal length distance by moving the *optical center* of the lens ahead of the front element so that the distance from the physical front of the lens

itself to the sensor can be less. The result: a "shorter" telephoto lens. In this case, our 60mm short telephoto measures just 50mm in length. The size benefits are even greater with telephoto lenses that have even longer focal lengths.

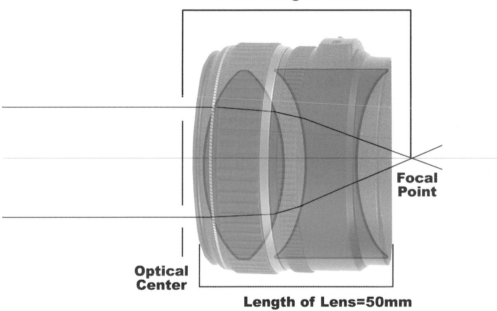

Figure 5.5 With a true telephoto, the optical center is moved ahead of the front element of the lens, so the lens barrel can be much shorter than the lens's focal length.

Choosing a Telephoto Lens

Most of us have to choose the lenses we buy carefully, as we can't afford to purchase every single lens that we'd like to own. Instead, we have to pick and choose the lenses that have the features we need most, and the focal lengths that cover the magnifications we'd prefer to have, with a minimum amount of overlap. Here are some tips for choosing the best telephoto lenses for the kinds of photos you want to take.

◆ **What focal lengths do you need?** For cameras with the typical 1.5-1.6X crop factor, what we think of as telephoto focal lengths begin at about 50-70mm, which is an excellent range for portrait photography as well as some types of indoor sports, including basketball and volleyball. You might want focal lengths in the 105-150mm range for macro photography of insects and other small critters, and for photographing sports along the sidelines of field sports like football and soccer. Sports action in the

middle of the field and some wildlife photography demands lenses with focal lengths of 200-300mm. You'll find lots of sports photographers, especially at baseball games where the action can range over a huge area, with 300-

500mm optics. See Figure 5.6. Lenses of 600mm or longer are useful for serious nature photography. You'll want to carefully analyze the type of photography you do to determine just what focal lengths will be most useful to you.

◆ **How many lenses to cover that range?** Suppose you decide that you need lenses in the 70mm to 400 mm range. Would you prefer a set of individual prime lenses (ignoring all the intermediate focal lengths that aren't covered by your

Figure 5.6 Baseball is one sport that can benefit from lenses with focal lengths of 300-500mm—or more.

set), or are you willing to tote around one zoom lens to cover that range (even though it is likely to be some combination of large, heavy, slow, and expensive)? Or would you prefer to own two or three zoom lenses, each, perhaps, optimized for a particular set of focal lengths? You'll find that there are telephoto prime lenses at all the most popular focal lengths, and zooms that cover huge swaths of magnification. If you have the bucks, you can buy a 50-500mm zoom lens, or one that covers 80-400mm. There are 70-300mm lenses, 200-400mm super telephoto zooms, and even "do-everything" zooms that go from wide angle to telephoto in an 18-200mm (or even longer) (as in Figure 5.7) swoop. The number of lenses you purchase will be based on your available funds, the size of your camera bag, and exactly which focal lengths you need the most.

◆ **What image quality do you need?** I explained sharpness, acuity, and other factors related to image quality in Chapter 4. Image quality will be a major concern for anyone choosing a telephoto lens. You might be willing to give up a little sharpness for a lens with a faster maximum aperture, because without that speed you might not

be able to get any shot at all. An imperfect picture is still better than nothing. Or, you might opt for a long lens with image stabilization over one that's a little sharper in the same range, because that extra sharpness is likely to be lost to camera shake at slow shutter speeds. But, most of the time, you'll want the sharpest lens you can get.

Figure 5.7 A single lens can cover a broad range of telephoto focal lengths or, like this zoom, encompass the whole range from 18mm to 200mm.

◆ **What aperture range do you want?** I use the term *aperture range* rather than, say, "maximum f/stop" because there's a lot more involved here than just how wide a lens can open. Whether that maximum aperture is constant (or varies with a zoom's focal length), and, under some circumstances, the size of the *minimum* aperture can also

be important. The maximum aperture of a telephoto lens is especially important when you're shooting hand-held, because it can determine the top shutter speed you can use at a particular ISO rating, and, as you know, fast shutter speeds are needed to counter blur that is magnified by the narrow field of view of the tele lens. The minimum, or smallest aperture a telephoto lens offers tends to be of less importance, unless you need to maximize depth-of-field.

◆ **Do you need a constant aperture?** The maximum aperture of most telephoto zoom lenses changes as you zoom in or out. An f/4.5 lens may have an f/6.3 maximum aperture at its longest focal length. There are some zoom lenses, usually of the more expensive variety, that are carefully designed so that the effective aperture size doesn't need to change as the lens is zoomed. These are sometimes called *fixed aperture* or *constant aperture* lenses, meaning that at any particular zoom setting, the f/stop remains at the same, constant value. An unchanging maximum aperture can be very important if you find yourself shooting much of the time at one of your lens's wider apertures.

Compressing Distances

Action movies make use of the telephoto lens' tendency to compress the apparent distance between objects, usually to show the hero pursued by a speeding train heading directly towards the camera. In truth, that locomotive may be 100 feet away and only *seem* to be right on top of the actor because of the telephoto effect. You can use this effect to make a row of fenceposts appear to be virtually on top of one another, or flatten the perspective of a city scene to produce a tighter, more crowded urban environment. Once you appreciate telephoto compression, you can put it to work.

You might also want to *avoid* it. A telephoto that is too long for portraiture can flatten a person's features, making faces appear wider than they really are. This is the opposite of the wide-angle effect that narrows faces and enlarges noses while reducing the apparent size of features such as ears. Clearly, when shooting portraits, a focal length of 60-70mm is best for head-and-shoulders shots. It's important to remember that the truly long focal lengths (in the 300mm range and up) are probably not going to provide a flattering rendition of people.

Figure 5.8 A long lens compressed the distance between these hot air balloons, which appear to be just a few feet apart in this shot.

When you want to use compression as a special effect, mount the longest lens you have and stand as far away from your subject as possible. A 400mm to 500mm lens will work best, although you can get good results from lenses as short as 200mm. For Figure 5.8, I was hundreds of yards away from the ascending balloons. The hot air balloons themselves were many feet apart, yet, photographed through a 400mm lens, they appear to be right on top of each other.

Compression can often be used to accentuate patterns, as you can see in Figure 5.9. Each brick column was separated from the next, yet when compressed by a telephoto perspective, they form an interesting pattern of light and shadow.

Figure 5.9 Telephoto compression brought these brick columns closer together and helped accentuate the pattern they formed.

Isolating Subjects

Selective focus can be applied to isolate your subject from the foreground and background with any focal length lens, but the reduced depth-of-field of telephoto lenses is ideal for this effect. Choose a long enough lens, focus carefully, and use an appropriate aperture. You need not shoot absolutely wide open, because telephotos provide relatively limited depth-of-field even when closed down a few f/stops.

Selective focus can be applied in many different ways. You can focus on your main subject and allow the foreground and background to blur. You focus somewhere between the main subject and foreground, so that both will be reasonably sharp, while the background becomes even blurrier. I've even seen effective images where some object in the background was in sharp focus and the main subject was blurred, but recognizable, in front

of it. (For an example, flip back to the chessmen image in Figure 4.16 in Chapter 4.) For the photo of "Abraham Lincoln" in Figure 5.10, I used a telephoto lens and a wide aperture to keep Honest Abe as the center of interest, while allowing his military bodyguard to blur in the background.

A telephoto lens as short as 70mm can be used effectively for isolating a subject, particularly if you use a large aperture. Longer lenses, up to about 200mm, work even better. Super-telephotos also are suitable, but the increased working distances required may make them impractical, particularly if you are shooting a human subject and want to provide some helpful posing directions during the shoot. I have, however, seen interesting photos of a model posing on the beach while the photographer shot from a great distance using a 500mm lens. They communicated with walkie-talkies!

Figure 5.10 A telephoto lens at a wide aperture concentrated the attention on Honest Abe for this shot.

Figure 5.11 shows a particularly challenging situation. The exquisite antique glassware could not be touched or moved to separate it from the adjacent pieces, and tripods were not allowed in the museum that had it on display. So, I used a 70-200mm f/2.8 constant aperture lens wide open at the 70mm setting, with the lens's vibration reduction feature turned on. I think the resulting photo, taken at 1/60 second at f/2.8 is quite acceptable.

Figure 5.11 This antique glassware couldn't be moved, so I shot wide open to allow its companion pieces to blur.

Closing in on Sports

A telephoto lens brings you from the sidelines into the middle of the huddle, from the stands into the action on the field, from just behind the dugout to the dust action of a runner sliding into second base. While some sports, like basketball, benefit from wide-angle lens coverage, most sports are best photographed with a telephoto lens that brings everything much closer.

Remember that the other attributes of a telephoto lens can be applied to sports photography, too. The offensive line in a football game is never more fearsome than when compressed into a single moving juggernaut at the moment of a snap. Selective focus can concentrate attention on a tennis player reaching back to serve an ace, or a soccer goalie blocking the ball in front of a net.

Many sports can be shot with 200mm to 300mm lenses. Even longer lenses usually require a monopod or a very high shutter speed to avoid blur from camera shake. Although I was on the sidelines of the college football game shown in Figure 5.12, I needed a 500mm lens to get a close-up view of a runner being brought down. A monopod helped steady the camera. Only a 200mm lens was required for Figure 5.13, as the soccer players were maneuvering for the goal I was standing near when I took this shot.

Telephoto lenses not only bring you close to the action, but they help blur the background and compress the apparent distance between subjects. The hurdler in Figure 5.14 had a healthy lead over the two competitors that trail him, but the telephoto perspective makes it look as if they are breathing (hard) down his neck.

Figure 5.12 A 500mm lens brought the action up close as this running back is brought to the turf.

Figure 5.13 A 200mm lens was long enough to capture these soccer players maneuvering towards the goal.

Figure 5.14 Telephoto compression and relatively shallow depth-of-field concentrates the attention on the first, second, and third place finishers in this high hurdles event.

Getting Close to Nature

Whether your photographic subject is a distant volcano that you'd rather not approach too closely, a waterfall that's unapproachable, or a nervous doe who'd prefer you not get too close to her, a telephoto lens can take you up close, with no risk to you or your photographic prey.

Telephoto lenses are sometimes used for landscape photography, especially when the vistas are especially distant. Selective focus generally isn't a tool you can use when photographing things that are, for practical purposes, located at infinity. However, the flattening effects of telephoto lenses can help you in several ways. You can compress a distant mountain range to make it seem as flat as a cardboard cutout on the horizon. The haze of the intervening atmosphere between you and your subject can add an interesting tone and texture to your photo. You can also capture details of distant objects that you might otherwise not be able to photograph up close. The waterfall shown in Figure 5.15 was visible from a footbridge that passed by, but was located on the other side of steep river banks that offered no easy access to a suitable viewpoint. So, I set up my tripod (for the long exposure that blurred the waters) and captured this image with a zoom lens set to 150mm.

Figure 5.15 The best view of this waterfall was from the other side of a rocky riverbank, so a telephoto lens was needed to take it all in.

Figure 5.16 Birds in flight can be captured with medium telephoto lenses. With really long lenses, you'll need a lot of practice to track them through the air.

Telephotos are also perfect for shooting wildlife, and are often the only practical way of grabbing a picture of creatures that aren't prone to waiting around while you set up and squeeze off a shot. A state park in my area has built a two-story "blind" with high walls and windows to view or shoot through. I go there frequently to take pictures of passing woodland animals and water birds, like the one shown in Figure 5.16. The lower level is covered and protected on three sides from the weather, while the upper level is open to the sky. A little patience and a long lens can yield wonderful results.

There are some creatures that are generally afraid of you and quick to hide, but others that, if hungry enough, are able to overcome their terror and snip off a few toes or stray fingers—or worse. Alligators roam wild in Florida, where the photo shown in Figure 5.17 was taken, but I preferred to use a telephoto lens for my close-up of this fellow, a resident of the St. Augustine Alligator Farm.

Figure 5.17 Although this gator was safely penned, I was happier snapping his photo with a telephoto lens that put a good amount of distance between us.

Teleconverters

Teleconverters are optical attachments that fit between your prime or zoom lens and your camera's body, providing additional magnification. They resemble extension tubes, but have optical elements that increase the lens's effective focal length. Teleconverters are available from third parties such as Kenko and Tamron, as well as from digital camera vendors. Both Nikon and Canon offer good-quality converters (Canon calls them "extenders").

The best quality teleconverters offer conservative magnifications in the 1.4X to 1.7X range, topping out at 2X. A few third-party vendors also offer 3X teleconverters, but they often reduce sharpness too much to be practical. Teleconverters also reduce the amount of light reaching the sensor. Unlike your camera's crop factor, a teleconverter does multiply your lens's focal length by its rated factor, so depth-of-field is slimmed down to match.

Here are the most important things to know about teleconverters:

◆ **F/stop loss.** Teleconverters reduce the amount of light reaching the sensor. A 1.4X converter costs you half an f/stop; a 1.7X converter reduces the light by 1.5 f/stops; a 2X by 2.0 f/stops; and a 3X by a whopping 3 f/stops. If your lens has a small maximum aperture to begin with, the light loss penalty might be too much. It's one thing to convert a 180mm f/2.8 lens into a 540mm f/5.6 super-telephoto with a 3X converter. But a 400mm f/6.3 lens transformed into a 1200mm f/18 lens that must be stopped down to f/32 to get acceptable sharpness is no bargain. In bright daylight you'd need to boost your dSLR's ISO setting to ISO 1600 to shoot at 1/400th second at the equivalent of f/32. Even with the camera locked down on a tripod, that might not be enough to eliminate camera/lens shake.

◆ **Autofocus performance may degrade.** Some cameras require an f/stop of f/5.6 or larger for the autofocus mechanism to work. With a 3X converter, your main lens will need to have a maximum aperture of f/2.8 to ensure proper autofocus. Even if autofocus does operate properly, teleconverters tend to reduce the contrast of the image, and contrast is what your autofocus system uses to zero in on

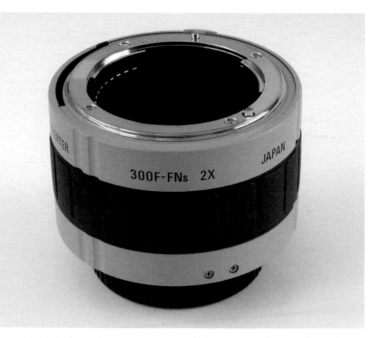

Figure 5.18 The best teleconverters are made by the manufacturer of your lens for specific sets of optics. Less expensive converters may work fine if you stop the lens down an extra stop or two.

correct focus. You might find that a given teleconverter can autofocus only with a limited number of non-zoom lenses. Should you choose to focus manually, you'll find the dimmer image difficult to focus with, too.

◆ **Lost sharpness.** All teleconverters cost you some sharpness. If the optics aren't first rate, you'll lose a little in the extra glass placed between your main lens and the sensor. More sharpness is lost because, with reduced light, you'll end up using an f/stop that may not offer the best resolution with your particular lens. If your camera isn't steadied with a tripod, more sharpness will be lost from camera shake. It's not uncommon to find that shooting an image without any teleconverter at all and then cropping in an image editor produces a better image. If you elect to use one of these attachments, you're better off with a high-quality 1.4X or 1.7X converter with at least four or five elements and special coatings to reduce flare.

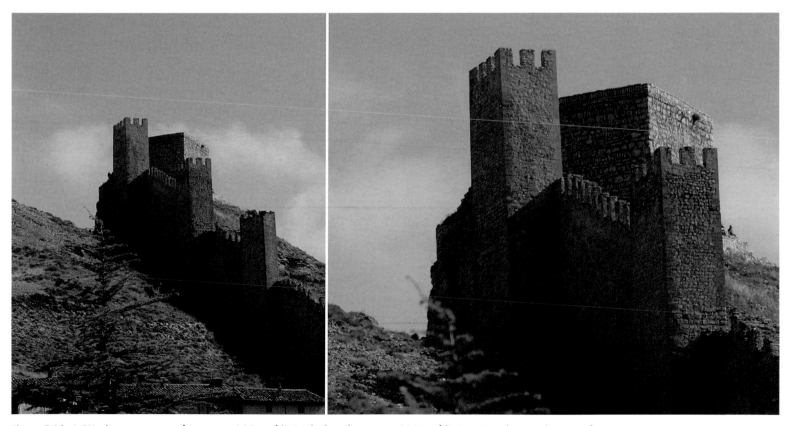

Figure 5.19 A 2X teleconverter transforms your 105mm f/2.8 telephoto lens into a 210mm f/5.6 optic with twice the magnification.

Telephoto Aberrations

Lenses can be plagued by a variety of optical aberrations, distortion, and anomalies, not all of which are the fault of the lens. Many of these can be fixed up nicely in Photoshop, or worked around with some clever compositional techniques. Here are the most common maladies facing users of telephoto lenses, and some tips for countering them.

◆ **Pincushion distortion.** This kind of distortion results in lines that are parallel to the edges of the image bowing slightly inward. It's commonly found in telephoto lenses, and can often be corrected in Photoshop using the Lens Correction filter. The opposite effect—barrel distortion—in which lines bow outward, is often found in wide-angle lenses.

◆ **Vignetting.** This is the darkening of the corners of an image and can result from mechanical, optical, and natural causes. Mechanical vignetting most often occurs when a lens hood is used that has too narrow a view for the focal length of the lens, especially if the lens is a zoom. A hood that properly shields the lens from extraneous light at the telephoto setting may intrude on the image when the lens is zoomed out to its wide-angle setting. A filter that is too thick for a lens (particularly a wide-angle lens) can also show up in the frame as vignetting. Optical vignetting is a property of any lens produced by illumination fall-off at the edges of the image. This effect is strongest when the lens is opened up to its maximum aperture, and when the subject matter is relatively contrasty. Natural vignetting is also caused by lens design, and afflicts wide-angle lenses more than telephotos. You can prevent vignetting by using the proper lens attachments, stopping down the lens to a smaller f/stop, and by using a tool like the Lens Correction filter in Photoshop.

Figure 5.20 This image has pincushion distortion, with lines bowing noticeably inward.

◆ **Chromatic aberration.** This is a kind of distortion caused by the inability of a lens to focus all the colors of light at the same point. This defect produces fringes of color around objects, and is most easily seen around backlit subjects. There are two kinds of chromatic aberration: *axial* (or *longitudinal*), in which the colors don't focus in the same plane and produce a colored halo around the subject and *transverse* (or *lateral*), in which the colors are shifted to one side. Preventing this kind of distortion, which is especially noticeable in telephoto lenses, is best tackled by the lens designer, but photographers can reduce axial chromatic aberration by stopping the lens down. Transverse chromatic aberration can sometimes be fixed by modules included with image editors like Photoshop (you'll find this tool in Adobe Camera RAW as well as the Photoshop Lens Correction filter). Figure 5.21 shows chromatic aberration at work.

Figure 5.21 Lateral chromatic aberration shifts some colors to the sides. In this extreme enlargement, you can see that magenta tones around backlit objects have been shifted to the right.

6 Using Wide-Angle Lenses

The perspective of wide-angle lenses provides a much more dramatic change than you get with telephoto optics. While telephotos offer magnification, a bit of distance compression, and depth-of-field that's useful for isolating subjects with selective focus, wide-angle lenses can create an entire array of special effects.

Photograph an object up close, and you can enjoy (or suffer from) interesting size distortion effects; point your camera upwards when snapping a photo of a tall object, and you'll end up with perspective distortion. Wide angles can emphasize the foreground, minimize objects in the background, and give you massive amounts of depth-of-field to embrace a deep image field. A small change in position can create a dramatic modification in the way your subject is framed. This chapter will introduce you to some of the cool things you can do with a wide-angle lens mounted to your digital SLR.

What Wide-Angle Lenses Can Do

There are five "special effects" that a wide-angle lens or wide-angle zoom can add to your images. You can use them alone, or in combination to produce very special images. Something as simple as shooting a subject from a high vantage point or down at ground level can give you a picture that is dramatically different from what you get with telephoto and "normal" focal length lenses. (Normal focal lengths are those from about 30mm to 38mm with a cropped—less than full frame—sensor, and 45 to 55mm on a full frame film or digital camera.) Here is a quick checklist of some of the things you can do with a wide-angle lens:

◆ **Give you room to move.** If you're shooting outdoors, you can quickly find yourself with your back to a wall, or needing to step into the street to move back far enough. Indoors, shooting an interior photo without a lens that's wide enough may be possible only if you go outside and shoot through a window!

But a wider lens or wider zoom setting makes it possible to fill the frame from a reasonable distance, and gives you room to move around for different angles even in tight confines.

◆ **Increase your depth-of-field.** Wide-angle lenses offer more depth-of-field at a given aperture than a telephoto lens. Of course, the fields of view and perspective differ sharply (if you step back far enough with a telephoto to take in the same field of view as a wide angle, the DOF is actually the same). But, as a practical matter, if lots of depth-of-field is your goal, a wide-angle lens is your best bet.

◆ **Emphasize foreground subjects and create distortion.** A wide-angle lens used for landscape photography emphasizes the foreground details while moving the distant scenery farther back from the camera. A wide-angle shot of distant mountains bordering a glassy lake shore might look dramatic. Or, you can get extra close to a living subject and create a distorted wide-angle look.

◆ **Broaden your field of view.** The wetlands area (like the one in Figure 6.1) is wide and dramatic, and you may need a wide-angle lens to take it all in.

◆ **Create interesting angles.** Too many photos are shot from the eye level of the photographer, and the resulting image is as mundane as the shooter's imagination. Crouch down and shoot up at your subject. Or, try climbing a ladder, scaling some stairs, or taking some other lofty vantage point to gain a new perspective as you change your viewpoint.

Wide-Angle Pitfalls

Wide-angle lenses have a few pitfalls to avoid, too. It's easy to fall into a trap that's lurking right there in your viewfinder:

◆ **Avoid unwanted size distortion.** Because you get closer with wide-angle lenses, you'll find that close subjects appear disproportionately large. Size distortion can be an interesting special effect, or can ruin your picture if it's unintentional. It may be a better idea to step back and use a slightly longer lens.

◆ **Align straight lines.** If the back of the camera is not parallel to the plane of your subject matter, you can end up with *perspective distortion*. Rotate the dSLR slightly, and vertical and horizontal features won't line up properly.

◆ **Watch for lens defects.** Wide-angle lenses often suffer from barrel distortion at the edges of their frames, with straight lines seeming to bow outwards. (The opposite of the telephoto lens's inward-bowing pincushion distortion.) You might even have vignetting or purple fringing around backlit subjects from chromatic aberration. Disguise barrel distortion by keeping subject matter with straight lines away from the edges of the frame; and fix vignetting (and sometimes chromatic aberration) in your image editor.

◆ **Avoid uneven flash.** Your camera's built-in flash unit probably doesn't cover the full frame of your widest lenses. Fix this problem by using a diffuser on the flash to spread the light, switching to an external flash unit with wider coverage, bouncing an external flash off a reflector or the ceiling, or using a slightly less wide zoom setting.

Figure 6.1 Wide angles give you a wider field of view, but make it important to watch that the straight lines (like the horizon in this shot) are properly aligned.

How a Wide-Angle Lens Works

In the last chapter, you learned that a *telephoto* design shortens the optical path so that a long lens can be physically smaller than its focal length would indicate. Wide-angle lenses have the reverse problem: the true focal length may be so short that with the most simple lens design the lens must be physically very close to the sensor surface to focus properly. (See Figure 6.2.) Because the swing-up mirror gets in the way, a type of lens that is sometimes called a *inverted telephoto* or, more commonly, a *retrofocus* lens arrangement is used. As you might guess, the lens elements are arranged like a backwards telephoto lens in order to make the physical length of the lens *longer* than its absolute focal length.

As I noted in Chapter 4, a lens that has a long focus distance tends to create a physically long lens, one that can become unwieldy once its focal length exceeds, say, 100mm (about four inches). Using negative elements to move the optical center out in front of the lens, so that the size of the lens can be shorter than the effective focal length, produces more compact telephoto lenses. Wide angles have a focal length that's too short. For example, with a 25mm wide-angle

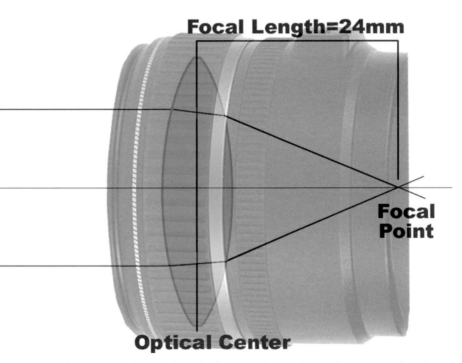

Focal Length=24mm

Focal Point

Optical Center

Figure 6.2 With a simple wide-angle lens, the focal length might have a focal point only a short distance from the back of the lens, not leaving enough room for an SLR's swing-up mirror.

lens, the distance from the optical center of the lens to the focal plane is almost exactly one inch. That sounds cool on first consideration (hey, a one-inch long lens would be remarkably compact!) but isn't practical from a technical standpoint.

The distance from the lens mount to the sensor (located behind the flip-up mirror) is *less* than an inch, so, an ordinary 25mm lens would have to extend far back into the body cavity of the camera, leaving no room for the mirror. Instead, the retrofocus design uses one or more negative lens elements placed *in front* of the positive element, spreading the beam of light so that when the positive lens element focuses it again on the sensor, the focal point is much farther back than it would be otherwise. The optical center has been moved *behind* the center of the lens, as you can see in Figure 6.3.

You can see that an inverted telephoto design helps digital camera lens designers produce wide angles that are physically "longer" than their focal lengths, just as the traditional telephoto configuration produced lenses that were physically "shorter" than their focal lengths. Indeed, the "shorter" a wide-angle lens for an SLR becomes the longer and larger it often must be to accommodate all the extra lens elements required. This size increase for wide-angle lenses is even more acute with optics designed for dSLRs with smaller than full-frame sensors, because even more elements must be used to achieve the same field of view.

For example, while an 18mm focal length serves perfectly well as a super-wide-angle lens for a full-frame, 24mm x 36mm sensor, a camera with a smaller sensor and a 1.5X crop factor requires a more complex lens with a 12mm actual focal length to achieve the same field of view.

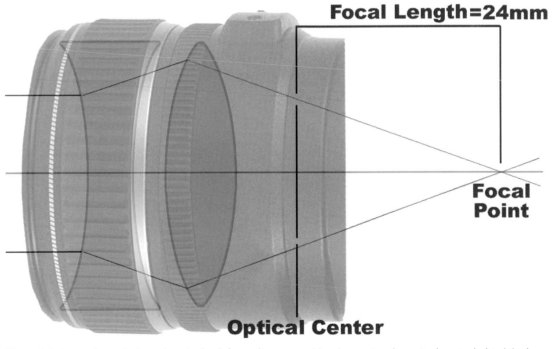

Focal Length=24mm

Focal Point

Optical Center

Figure 6.3 A retro-focus design solves the back focus distance problem by moving the optical center behind the lens, increasing the distance between the lens and the focal plane, even though the focal length remains the same.

Choosing a Wide-Angle Lens

Chapter 5 had an extensive section on choosing the right telephoto lens. Many of the considerations discussed there apply equally to wide-angle lenses, so I'm not going to repeat all that information here. Instead, I'll recap some of the key points as they relate to wide angles, because there are a few differences between long and short lenses when you're shopping for the right optics. To review, the major considerations are:

◆ **Image Quality.** As with telephoto lenses, the quality of the images produced by a wide angle is likely to be your number one selection criterion. You're wasting the 10 or 12 megapixels your sensor can capture if your lens focuses a fuzzy image on its surface. You'll find sharpness useful even if you aren't making huge prints; a high quality wide-angle lens can let you crop a small picture from a larger one, as you can see in Figure 6.4. You want raw resolving power, of course, but freedom from various optical distortions, especially barrel distortion, is particularly important. You'll want a lens that's relatively free from chromatic aberrations, too.

◆ **Aperture range.** The maximum aperture determines how readily you'll be able to shoot under low lighting conditions hand-held. Tripods are used less often with wide lenses than with telephotos because their shorter focal lengths don't magnify camera shake as much. (Although a tripod is still a good idea for architectural/interior work to help you compose your image tightly.) With all that hand-held work ahead of you, you'll want a fast wide-angle lens. Maximum apertures of f/1.4 or a little slower are available for 28mm and slightly longer wide-angle prime lenses, and f/1.8 and f/2.0 lenses are also common in this range. If your camera's crop factor doesn't convert such an optic into a "normal" lens, you can work effectively in relatively dim light, as the extra depth-of-field works for you when you're using those wide f-stops. The *smallest* f-stop available is less important with a wide-angle lens from a depth-of-field standpoint, but you still will need f/22 or smaller to cut down bright light and enable slower shutter speeds when you need to. Wide-angle zooms have the same aperture limitations as their longer cousins, so don't be surprised to see f/4-f/5.6 maximum apertures on these complex lenses.

◆ **Constant aperture.** Expect to pay a premium for a wide-angle zoom that doesn't change its maximum aperture when it zooms. One vendor's 18mm-55mm budget wide-to-short-tele zoom (less than $300) varies from f/3.5 to f/5.6 over its zoom range. The same manufacturer also offers a 17mm-55mm f/2.8 lens for about $1,000 more. It happens to be sharper and better built, but part of that premium comes from the more sophisticated design that allows a constant aperture.

◆ **Zoom or prime.** As with lenses in the normal and telephoto range, wide-angle optics that can zoom through a range of focal lengths are heavier, slower, and sometimes not as sharp as fixed focal length prime lenses (unless they're very expensive). Yet, zooms can't be beat for convenience. Use a prime lens when you need the sharpest image and largest maximum aperture. Primes can be extra compact, too, but, in the wide-angle arena, they're not likely to be especially inexpensive. Vendors realize that anyone purchasing a prime lens rather than a zoom is likely to place a premium on image quality and speed, so they lavish a great deal of attention on their wide-angle designs. And that means the lenses aren't cheap.

◆ **Autofocus features.** Because wide-angle lenses boast so much depth-of-field, you might think that autofocus accuracy and speed aren't as important. Not so. Correct focus is correct focus regardless of the focal length used, and you want your image accurately focused when you're using a wide-angle lens. If anything, autofocus is more critical, because the broad focus range provided by

wide-angle lenses reduces the contrast factors in an image that an autofocus system uses to zero in on the right setting. (Wide angles can be more difficult to focus manually for the same reason; everything may *appear* to be in focus, even if focus is a little off.)

◆ **Construction quality.** There's really not a lot of difference in the importance of good build quality between telephoto and wide-angle lenses. Both types of optics work best when all the parts are built to fine tolerances and fit together well for smooth operation under moderate to heavy use. If you don't plan on using your wide angle much, you may be able to save money with an inexpensive brand.

When selecting a lens, remember that lenses don't become obsolete as quickly as camera bodies, so you shouldn't hesitate to spend a little more to get a quality product. Five years from now when you're spending $500 for a 21-megapixel dSLR, your current lenses may work just as well with the new camera body.

Figure 6.4 A lens that is sufficiently sharp provides enough detail that you can crop extensively and still have an acceptable image.

Using Size Distortion

One characteristic of wide-angle lenses is the way they seemingly distort the relative size of objects. Subjects closer to the camera seem much larger than objects that are actually only a little farther away. Size distortion can be annoying when it's unintentional—say, when you use a wide lens to shoot a human face—but can create some interesting effects in other circumstances. If you have trouble picturing exactly what this effect will do to your photos, check out the Old Dobbin in Figure 6.5.

While a horse may not view such an unflattering portrait and vote "neigh," humans are not so tolerant. If you get too close with a lens that is too wide, your subject's nose will appear too large in relation to the rest of the face, and the ears will seem to be much too small.

But size distortion can be used to add drama. For Figure 6.6, I got close to the front of a classic Chevy coupe and shot with a 12mm wide-angle lens. The combination of my proximity and the extreme wide-angle optic enlarged the apparent size of the features on the front of the automobile, emphasizing the grille, headlamps, bumper, and hood, while allowing the rest of the car to trail off into the distance. In this case, size distortion drew attention to the parts of the subject that I wanted to capture.

Figure 6.5 A wide-angle lens offers an interesting, if distorted, perspective when you get in close to your subject—human or animal.

Figure 6.6 An extreme wide-angle lens distorts the shape of this classic car in a creative way.

Emphasizing the Foreground

A wide-angle phenomenon that goes hand-in-hand with distorting the size of objects in the foreground is the tendency to *emphasize* those objects even if their relative size doesn't seem bizarre. Any time you use a wide-angle lens, the background will seem farther away and less important, while the foreground will take up more area, in comparison.

At the top in Figure 6.7, I photographed a dry stream bed at eye level with at a barely-wide 24mm focal length, which gave just about equal emphasis to the foreground and middle ground. Then I switched to a wide 14mm focal length (21mm on a full frame camera) and got down at ground level for the version shown at bottom. Now the foreground is emphasized at the expense of the receding background subject matter. Because there is nothing to provide scale in the picture, the fact that the rocks and gravel in the stream bed have become much larger than they appeared in real life isn't immediately

noticeable. Foot-long rocks have become huge boulders that are the center of attention. The photograph is a lot more interesting shot from this angle with this lens.

Another example of using a wide angle to emphasize the foreground is shown in Figure 6.8. It was taken with an 18mm lens (27mm equivalent) of a stately *faux* castle, built in the United States from an original design in 1904. The grounds of this former mansion are beautiful, and I wanted to emphasize the brickwork and stairs that, in this photo, seem to lead up to the front door. In truth, the castle lies 50 yards farther up the hill, but the angle I used, combined with the wide-angle perspective, helps to unify the foreground and background.

You can see how use of the wide-angle lens provides extra depth and a three-dimensional feel. You can emphasize this by getting down low, as I did for the castle photo (because the grounds sloped away from the façade of the building).

Figure 6.7 A conventional view emphasizes neither foreground nor background (top); a low angle and a wide-angle perspective puts the focus on the rocky dry stream bed.

Figure 6.8 A wide-angle view emphasizes the foreground landscaping in this photo.

Working with Perspective Distortion

Perspective distortion is the convergence caused when the camera is tilted so that the plane of the sensor is not parallel to the plane of the subject. It's most commonly seen in architectural photos and with other types of subjects that have straight lines that make this convergence obvious. Often, the camera is tilted back to take in the top of a tall building or structure, which then appears to be falling backwards, as you can see in the unfortunate photo shown in Figure 6.9. This Florida lighthouse was surrounded by tall hedges on three sides, and the large lighthouse keeper's home on the remaining flank. Moving back to take its photo would have yielded nothing more than the top half towering over the hedges. Even with my widest lens (a 10-17mm fisheye zoom) mounted on my camera, I had no recourse but to tilt the camera. The lighthouse was

Figure 6.9 There wasn't a lot that could be done to avoid converging lines in this photo if the entire lighthouse was to be included in the shot.

an historic landmark, and I wanted to capture the façade because of its architectural interest, so I fired away, knowing there was no easy fix for this photo.

I had greater hopes for the images shown in Figures 6.10 and 6.11, of an impressive Roman arch located on a hilltop overlooking a valley. The tilted view was fixable using the Lens Correction tools built into Photoshop (most image editors have similar tools). This photo provided more to work with, because there was plenty of room around the arch itself within the shot to allow perspective correction. I was able to stretch and tilt parts of the image to bring the straight lines (mostly) back into the desired parallel orientation.

Figure 6.10 The two-way perspective distortion in this shot of a Roman arch can be fixed easily in an image editor.

Figure 6.11 The edited version is a great improvement with all the straight lines lined up as they should be—mostly.

Using Depth-of-Field

Another characteristic of wide-angle lenses you can put to good use is the generous depth-of-field provided even at relatively large f/stops, which can allow you to use a faster shutter speed in difficult lighting. For example, Figure 6.12 was taken in an old Moorish edifice under what I'd describe as available darkness. Tripods were not permitted, so I got away with using a monopod for a 1/30 second exposure at 12mm (18mm full frame equivalent) at f/4 (despite pushing my camera's sensitivity setting to ISO 1600). There was still enough depth-of-field that all the receding columns were sharp with the lens wide open.

A tripod and a wide-angle lens make a good team when you're trying to push depth-of-field to its limits. Figure 6.13 shows a display of 2,500 American flags erected in a park in commemoration of the 9/11 attack, and in support of our troops abroad. It was photographed with a 12mm lens (18mm equivalent on a full

Figure 6.12 A monopod, a wide-angle lens, and an exposure of 1/30 second at ISO 1600 made this shot possible.

frame camera) at f/8 for two seconds. The flags were actually fairly dimly lit, solely by light that spilled in from spotlights erected at the periphery of the memorial. I didn't want to increase the ISO past 400, because my camera produces more noise at higher ISOs than anyone would find acceptable. The two-second exposure was about as long as I dared to use, even with the camera mounted on a tripod, because the flags had a tendency to flutter in the breeze. Fortunately, my lens is sharp at f/8, and thanks to the miracle of wide-angle depth-of-field, the zone of sharpness was extensive enough at that f/stop to bring virtually everything in the photo into sharp (enough) focus.

Take advantage of your wide-angle lens' bountiful depth-of-field characteristics when you photograph subjects that can benefit from an extended zone of sharpness. Sometimes you'll want to use selective focus to isolate subjects, but other times you'll want to render a large area of your image sharply, and that's where wide angles are particularly useful.

Figure 6.13 A wide-angle lens, a tripod, and a two-second exposure yielded a sharp photo at f/8.

Fisheye Lenses

All wide-angle lenses have at least some tendency towards the outward bowing of straight lines called barrel distortion. Most of the time, the designers of the lens try to correct this defect, but, sometimes, it is exaggerated to produce a lens that deliberately produces curving lines, creating what can be called a *curvilinear* lens (from the Latin for curved lines). This kind of "turning a bug into a feature" produces the so-called *fisheye* and *semi-fisheye* lenses, which are so-named because they resemble the bulging eyes of fish and not because, as far as we know, this curvy view is the way fish actually see.

A true fisheye lens produces a round image (one that doesn't fill the frame) that encompasses a field of view of 180 degrees (or more) horizontally, as shown in Figure 6.14. As I noted in Chapter 3, they were originally designed to image an entire hemisphere, such as the canopy of the sky, or to take photos inside very

tight quarters, such as boilers, allowing engineers to examine the interiors of components that can't easily be viewed using conventional optical systems.

Semi-fisheye lenses create distorted, rounded images, but do

fill the frame, providing the same kind of intentional distortion but in a less dramatic, but often more practical way, because true fisheyes can alter a subject so much that it's no longer recognizable. Both kinds of fisheye lens are most often used today for

creative purposes, because of the special perspective they offer. A semi-fisheye shot is shown in Figure 6.15.

Technically, a fisheye lens creates its look because the focal length of the lens varies radially outward

Figure 6.14 A true fisheye lens produces a circular image.

Figure 6.15 Semi-fisheye lenses are popular because they produce a (slightly) less extreme image with reduced distortion.

from the center of the field of view. Objects in the exact center are rendered in somewhat normal fashion at the nominal focal length of the lens (that is, 7.5mm, 10mm, 16mm, and so forth), while the focal length decreases as you move outward from the center until, in the case of true fisheyes, the image detail at the edge becomes so tiny that it actually fades from view. Because of the way a fisheye lens operates, straight lines that radiate from the center remain straight, while other lines curve outward.

Fisheye lenses are available in several forms. You'll get the best optical quality from a fisheye prime lens, available in focal lengths from 4.5mm to about 10mm, but these can be expensive (up to $600 or more). Tokina offers a fisheye zoom lens that goes from really fishy (at 10mm) to only slightly curvy (at 17mm). Figure 6.15 was taken with this lens at its freaky 10mm extreme. Like most of today's fisheye lenses, the Tokina zoom is designed solely for cameras with smaller than full frame sensors. Its built-in lens hood produces an odd, keyhole shaped partial-frame image when the

lens is mounted on a full frame cameras.

A fisheye effect can also be gained from special attachments that screw into the filter threads of a conventional lens to produce an extra-wide, fisheye look, as discussed in Chapter 3. Although the sharpness of such a lens may not equal that of a prime fisheye, if you just want to play around and don't plan on using a curvilinear lens enough to justify the cost of an expensive model, the attachment type can be a lot of fun. When considering any fisheye lens, keep in mind your particular camera's crop factor. A full-frame fisheye might be converted into a semi-fisheye, and a semi-fisheye lens transformed into nothing more than a wide-angle lens that curves a lot at the edges.

Some semi-fisheye lenses can be used effectively as a super-wide-angle ersatz rectilinear lens if you have software that can correct for the curved distortion. DxO Optics, Nikon Capture NX, and numerous shareware, freeware, and trialware programs also can perform this "de-fishing" function.

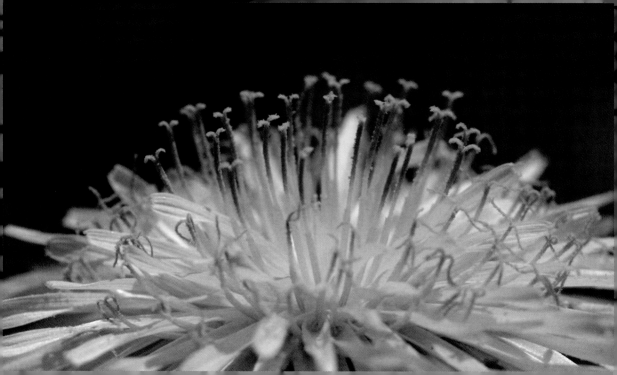

7 Using Macro Lenses

Macro, micro, and close-up lenses are indispensable when you want to capture an intimate portrait of a blossoming flower, the fine detail of an exquisite antique timepiece, or a product shot of a small component for your company's catalog. Digital SLRs are perfect for this kind of photography because they simplify framing and focusing close-up subjects, and, thanks to interchangeable lenses, can be fitted with optics that are specially designed for this kind of work. Even so, you don't need to buy expensive special lenses to shoot macro images, as the lenses you already own might be up to the task if fitted with an inexpensive close-up attachment. Or, that $99, 50mm f/1.8 lens can be adapted easily for this kind of photography. Your dSLR has a leg up on film cameras (even if both are outfitted with identical lenses). In the film era it was common for professional photographers to shoot Polaroid images of product setups to preview lighting and other image attributes. With a digital SLR, you can see the results of your efforts in seconds, make any changes necessary, and then shoot again, if required.

This chapter explains exactly what you should look for in lenses and accessories that will let you get great close-up, macro, and product photos.

Magnification

Although point-and-shoot cameras usually tout how close they can focus, as a macro photographer you'll be more interested in the *magnification* of the subject in your finished picture. Lens A, a 50mm f/1.8 prime lens, happens to focus to within four inches of the subject. Lens B, an ordinary 100mm telephoto, focuses only to eight inches, and Lens C, a 200mm macro lens, focuses to sixteen inches. Which would you choose to photograph your stamp collection? You might be surprised to realize that *all three* lenses will produce exactly the same size image at their respective closest focusing distances. A 50mm lens at four inches, a 100mm lens at eight inches, and a 200mm lens at sixteen inches

all produce *exactly the same* magnification, so your philately photography will have the same image size on your sensor. You can see another example, using doughnuts, in Figure 7.1.

Given the three lenses in the example, the 200mm macro lens would be your best choice. It's already designed to produce good results at close distances, whereas your telephoto lens might be optimized for distant subjects. It's likely that your 50mm f/1.8 prime lens would do an acceptable job, but that four-inch focusing distance could complicate illuminating your stamps evenly. Beginning macro photographers always want to know how close they can get to their subject, even though, most of the time, it's the focal length of the lens and the magnification you achieve that's more important than the raw distance between your lens hood and the subject you're shooting.

With a flat subject like a postage stamp, there really isn't much of an advantage with using one lens over another with the same magnification, other than the ease of lighting. That's not true of other types of subjects, as you'll see in the next section on perspective. Because final image size depends on both the lens focal length and distance to the subject, magnification is the most useful way of expressing how an image is captured with macro photography. If your magnification is 1X, the object will appear the same size on the sensor (or film) as it does in real life, completely filling the frame. At 2X magnification, it will be twice as big, and you'll only be able to fit half of it in the frame. At .5X, the subject will be half life-size and will occupy only half the width or height of the frame. These magnifications are most commonly

referred to as ratios: 1X is 1:1, 2X is 2:1, .5X is 1:2, and so forth. As you work with close-up photography, you'll find using magnifications more useful than focusing distances.

In fact, macro lenses often use the magnifications they provide as an important specification. One macro lens will be advertised as providing 1:2 magnification, while another is listed as offering 1:1 (or 1X) magnification. You'll even see some "macro" zoom lenses listed with, say, 1:4 magnification even though such paltry capabilities barely qualify as macro specifications at all. Still, magnification figures provide the most useful way of comparing lenses and accessories based on their real-world close-up performance.

Figure 7.1 Taking a photo from a few inches away with a 50mm lens (top) produces the same size image as one captured at double the distance with a 100mm lens of twice the focal length.

Perspective and Subject Distance

Perspective must be taken into consideration when you photograph subjects that are not flat like pancakes (or postage stamps). While lenses of different focal lengths may provide the same amount of *magnification* at distances proportionate to their focal lengths, they don't provide the same *perspective*. Parts of a subject that are much closer to the lens, relatively speaking, than other parts are rendered much larger.

Just as noses grow in apparent size and ears shrink when shooting portraits with a wide-angle lens, if you're taking a macro photograph of, say, a small figurine, the portions of the figurine closest to the lens will look oversized when using a macro lens with a shorter focal length, and more normal when shot with a macro lens having a longer focal length. That's true even if the magnification provided in either case were exactly the same.

You can see how this works by studying Figures 7.2 and 7.3 carefully. The former was taken with a wide-angle lens, while the latter was shot from the same angle twice as far away, with a lens having twice the focal length. As in Figure 7.1, the subjects in the two versions are about the same size. However, you can see the perspective differences more clearly. See how, in Figure 7.2, the flower in the clown's hat is partially hidden behind his tuft of hair, because the lens was so close to the figurine that the hairline actually obscured part of the flower? Yet, from a greater distance, the flower is completely visible, even though the angle from the camera to the figurine was kept the same. See how the clown's nose is larger in Figure 7.2—because it's closer to the camera—even though, overall, the face seems to be narrower than in Figure 7.3? Similarly, the ears are smaller in

the first version than in the second. You need to take these perspective differences into account when shooting three-dimensional subjects.

◆ **Perspective.** Longer lenses may provide a more natural perspective for three-dimensional objects. Many photographers (myself included) own several macro lenses. I use my compact, convenient 55mm macro lens when appropriate, and turn to my 105mm macro lens when I need its perspective (or other characteristics described next).

◆ **Distance.** I've already mentioned twice that a macro lens with a longer focal length can be used at a greater distance to achieve the same magnification as a lens with a shorter focal length. That's why close-up lenses used for medical photography often have 200mm or similar focal lengths. When photographing surgical procedures, for example, the proper distance from the surgical field must be maintained not only to avoid interfering

with the medical team, but to preserve sterility. Other times, you'll be photographing living creatures that are difficult to approach closely, and that distance can be important. Most wild creatures become apprehensive when a photographer pokes a macro lens at them from a couple inches away. Others, like hummingbirds, butterflies, or tree frogs may flee entirely. In such cases, you'll find that a 100mm, 200mm, or other longer focal length lens can provide the perfect combination of magnification and subject distance.

◆ **Ease of lighting.** When you're shooting three-dimensional objects, one thing you'll have to contend with is the need to illuminate your subject. A longer focal length gives you more room to place lights or even simply to allow the existing lighting to make its way to your subject. (There are special lights, called *ringlights* that wrap around the front of the lens to provide diffuse, even lighting even at close distances.)

◆ **Extra magnification.** When using conventional macro lenses, getting closer and closer to your subject to increase magnification requires increasing the distance between the elements of the lens and the sensor. For example, a 55mm lens might require 55mm of extension to produce a 1:1 magnification, and 110mm of extension to create a 2:1 magnification factor (both with full frame digital or film cameras). To get the same magnification with a 200mm macro lens, you'd need 200mm (four inches) of extension for 1:1 and a whopping 400mm (eight inches!) for 2:1 on a full-frame camera.

When you're shooting tabletop setups, especially product shots or things like architectural models, perspective and lighting become especially important. Use the right macro lens and distance, and your perspective and lighting will be realistic and flattering. Use the wrong macro lens (say, one with too short a focal length) and your model may more closely resemble a badly lit mockup.

Figure 7.2 The perspective in this close-up taken with a wide-angle lens from a few inches away displays the typical large nose and smaller ears produced with human subjects—or their representations.

Figure 7.3 This shot, taken from twice the distance with a lens having double the focal length, has a wider face, smaller nose, and larger ears among the changes caused by perspective.

Depth-of-Field

Depth-of-field is most important when working with three-dimensional objects. You probably don't need much when you're photographing stamps and coins, but will require a great deal more for your product photography or those shots of your porcelain figurine collection.

Available DOF is related to the focal length of the macro lens you use; that is, a 50mm macro lens will have more depth-of-field at a given *distance* than a longer lens. However, for a particular subject size on the sensor (the magnification), you'll find that depth-of-field will be similar, so it will not be an overriding factor in choosing the focal length of your lens. All lenses have limited depth-of-field when used to photograph subjects up close, so you'll have to

Figure 7.4 Wide open (left), there is very little depth-of-field; the range of sharpness is deeper at f/8 (middle); at f/22, several rows of crayons are in focus.

deal with it whether you're using a short macro, telephoto macro, or tele-zoom macro lens, as well as ordinary lenses pressed into service for close-ups. Choose your focal length based on perspective and appropriate distance first, and the magnification you hope to achieve.

Of course, the depth-of-field provided by a given lens is also related to the f/stop used, with larger f/stops providing less DOF, and smaller f/stops offering more. However, as a general rule of thumb, figure that you'll want to use a small enough f/stop to provide ample DOF in most cases, unless you're using selective focus as a creative tool. If you'd like to preview the depth-of-field that your image will have, most dSLRs have a button that can be depressed to stop the lens down from the viewing aperture (which is always wide open) to the f/stop that will be used for the actual exposure. This DOF preview can provide a more accurate look at how deep the zone of focus will be, although stopping down the lens also makes the view dimmer and harder to see. Other cameras have no DOF button at all.

Figure 7.4 shows three examples of the depth-of-field you might expect when focusing on the yellow-green crayon in the middle. At f/2.8 only the "featured" crayon is in focus, as you can see at left. When the lens is stopped down to f/8, some of the crayons in the foreground and background come into focus (center). At f/22 (right), several rows pop into sharper focus. You'll want to use the smallest f/stop you can when lots of depth-of-field is needed for your close-up photos, such as the shot of the fire hydrant in Figure 7.5.

Figure 7.5 This dramatic view of a fire hydrant was snapped with a 12mm ultra-wide-angle lens positioned just a few inches away from the fixture. The extra depth-of-field the lens offered allowed everything in the frame to be sharply focused.

Using Your Existing Lenses

When you begin taking close-up pictures, you probably won't already own a special macro lens. For practical or budgetary reasons, you may want to press your current optics into service. There's no need to purchase a macro lens until you decide that this type of photography is something you want to investigate more deeply, and you find that the lenses you already own can't produce the results you want.

Fortunately, your current lenses, even zoom lenses, can be used for macro photography if they focus closely enough. Although these lenses aren't designed to produce optimum results at close range, they'll frequently provide pleasing results. If they don't focus closely enough, I'll show you how to enable them to focus closer using close-up attachments, extension tubes, and other accessories later in this chapter. Here are some tips for sizing up possible candidates among your lens collection:

Figure 7.6 Some close-up subjects concentrate all the interesting subject matter in the center of the frame.

◆ **50mm prime lens**. The basic "normal" lens in a 50-55mm focal length and an aperture of f/1.4 to f/2 is a holdover from the film era, when such optics were often furnished with a camera by default. With cameras having a 1.5X or 1.6X crop factor, these 50mm lenses are actually short telephotos, but they have the advantage of being very high quality and, thanks to the efficiencies of mass production, quite inexpensive. That $100 50mm f/1.8 lens just may be the sharpest lens you own, for macrophotography, portraits, or general picture taking. These lenses (as well as other prime lenses) can be reversed, used with close-up attachments, and otherwise function flexibly in macro work.

◆ **Other prime lenses.** Wide-angle prime lenses in the 24mm to 35mm range can be your second choice for double duty. Many of them focus as close as a few inches even without additional accessories. Even longer lenses, such as 85mm to 105mm optics, can make good macro lenses when coupled with some of the aids described later on that allow them to focus closer. Prime lenses usually are fairly sharp across their entire field of view, even in the corners, so they can be used both for flat subjects (stamps and coins,

again), which benefit from corner-to-corner sharpness, as well as three-dimensional objects, such as flowers, hobby items, small animals, and so forth, which may concentrate all the interesting subject matter in the center of the frame, as in the photo of a two-inch vase pictured in Figure 7.6.

◆ **Zoom lenses.** Your existing zoom lenses may also function as macro lenses, but you'll need to evaluate their performance before using them for critical work that cannot be reshot if the results displease you. The chief drawbacks of using zoom lenses for macro work is that they rarely focus close enough, and the more affordable lenses are likely to have maximum apertures in the f/4.5-f/6.3 range. There are exceptions, of course. I own a 17-35mm f/2.8 lens that focuses down to less than a foot, enabling me to fill the frame with a single flower blossom (or, as shown in Figure 7.7, a few oranges) at the 35mm setting. Its f/2.8 aperture is large enough to make automatic or manual focus easy. Avoid lenses with extreme zoom ranges: an 18-250mm or 50-500mm zoom is unlikely to make a good macro lens. You'll find that most zoom lenses don't perform well when reversed (as described later in this chapter), either.

Figure 7.7 These Valencia oranges (at least, they were photographed near Valencia, Spain) were captured with a wide-angle lens that focuses to less than one foot.

Using Macro Lenses

These are lenses designed especially for close-up photography, in focal lengths from about 50mm to about 200mm. I've already outlined earlier why it's useful to have macro lenses in a variety of focal lengths to increase distance and optimize perspective. Specialized macro lenses include features like smaller minimum f/stops (f/32 or f/45 apertures are not that unusual), longer focusing barrels to allow increasing magnification without the need for attachments, conveniently placed controls to allow switching into macro focusing mode, and "limit" switches that confine the lens's autofocus mechanism to either the close-up or the normal focusing range so your camera won't "hunt" needlessly back and forth. Of course, most importantly, such lenses have optics that are optimized for sharp close-up images.

Macro lenses can cost a few hundred dollars or more than $1,000, depending on the lens and its capabilities. If the expenditure gives you pause, remember that a macro lens can also be used for non-macro work. That 105mm f/2.8 macro lens (like the one shown in Figure 7.8) is a fairly fast medium telephoto lens, too.

As I mentioned under the section on perspective and subject distance, your choice of a focal length for your macro lens will depend on what kind of photographs you take. I used my 105mm macro to shoot birds like the parrot shown in Figure 7.9. This particular avian wasn't particularly frightened of humans who visited his zoo environment, but he was a lot happier having me stand back at arms' length when shooting his close-up, rather than poking a shorter macro lens right up to his cautious eyeball.

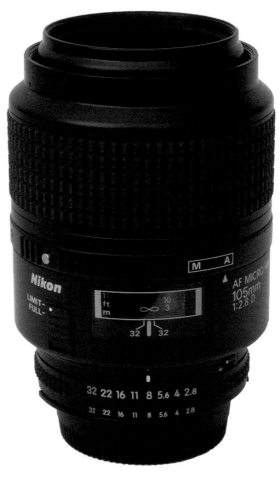

Figure 7.8 A short telephoto macro lens, like this one, is a good choice for photographing macro subjects from six inches to a foot or more away.

Features to look for (or to avoid) in a macro lens include:

◆ **Autofocus.** Most newer macro lenses will focus automatically with your digital SLR camera. However, if you're looking to save some money, you can often find older manual focus macro lenses for very little money. Older Nikon-brand Micro-Nikkor lenses from 30 years ago can cost as little as $50, and will work just fine on newer Nikon digital SLRs (although automatic metering is possible only with Nikon's mid-level and pro dSLR bodies). Because macro photography is often done with the camera locked down on a tripod, while the photographer painstakingly frames the photo, manually focusing is no big deal. Some even *prefer* to focus close-up shots manually, and turn off the autofocus feature in lenses that have it.

◆ **Image stabilization.** There are a few macro lenses that have image stabilization/vibration reduction built-in. (And keep in mind that cameras with in-body IS add that feature to any macro lens

you might use.) The anti-shake feature can be very handy when shooting macro photos hand-held, because that image you're exposing at 1/60 second and f/11 will have the same steadiness (at least in the camera) as one taken with a shutter speed of 1/250 or 1/500 second and the same f/stop. However, IS is not a panacea, and may not even be useful for most close-up photographers. You still have to worry about subject movement, which, thanks to unexpected breezes, can be the number one vexation facing outdoor plant and flower photographers. In addition, if you want to use a tripod to steady your camera and help ensure precise framing, image stabilization may not even be needed.

◆ **Small minimum f/stop.** Every macro lens you consider will have a minimum f/stop of at least f/22. If f/32 or even f/45 are available, that's a plus. Depth-of-field is so scarce at close-focusing distances that you'll take all you can get, and not even think twice about the minor sharpness loss that diffraction brings.

Figure 7.9 This parrot was happy to have me keep my distance when I shot his close-up.

Close-up Attachments

Although they are called *close-up lenses*, these popular macro accessories aren't generally used as stand-alone lenses. They are actually filter-like attachments that screw onto the front of a conventional lens and enable it to focus closer. Technically, close-up lenses *are* simple lenses; they just lack the mounts and focusing mechanisms that would allow you to use them all by themselves. Instead, they must always be used attached to another lens.

Close-up lenses, like the one shown in Figure 7.10, are generally labeled with their relative "strength" or magnification, using a measure of optical power called "diopter." The diopter value of a lens measures its refractive power, expressed as the reciprocal of the lens's focal length in meters. A diopter with a value of 1 would, all by itself, focus parallel rays of light at one meter; a 2 diopter would focus

the light at 1/2 meter, and a 3 diopter would focus the light at 1/3 meter.

Of course, these lenses aren't used all alone when serving as close-up attachments for camera optics. To calculate their close-focusing abilities, you need to factor the close-up device's magnification power with the actual focusing abilities of the lens. In this configuration, close-up lenses are available in magnifications from +1 diopter (mild) to +10

Figure 7.10 Diopter lens attachments can add close-focusing capabilities to non-macro lenses.

diopters (strong). The actual formula used to calculate the effect of a diopter lens is:

Camera Focal Length/ (1000/diopter strength)= Magnification at Infinity

Therefore, a +4 diopter mounted on a 125mm lens would work out to 125/(1000/4)=0.5, or half life-size *when focused at infinity*. Magnification is larger when a lens equipped with a diopter attachment is focused even closer. For example, if a 50mm lens normally focuses as close as one meter (39.37 inches; a little more than three feet), a +1 diopter will let you focus down to one-half meter (about 20 inches); a +2 diopter to one-third meter (around 13 inches); a +3 diopter to one-quarter meter (about 9.8 inches); and so forth. If your lens normally focuses closer than one meter, you'll be able to narrow the gap between you and your subject even more. Close-up lenses can let you grab extreme

macro shots like the one shown in Figure 7.11.

Diopter attachments can be stacked to provide greater magnification. You can purchase several close-up lenses (they cost roughly $20 each and can often be bought in a set) so you'll have the right one for any particular photographic chore. You can combine several, using, say, a +2 lens with a +3 lens to end up with +5, but avoid using more than two close-up lenses together. The toll on your sharpness will be too great with all those layers of glass. Plus, three lenses can easily be thick enough to vignette the corners of your image.

The key factors to consider when using diopter attachments are these:

◆ **Quality varies.** As with filters, the quality of construction and the glass itself can vary from vendor to vendor. While most filters are simply flat pieces of glass with an antireflection coating, and then

mounted in a frame, diopter attachments are true lenses. So, the quality of the lens can impact the quality of your final image, particularly if you do choose to stack a pair of them together. More expensive diopter lenses may consist of more than one element, such as the two-element diopters known as *achromats*.

◆ **No effect on exposure.** Close-up lenses have virtually no effect on exposure, which is not true with other macro options that increase magnification by lengthening the distance between the lens and the sensor.

◆ **Works with multiple lenses.** A diopter attachment can be used with any lens having a compatible filter thread size or appropriate step-up or step-down ring.

◆ **May cause vignetting.** As with filters, a close-up lens or stack of lenses can cause vignetting.

◆ **No infinity focus.** With a close-up lens attached, your lens will no longer focus to infinity; it can only be used for macro focusing.

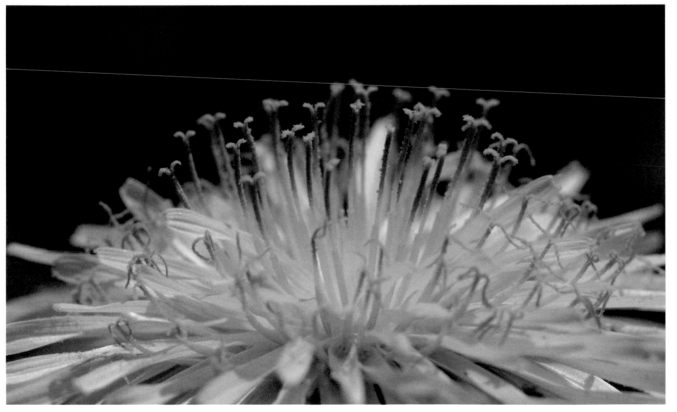

Figure 7.11 Stack several close-up attachments together to get extreme close-ups like this one.

Extension Tubes

Extension tubes are a perfect tool for those who already own a macro lens and want to increase their magnification by getting in tighter with a subject, as well as those who own a non-macro lens that could be pressed into service for close-ups if only it could focus a little closer. They operate by increasing the distance between the lens and the sensor. You attach the tube to your camera body (it has a fitting that's just like the attachment end of a lens) and fasten the lens to the tube's mount, which is a twin of the lens mount on your camera body. The tubes come in various depths, from about 10-12mm to 50mm, as you can see in Figure 7.12.

The combination provides a closer focusing range for your lens, with the range depending on the depth of the tube and the original focusing range of your lens. The simplest way to visualize what an extension tube does is to imagine the lens focused at infinity. In that mode, attaching a 50mm extension tube to a 50mm lens would produce a combination capable of producing a life-size (1:1) image *when the original lens is focused at infinity.* A 25mm extension tube would give you a 1:2 (half life-size) image, while a 12.5mm tube would produce a 1:4 magnification. In practice, the focusing mechanism of the lens being extended continues to operate, so you can focus even closer than those minimum figures.

You're probably already way ahead of me on this, but those tube extensions used in the previous example provide different magnification factors when used with lenses of shorter or longer focal lengths. For example, when a 50mm tube is used with a 25mm lens, you get a 2:1 (twice life-size) image; the 25mm tube gives you 1:1 magnification, and the 12.5mm tube offers 1:2 magnification.

Similarly, when used with a 100mm lens, the 50mm tube produces 1:2 magnification (half life-size), the 25mm tube 1:4 magnification, and so forth.

Figure 7.12 Extension tubes come in several different sizes, each producing a fixed amount of extension.

Things to consider when using extension tubes:

◆ **Reduced exposure.** Moving the aperture farther from the sensor reduces its apparent size, causing a decrease in exposure. The penalty is two f/stops for an extension equal to the focal length of the lens; that is, moving a 50mm lens out an additional 50mm using an extension tube changes the lens's maximum aperture from, say, f/2 to f/5.6. Or, a working f/stop of f/11 would actually be the equivalent of f/22. Your camera's autoexposure system should compensate for this reduced exposure automatically, but if you're calculating exposure manually for some reason, you should be aware of the difference.

◆ **No quality hit.** Unlike diopter lenses, extension tubes don't affect the quality of your image. There are no glass elements in an extension tube, so you can get extra sharp photos. (See Figure 7.13.)

◆ **Mechanical/electrical coupling.** When your lens is separated from the camera body, provisions must be made to restore communications between the lens and camera for functions such as automatic aperture open/close commands, aperture setting, and automatic focus. The least expensive extension tubes may have none of these, turning your lens into a manual focus, preset exposure lens (which can be a major problem if you have a lens without an aperture ring—the aperture is set from a dial on the camera body). Or, an extension tube might have auto aperture open/closing (so you can view the image with the f/stop wide open, but the lens automatically closes down to the aperture used to take the picture when the shutter is released). The best tubes retain all automatic functions.

◆ **Autofocus limitations.** Extension tubes reduce the amount of illumination on the focusing screen autofocus sensor (which is used by the camera to measure contrast of the image and set focus) sufficiently that, with slower lenses, autofocus no longer works. The tipping point is often around f/5.6. If you have an f/4 lens and lose two stops from the extra extension, the lens becomes, effectively, an f/8 lens and autofocus functions may fail. You might be forced to focus manually even though you have "fully automatic" extension tubes.

◆ **No infinity focus.** As with close-up lenses, you can no longer focus to infinity when a lens is mounted on an extension tube.

Figure 7.13 Extension tubes will let you photograph coins from your collection from only a few inches away.

Bellows

A bellows is an accordion-like, variable length extension that is much more versatile than an extension tube, because it can provide a full range of magnifications, not simply the relatively fixed set of extensions offered by tubes sets. One end of the bellows has a lens-like mount that attaches to your camera, while the other end has a camera body-like mount used to attach the lens, as you can see in Figure 7.14. Supporting the bellows is a rail that can move the lens-end of the bellows closer to and farther from the camera body, decreasing and increasing the amount of extension.

The whole thing is attached to a focusing rail mounted on a tripod. The focusing rail can be moved to and fro in relation to your subject. In that way, you can set the amount of extension with the upper rail, and then move the entire assembly closer or farther from your subject. Both sets of rails are often etched with millimeter markings, so you can easily see how much extension is being used, and how far you are moving the bellows toward or away from your subject.

Figure 7.14 A bellows lets you extend your lens much farther from the sensor than is possible with a set of extension tubes.

Figure 7.15 Slide copier attachments let you make digital duplicates of your 35mm slide collection—or copy negatives, too.

You'll find that a bellows costs quite a bit more than extension tubes, usually several hundred dollars or more, and may be more difficult to find in your local camera shop. They're worth a special order if you do a great deal of close-up work and want to extend your lenses as far as possible. Keep in mind that bellows don't couple with the autofocus, autoexposure, or autodiaphragm features of your lens, so you'll have to handle these tasks manually. Bellows often have sophisticated features to further increase your close-up versatility. These include:

◆ **Rotating camera mount.** This allows you to rotate the camera from the horizontal to the vertical position while the bellows itself is still attached to a tripod. You can then shoot horizontal or vertical compositions without adjusting the tripod's orientation.

◆ **Lens standard shift/tilt.** This feature lets you move the lens up or down vertically, or tilt the lens up and down or rotate it side to side, providing fine-tuning perspective adjustments much like a perspective control lens or view camera.

◆ **Rotating standard.** This feature lets you reverse the lens mounting standard so that the lens can be oriented with the front elements pointing toward the sensor, and the rear elements toward your subject. This orientation provides a bit more magnification and can improve sharpness. I'll tell you more about this technique later in this chapter.

◆ **Slide copy attachment.** These fasten to the bellows and allow copying 35mm slides with a digital camera. Such an attachment, like the one shown in Figure 7.15, can be useful for those who don't have a scanner capable of capturing transparencies.

A good bellows will open up new types of extreme close-up photography to you. Simple everyday objects, like the paper clips shown in Figure 7.16, become interesting macro subjects if you can focus close enough.

Figure 7.16 Ordinary household objects become interesting fodder for macro photos when examined up close.

Reversing Rings

Reversing rings let you mount your lenses backwards, which, thanks to the miracle of optical science, provides closer focusing and improved image quality for some lenses when compared to mounting in normal orientation, or with close-up attachments. That's because lenses are designed to be their sharpest when the distance between the subject and the optical center of the lens is *greater* than the distance from the optical center to the film or sensor. If you tip that relationship on its head by adding extension to an unreversed lens, your optics may not perform at their best.

The solution is to mount the lens backwards, so the lens mount is facing your subject, and the "front" of the lens is pointed towards the sensor. This orientation usually produces sharper results, and may even increase the magnification factor.

A reversing ring is a dual-sided metal ring with a male thread matching your lens's filter thread on one side, and a duplicate of the lens mount on the other. Simply screw the threaded side into your filter thread, turn the lens around, and mount it on the camera, facing the "wrong" way, as you can see in Figure 7.17. You can also mount the reversed lens on an extension tube or two, or on a bellows to get the maximum amount of magnification.

In this orientation, the normal bayonet mount of the lens points away from the camera, as you

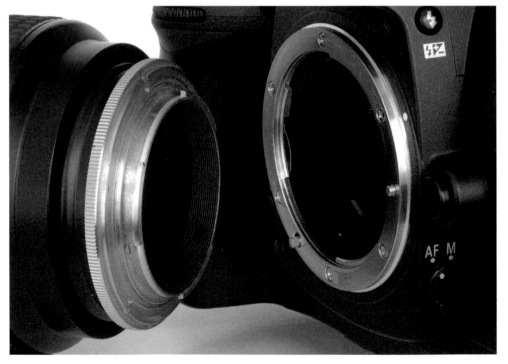

Figure 7.17 A reversed lens can get you really, really close with a high degree of magnification.

can see in Figure 7.18. It's possible to purchase the inverse of a reversing ring, which has a female filter thread on one side and a camera mount on the other. This ring fastens to the other (bayonet) end of the reversed lens, adding a filter thread that can be used to attach a filter if you like, but which is most often coupled with a slide copying attachment or other accessory that normally screws onto the front of an unreversed lens.

When a lens is reversed in this manner, its automatic diaphragm is disabled for both automatic stop-down and autoexposure features. You'll have to change the aperture manually, assuming your lens has an aperture ring. If your lens does not have an aperture ring, you'll have to use the lens with the f/stop set wide open or fully stopped down, depending on the default mode for that lens when not mounted on a camera body. You'll need to focus manually, too. Reversing rings are an excellent accessory for turning non-macro lenses into close-up optics, and they work particularly well with prime lenses in the normal to wide-

angle focal lengths, and can take you *really* close.

Another option is an adapter that mates two lenses together, filter thread to filter thread, so that one lens is mounted on the camera normally and the second lens is attached, reversed, to the front of that lens. To properly match the fronts of several lenses, you may need step-down or step-up rings to match the filter thread sizes of the two lenses being matched.

Even more dramatic increases in magnification are possible with such combos, if you're in an experimental mood and willing to try out different combinations of lenses to find one that works well for you.

Figure 7.18 With a reversing ring you can mount a lens on your camera with the "front" facing the sensor, and the bayonet mount pointing outwards.

Glossary

angle of view The area of a scene that a lens can capture, determined by the focal length of the lens. Lenses with a shorter focal length have a wider angle of view than lenses with a longer focal length. Also called *field of view,* or FOV.

aperture The variable-size opening inside the lens that admits light, created by overlapping leaves of the diaphragm that dilate and contract. See also *diaphragm* and *f/stop.*

aperture-preferred/ aperture-priority A camera setting that allows you to specify the lens opening or f/stop that you want to use, with the camera selecting the required shutter speed automatically based on its light-meter reading. See also *shutter-preferred.*

aperture ring A control on the barrel of many SLR lenses that allows setting the f/stop manually. Some lenses have the aperture set by the camera only, and lack this ring.

aspherical Lens elements that are not sections of a sphere, and so can be shaped precisely to reduce or eliminate lens aberrations and optical defects.

autofocus A camera setting that allows the camera to choose the correct focus distance for you, usually based on the contrast of an image (the image will be at maximum contrast when in sharp focus) or a mechanism such as an infrared sensor that measures the actual distance to the subject. Cameras can be set for AF-S, *single autofocus* (the lens is not focused until the shutter release is partially depressed), or AF-C, *continuous autofocus* (the lens refocuses constantly as you frame and reframe the image). Many cameras also have an *automatic*

autofocus (AF-A) setting that switches from AF-S to AF-C when a stationary subject begins to move.

autofocus assist lamp A light source built into a digital camera (or, sometimes, an internal or external flash unit) that provides extra illumination that the autofocus system can use to focus dimly lit subjects.

averaging meter A light-measuring device that calculates exposure based on the overall brightness of the entire image area. Averaging tends to produce the best exposure when a scene is evenly lit or contains equal amounts of bright and dark areas that contain detail. Most digital cameras use much more sophisticated exposure measuring systems based in center-weighting, spot-reading, or calculating exposure from a matrix of many different picture areas. See also *spot meter.*

B (bulb) A camera setting for making long exposures. Press down the shutter button and the shutter remains open until the shutter button is released. Bulb exposures can also be made using a camera's electronic remote control, or a cable release cord that fits to the camera. See also *T (Time).*

back focus A miscalibrated lens may consistently focus on a point that is actually *behind* the subject that should be in sharp focus. This defect can be fixed by the manufacturer of the lens during servicing. Some professional cameras, such as the Nikon D3, allow the user to calibrate autofocus.

back lighting A lighting effect produced when the main light source is located behind the subject. Back lighting can be used to create a silhouette effect, or to illuminate translucent objects.

Back lighting is also a technology for illuminating an LCD display from the rear, making it easier to view under high ambient lighting conditions.

ball head A type of tripod mount with a ball-and-socket mechanism that allows greater freedom of movement than simple pan and tilt heads.

barrel distortion A defect found in some wide-angle prime and zoom lenses that causes straight lines at the top or side edges of an image to bow outward into a barrel shape. See also *pincushion distortion.*

bellows An adjustable extension accessory for close-up photography that is mounted between a camera body and lens, and which has a system of rails and a folding bellows that can provide a variable amount of focusing distance.

blooming An image distortion caused when a photosite in an image sensor has absorbed all the photons it can handle, so that additional photons reaching that pixel overflow to affect surrounding pixels producing unwanted brightness and overexposure around the edges of objects.

blur In photography, to soften an image or part of an image by throwing it out of focus, or by allowing it to become soft due to subject or camera motion. In image editing, blurring is the softening of an area by reducing the contrast between pixels that form the edges.

bokeh A buzzword used to describe the aesthetic qualities of the out-of-focus parts of an image, with some lenses producing "good" bokeh and others offering "bad" bokeh. *Boke* is a Japanese word for "blur," and the h was added to keep English speakers from rhyming it with *broke.*

Out-of-focus points of light become discs, called the *circle of confusion.* Some lenses produce

a uniformly illuminated disc. Others, most notably *mirror* or *catadioptric* lenses, produce a disk that has a bright edge and a dark center, producing a "doughnut" effect, which is the worst from a bokeh standpoint. Lenses that generate a bright center that fades to a darker edge are favored, because their bokeh allows the circle of confusion to blend more smoothly with the surroundings. The bokeh characteristics of a lens are most important when you are using selective focus (say, when shooting a portrait) to deemphasize the background, or when shallow depth-of-field is a given because you're working with a macro lens, long telephoto, or with a wide-open aperture. See also *mirror lens* and *circle of confusion.*

bracketing Taking a series of photographs of the same subject at different settings to help ensure that one setting will be the correct one. Many digital cameras will automatically snap off a series of bracketed exposures for you. Other settings, such as color and white balance, can also be

"bracketed" with some models. Digital SLRs may even allow you to choose the order in which bracketed settings are applied.

buffer A digital camera's internal memory that stores an image immediately after it is taken until the image can be written to the camera's non-volatile (semi-permanent) memory or a memory card.

burst mode The digital camera's equivalent of the film camera's "motor drive," used to take multiple shots within a short period of time in continuous shooting mode.

camera shake Movement of the camera, aggravated by slower shutter speeds, which produces a blurred image. Some of the latest digital cameras have *image stabilization* features that correct for camera shake, while some interchangeable lenses have a similar vibration correction or reduction feature. See also *image stabilization.*

cast An undesirable tinge of color in an image.

CCD Charge-Coupled Device. A type of solid-state sensor that captures the image, used in scanners and digital cameras. See also *CMOS*.

center-weighted meter
A light-measuring device that emphasizes the area in the middle of the frame when calculating the correct exposure for an image. See also *averaging meter* and *spot meter*.

chroma Color or hue.

chromatic aberration An image defect, often seen as green or purple fringing around the edges of an object, caused by a lens failing to focus all colors of a light source at the same point. See also *fringing*.

circle of confusion A term applied to the fuzzy discs produced when a point of light is out of focus. The circle of confusion is not a fixed size. The viewing distance and amount of enlargement of the image determine whether we see a particular spot on the image as a point or as a disc.

close-up lens A lens add-on that attaches to the front filter thread of a lens, allowing you to take pictures at a distance that is less than the closest-focusing distance of the lens alone.

CMOS Complementary Metal-Oxide Semiconductor. A method for manufacturing a type of solid-state sensor that captures the image, used in scanners and digital cameras. See also *CCD*.

color correction Changing the relative amounts of color in an image to produce a desired effect, typically a more accurate representation of those colors. Color correction can fix faulty color balance in the original image, or compensate for the deficiencies of the inks used to reproduce the image.

composition The arrangement of the main subject, other objects in a scene, and/or the foreground and background.

constant aperture A maximum aperture in a zoom lens that does not change as the magnification is varied. Usually, constant aperture lenses are both faster and more expensive than their variable aperture counterparts. For example, one vendor's 17-55mm zoom lens with an f/2.8 constant aperture costs more than $1,000; the same company's variable aperture 18-55mm "kit" lens, priced 80 percent less, has a maximum aperture of f/3.5 at the 18mm setting, but provide only an f/5.6 maximum aperture at the 55mm setting.

continuous autofocus An automatic focusing setting in which the camera constantly refocuses the image as you frame the picture. This setting is often the best choice for moving subjects.

contrast The range between the lightest and darkest tones in an image. A high-contrast image is one in which the shades fall at the extremes of the range between white and black. In a low-contrast image, the tones are closer together.

crop To trim an image or page by adjusting its boundaries.

density The ability of an object to stop or absorb light. The less light reflected or transmitted by an object, the higher its density.

depth-of-field A distance range in a photograph in which all included portions of an image are at least acceptably sharp. With many dSLRs, you can see the available depth-of-field at the taking aperture by pressing the depth-of-field preview button, or estimate the range by viewing the depth-of-field scale found on many lenses.

desaturate To reduce the purity or vividness of a color, making a color appear to be washed out or diluted.

diaphragm An adjustable component, similar to the iris in the human eye, which can open and close to provide specific sized lens openings, or f/stops. See also *f/stop* and *iris*.

diffraction The loss of sharpness due to light scattering as an image passes through smaller and smaller f/stop openings. Diffraction is dependent only on the actual f/stop used, and the wavelength of the light.

diffuse lighting Soft, low-contrast lighting.

diffusion Softening of detail in an image by randomly distributing gray tones in an area of an image to produce a fuzzy effect. Diffusion can be added when the picture is taken, often through the use of diffusion filters, or in post-processing with an image editor. Diffusion can be beneficial to disguise defects in an image and is particularly useful for portraits of women.

diopter A value used to represent the magnification power of a lens, such as a close-up accessory, calculated as the reciprocal of a lens's focal length (in meters). Diopters are most often used to represent the optical correction used in a viewfinder to adjust for limitations of the photographer's eyesight, and to describe the magnification of a close-up lens attachment.

existing light In photography, the illumination that is already present in a scene. Existing light can include daylight or the artificial lighting currently being used but is not considered to be electronic flash or additional lamps set up by the photographer.

exposure The amount of light allowed to reach the film or sensor, determined by the intensity of the light, the amount admitted by the iris of the lens, and the length of time determined by the shutter speed.

exposure program An automatic setting in a digital camera that provides the optimum combination of shutter speed and f/stop at a given level of illumination. For example a "sports" exposure program would use a faster, action-stopping shutter speed and larger lens opening instead of the smaller, depth-of-field-enhancing lens opening and slower shutter speed that might be favored by a "close-up" program at exactly the same light level.

exposure values (EV) EV settings are a way of adding or decreasing exposure without the need to reference f/stops or shutter speeds. For example, if you tell your camera to add +1EV, it will provide twice as much exposure, either by using a larger f/stop, slower shutter speed, or both.

fast lens A "fast" lens is one with a relatively large maximum aperture for its focal length and intended use. For example, a 55mm f/1.4 lens is considered fast, while a 55mm f/3.5 lens is "slow" when used for available light photography, but quite adequate if intended for close-up work. See also *lens speed*.

fill lighting In photography, lighting used to illuminate shadows. Reflectors or additional incandescent lighting or electronic flash can be used to brighten shadows. One common technique outdoors is to use the camera's flash as a fill.

filter In photography, a device that fits over the lens, changing the light in some way. In image editing, a feature that changes the pixels in an image to produce blurring, sharpening, and other special effects.

flat An image with low contrast.

focal length The distance between the film and the optical center of the lens when the lens is focused on infinity, usually measured in millimeters.

focal plane A line, perpendicular to the optical access, that passes through the focal point forming a plane of sharp focus when the lens is set at infinity.

focus To adjust the lens to produce a sharp image.

focus limiter A control on a lens that restricts autofocus seeking to a specific set of distances, such as only subjects that are relatively close to the camera, or only subjects that are more distant from the camera. For example, if you were shooting sports

with a lens that is capable of focusing closely, locking out the shorter range would improve autofocus performance by preventing the lens from wasting time seeking to focus at those distances.

focus lock A camera feature that lets you freeze the automatic focus of the lens at a certain point, when the subject you want to capture is in sharp focus. Some lenses include a focus lock button right on the lens barrel.

focus range The minimum and maximum distances within which a camera is able to produce a sharp image, such as two inches to infinity.

focus ring The band on the barrel of the lens that can be rotated to focus manually.

focus scale An array of focus distances on some lens's lens barrels from infinity to the closest focusing distance for that lens, with a indicator that shows the current focus point.

focus tracking The ability of the automatic focus feature of a camera to change focus as the distance between the subject and the camera changes. One type of focus tracking is *predictive*, in which the mechanism anticipates the motion of the object being focused on, and adjusts the focus to suit.

framing In photography, composing your image in the viewfinder. In composition, using elements of an image to form a sort of picture frame around an important subject.

fringing A chromatic aberration that produces fringes of color around the edges of subjects, caused by a lens's inability to focus the various wavelengths of light onto the same spot. *Purple fringing* is especially troublesome with backlit images.

front focus A miscalibrated lens may consistently focus on a point that is actually *in front of* the subject that should be in sharp focus. This defect can be fixed by the manufacturer of the lens during servicing.

front lighting Illumination that comes from the direction of the camera. See also *back lighting* and *side lighting*.

f/stop The relative size of the lens aperture, which helps determine both exposure and depth-of-field. The larger the f/stop number, the smaller the f/stop itself. It helps to think of f/stops as denominators of fractions, so that f/2 is larger than f/4, which is larger than f/8, just as 1/2, 1/4, and 1/8 represent ever-smaller fractions. In photography, a given f/stop number is multiplied by 1.4 to arrive at the next number that admits exactly half as much light. So, f/1.4 is twice as large as f/2.0 (1.4 × 1.4), which is twice as large as f/2.8 (2 × 1.4), which is twice as large as f/4 (2.8 × 1.4). The f/stops that follow are f/5.6, f/8, f/11, f/16, f/22, f/32, and so on. See also *diaphragm*.

Gaussian blur A method of diffusing an image using a bell-shaped curve to calculate the pixels that will be blurred, rather than blurring all pixels, producing a more random, less "processed" look.

graduated filter A lens attachment with variable density or color from one edge to another. A graduated neutral density filter, for example, can be oriented so the neutral density portion is concentrated at the top of the lens's view with the less dense or clear portion at the bottom, thus reducing the amount of light from a very bright sky while not interfering with the exposure of the landscape in the foreground. Graduated filters can also be split into several color sections to provide a color gradient between portions of the image.

grain The metallic silver in film that forms the photographic image. The term is often applied to the seemingly random noise in an image (both conventional and digital) that provides an overall texture.

gray card A piece of cardboard or other material with a standardized 18-percent reflectance. Gray cards can be used as a reference for determining correct exposure and for setting white balance.

grayscale image An image represented using 256 shades of gray. Scanners often capture grayscale images with 1,024 or more tones, but reduce them to 256 grays for manipulation by Photoshop.

highlights The brightest parts of an image containing detail.

histogram A kind of chart showing the relationship of tones in an image using a series of 256 vertical "bars," one for each brightness level. A histogram chart typically looks like a curve with one or more slopes and peaks, depending on how many highlight, midtone, and shadow tones are present in the image.

hyperfocal distance A point of focus where everything from half that distance to infinity appears to be acceptably sharp. For example, if your lens has a hyperfocal distance of four feet, everything from two feet to infinity would be sharp. The hyperfocal distance varies by the lens and the aperture in use. If you know you'll be making a "grab" shot without warning, sometimes it is useful to turn off your camera's automatic focus and set the lens to infinity, or, better yet, the hyperfocal distance. Then, you can snap off a quick picture without having to wait for the lag that occurs with most digital cameras as their autofocus locks in.

image stabilization A technology, also called vibration reduction and anti-shake, that compensates for camera shake, usually by adjusting the position of the camera sensor or lens elements in response to movements of the camera.

incident light Light falling on a surface.

infinity A distance so great that any object at that distance will be reproduced sharply if the lens is focused at the infinity position.

infrared illumination The non-visible part of the electromagnetic spectrum with wavelengths between 700 and 1,200 nanometers, which can be used for infrared photography when the lens is filtered to remove visible light.

interchangeable lens Lens designed to be readily attached to and detached from a camera; a feature found in more sophisticated digital cameras.

International Organization for Standardization (ISO) A governing body that provides standards such as those used to represent film speed, or the equivalent sensitivity of a digital camera's sensor. Digital camera sensitivity is expressed in ISO settings.

interpolation A technique digital cameras, scanners, and image editors use to create new pixels required whenever you resize or change the resolution of an image based on the values of surrounding pixels. Devices such as scanners and digital cameras can also use interpolation to create pixels in addition to those actually captured, thereby increasing the apparent resolution, size, or color information in an image.

iris A set of thin overlapping leaves in a camera lens, also called a diaphragm, that pivot outwards to form a circular opening of variable size to control the amount of light that can pass through a lens.

jaggies Staircasing effect of lines that are not perfectly horizontal or vertical, caused by pixels that are too large to represent the line accurately.

kit lens A basic and relatively inexpensive zoom lens furnished with a digital SLR camera body, usually with a focal length range of 18-55mm, 18-70mm, or 18-135mm. These lenses usually have variable apertures in the f/3.5-5.6 range. Some models, especially more expensive dSLRs, are sometimes furnished with more costly "kit" lenses, such as the 18-200mm vibration reduction lens sold with some Nikon cameras.

Kelvin (K) A unit of measurement based on the absolute temperature scale in which absolute zero is zero; used to describe the color of continuous spectrum light sources, such as tungsten illumination (3200 to 3400K) and daylight (5500 to 6000K).

landscape The orientation of a page in which the longest dimension is horizontal, also called wide orientation. Also, a type of photographic image, usually incorporating scenery or natural elements.

latitude The range of camera exposures that produces acceptable images with a particular digital sensor or film.

lens One or more elements of optical glass or similar material designed to collect and focus rays of light to form a sharp image on the film, paper, sensor, or a screen.

lens aperture The lens opening, or iris, that admits light to the film or sensor. The size of the lens aperture is usually measured in f/stops. See also *f/stop* and *iris*.

lens creep The unwanted tendency of a zoom lens to "zoom" all by itself when the lens is tilted up or down.

lens flare A feature of conventional photography that is both a bane and creative outlet. It is an effect produced by the reflection of light internally among elements of an optical lens. Bright light sources within or just outside the field of view cause lens flare. Flare can be reduced by the use of coatings on the lens elements or with the use of lens hoods.

Photographers sometimes use the effect as a creative technique, and Photoshop includes a filter that lets you add lens flare at your whim.

lens hood A device that shades the lens, protecting it from extraneous light outside the actual picture area, which can reduce the contrast of the image, or allow lens flare.

lens speed The relative size of the maximum aperture of a lens, compared to its focal length and intended use. A 35mm f/1.4 lens would be "fast," while a lens of the same focal length with an f/3.5 maximum aperture might be considered "slow." However, a 400mm lens with an f/2.8 maximum aperture is considered very fast indeed (and quite expensive).

lighting ratio The proportional relationship between the amount of light falling on the subject from the main light and other lights to produce defined highlights and shadows, expressed in a ratio, such as 3:1.

luminance The brightness or intensity of an image, determined by the amount of gray in a hue.

macro lens A lens that provides continuous focusing from infinity to extreme close-ups, often to a reproduction ratio of 1:2 (half life-size) or 1:1 (life-size).

magnification ratio A relationship that represents the amount of enlargement provided by the macro setting of the zoom lens, macro lens, or with other close-up devices.

matrix metering A system of exposure calculation that looks at many different segments of an image to determine the brightest and darkest portions.

maximum aperture The largest lens opening or f/stop available with a particular lens, or with a zoom lens at a particular magnification.

midtones Parts of an image with tones of an intermediate value, usually in the 25 to 75 percent range. Many image-editing features allow you to manipulate midtones independently from the highlights and shadows.

mirror lens A type of lens, more accurately called a *cata-dioptric lens*, which contains both lens elements and mirrors to "fold" the optical path to produce a shorter, lighter telephoto lens. Because of their compact size and relatively low price, these lenses are popular, even though they have several drawbacks, including reduced contrast, fixed apertures, and they produce doughnut-shaped out-of-focus points of light (because one of the mirrors is mounted on the front of the lens).

mirror lock-up The ability to retract the SLR's mirror to reduce vibration prior to taking the photo, or to allow access to the sensor for cleaning.

moiré An objectionable pattern caused by the interference of halftone screens, frequently generated by rescanning an image that has already been halftoned, or, sometimes, by digital cameras that don't have a sufficiently aggressive low pass filter (which is designed to remove moiré) in front of the sensor. An image editor can frequently minimize these effects by blurring the patterns.

monochrome Having a single color, plus white. Grayscale images are monochrome (shades of gray and white only).

monopod A one-legged support that can be attached to a camera or lens to reduce the effects of camera/lens movement.

multi-coating Thin layers of material placed on the surface of a lens element to minimize reflections, remove undesirable wavelengths of light, and to provide a protective shield on the glass.

neutral density filter A gray camera filter reduces the amount of light entering the camera without affecting the colors.

noise In an image, pixels with randomly distributed color values. Noise in digital photographs tends to be the product of low-light conditions and long exposures, particularly when you have set your camera to a higher ISO rating than normal.

noise reduction A technology used to cut down on the amount of random information in a digital picture, usually caused by long exposures at increased sensitivity ratings. Noise reduction involves the camera automatically taking a second blank/dark exposure at the same settings that contain only noise, and then using the blank photo's information to cancel out the noise in the original picture. With most cameras, the process is very quick, but does double the amount of time required to take the photo. Noise reduction can also be performed within image editors and stand-alone noise reduction applications.

normal lens A lens that makes the image in a photograph appear in a perspective that is like that of the original scene, typically with a field of view of roughly 45 degrees. A quick way to calculate the focal length of a normal lens is to measure the diagonal of the sensor or film frame used to capture the image, usually ranging from around 7mm (with point-and-shoot cameras) to 45mm (with full-frame film and digital cameras).

optical aberration A defect in the design of a lens that causes the image to diverge from the ideal focus point, causing some or all of the image to blur in some way. *Chromatic aberrations* disperse the various wavelengths of light in an undesirable way. *Monochromatic aberrations*, such as barrel distortion and pincushion distortion, warp all colors of light equally. See also: *chromatic aberration, barrel distortion, pincushion distortion*.

overexposure A condition in which too much light reaches the film or sensor, producing a dense negative or a very bright/light print, slide, or digital image.

pan-and-tilt head A tripod head allowing the camera to be tilted up or down or rotated 360 degrees.

panning Moving a still camera so that the image of a moving object remains in the same relative position in the viewfinder as you take a picture. The eventual effect creates a strong sense of movement.

perspective The rendition of apparent space in a photograph, such as how far the foreground and background appear to be separated from each other. Perspective is determined by the distance of the camera to the subject. Objects that are close appear large, while distant objects appear to be far away.

perspective control lens A special lens, most often used for architectural photography, that allows correcting distortion resulting from a high or low camera angle by shifting the lens so that the subject remains more closely parallel to the sensor or film.

pincushion distortion A type of distortion, most often seen in telephoto prime lenses and zooms, in which lines at the top and side edges of an image are bent inward.

pixel The smallest element of a screen display that can be assigned a color. The term is a contraction of "picture element."

pixels per inch (ppi) The number of pixels that can be displayed per inch, usually used to refer to pixel resolution from a scanned image or on a monitor.

polarizing filter A filter that restricts the light, which normally vibrates in all directions, so that more of the illumination that passes through the filter vibrates only in a single plane. This effect reduces or removes the specular reflections from the surface of objects and emphasizes the blue of skies in color images, and is strongest when the light source is located at a 90-degree angle from the direction the camera is pointed.

portrait The orientation of a page in which the longest dimension is vertical, also called tall orientation. In photography, a formal picture of an individual or, sometimes, a group.

positive The opposite of a negative, an image with the same tonal relationships as those in the original scenes—for example, a finished print or a slide.

prime A camera lens with a single fixed focal length, as opposed to a zoom lens.

RAW An image file format offered by many digital cameras that includes all the unprocessed information captured by the camera. RAW files are very large, and must be processed by a special program supplied by camera makers, image editors, or third parties, after being downloaded from the camera.

reflector Any device used to reflect light onto a subject to improve balance of exposure (contrast). Another way is to use fill-in flash.

reproduction ratio Used in macrophotography to indicate the magnification of a subject.

resolution In image editing, the number of pixels per inch used to determine the size of the image when printed. That is, an 8×10-inch image that is saved with 300 pixels per inch resolution will print in an 8×10-inch size on a 300 dpi printer, or 4×5-inches on a 600 dpi printer. In digital photography, resolution is the number of pixels a camera or scanner can capture.

retouch To edit an image, most often to remove flaws or to create a new effect.

reversing ring An accessory that allows flipping a lens so that its mount faces the subject, and the front of the lens faces the camera body, an orientation that produces greater magnification

and better image quality with some lenses. The ring has a male thread (like that on a filter) matching the thread diameter of the reversed lens, and a bayonet mount on the other side. In use, the ring is screwed onto the front of the lens, which is flipped and then fastened onto a camera body, extension tube, or bellows.

saturation The purity of color; the amount by which a pure color is diluted with white or gray.

selective focus Choosing a lens opening that produces a shallow depth-of-field. Usually this is used to isolate a subject by causing most other elements in the scene to be blurred.

self-timer Mechanism delaying the opening of the shutter for some seconds after the release has been operated. Also known as delayed action.

sensitivity A measure of the degree of response of a film or sensor to light.

sensor array The grid-like arrangement of the red, green, and blue-sensitive elements of a digital camera's solid-state capture device. Sony offers a sensor array that captures a fourth color, termed *emerald*.

shadow The darkest part of an image, represented on a digital image by pixels with low numeric values or on a halftone by the smallest or absence of dots.

sharpening Increasing the apparent sharpness of an image by boosting the contrast between adjacent pixels that form an edge.

shutter In a conventional film camera, the shutter is a mechanism consisting of blades, a curtain, plate, or some other movable cover that controls the time during which light reaches the film. Digital cameras can use actual shutters, or simulate the action of a shutter electronically. Some use a combination, employing a mechanical shutter for slow speeds and an electronic version for higher speeds.

shutter lag The tendency of a camera to hesitate after the shutter release is depressed prior to making the actual exposure. Point-and-shoot digital cameras often have shutter lag times of up to two seconds, primarily because of slow autofocus systems. Digital SLRs typically have much less shutter lag, typically 0.2 seconds or less.

shutter-preferred/shutter priority An exposure mode in which you set the shutter speed and the camera determines the appropriate f/stop. See also *aperture-preferred*.

side lighting Light striking the subject from the side relative to the position of the camera; produces shadows and highlights to create modeling on the subject.

single lens reflex (SLR) camera A type of camera that allows you to see through the camera's lens as you look in the camera's viewfinder. Other camera functions, such as light metering and flash control, also operate through the camera's lens.

soft focus An effect produced by use of a special lens or filter that creates soft outlines.

soft lighting Lighting that is low or moderate in contrast, such as on an overcast day.

specular highlight Bright spots in an image that lack detail, caused by reflection of light sources.

spot meter An exposure system that concentrates on a small area in the image. See also *averaging meter*.

T (time) A shutter setting in which the shutter opens when the shutter button is pressed, and remains open until the button is pressed a second time. See also *B (bulb)*.

telephoto A lens or lens setting that magnifies an image.

threshold A predefined level used by a device to determine whether a pixel will be represented as black or white.

time exposure A picture taken by leaving the shutter open for a long period, usually more than one second. The camera is generally locked down with a tripod to prevent blur during the long exposure. See also *B (bulb)*.

time lapse A process by which a tripod-mounted camera takes sequential pictures at intervals, allowing the viewing of events that take place over a long period of time, such as a sunrise or flower opening. Many digital cameras have time-lapse capability built in, or have a plug-in cable that can provide the feature. Others require you to attach the camera to your computer through a USB cable, and let software in the computer trigger the individual photos.

tint A color with white added to it. In graphic arts, often refers to the percentage of one color added to another.

tolerance The range of color or tonal values that will be selected with a tool like the Photoshop's Magic Wand, or filled with paint when using a tool like the Paint Bucket.

transparency A positive photographic image on film, viewed or projected by light shining through film.

tripod A three-legged supporting stand used to hold the camera steady. Especially useful when using slow shutter speeds and/or telephoto lenses.

tripod collar A rotating, lockable fitting around a lens with a socket that can be used to attach a tripod or monopod to the lens.

TTL Through the lens. A system of providing viewing through the actual lens taking the picture (as with a camera with an electronic viewfinder, LCD display, or single lens reflex viewing), or calculation of exposure, flash exposure, or focus based on the view through the lens.

tungsten light Usually warm indoor light from ordinary room lamps and ceiling fixtures, as opposed to fluorescent illumination.

underexposure A condition in which too little light reaches the film or sensor, producing a thin negative, dark slide, muddy-looking print, or dark digital image.

unsharp masking The process for increasing the light/contrast between adjacent pixels in an image, increasing sharpness, especially around edges.

USB A high-speed serial communication method commonly used to connect digital cameras and other devices to a computer or printer.

variable aperture In a zoom lens, a maximum aperture that changes as the lens is zoomed in or out. For example, an 18-55mm "kit" lens may have a maximum aperture of f/3.5 at the 18mm setting, but provide just f/5.6 at the 55mm setting.

vibration reduction See *image stabilization*.

viewfinder The device in a camera used to frame the image. With an SLR camera, the viewfinder is also used to focus the image if focusing manually. You can also focus an image with the LCD display of a digital camera, which is a type of viewfinder.

vignetting Dark corners of an image, often produced by using a lens hood that is too small for the field of view, or generated artificially using image-editing techniques in order to enhance a portrait or other subject in which the photographer wants to concentrate attention on the center of the photo.

wide-angle lens A lens that has a shorter focal length and a wider field of view than a normal lens for a particular film or digital image format.

zoom In image editing, to enlarge or reduce the size of an image on your monitor. In photography, to enlarge or reduce the size of an image using the magnification settings of a lens.

zoom ring A control on the barrel of a lens that allows changing the magnification, or zoom, of the lens by rotating it.

Index